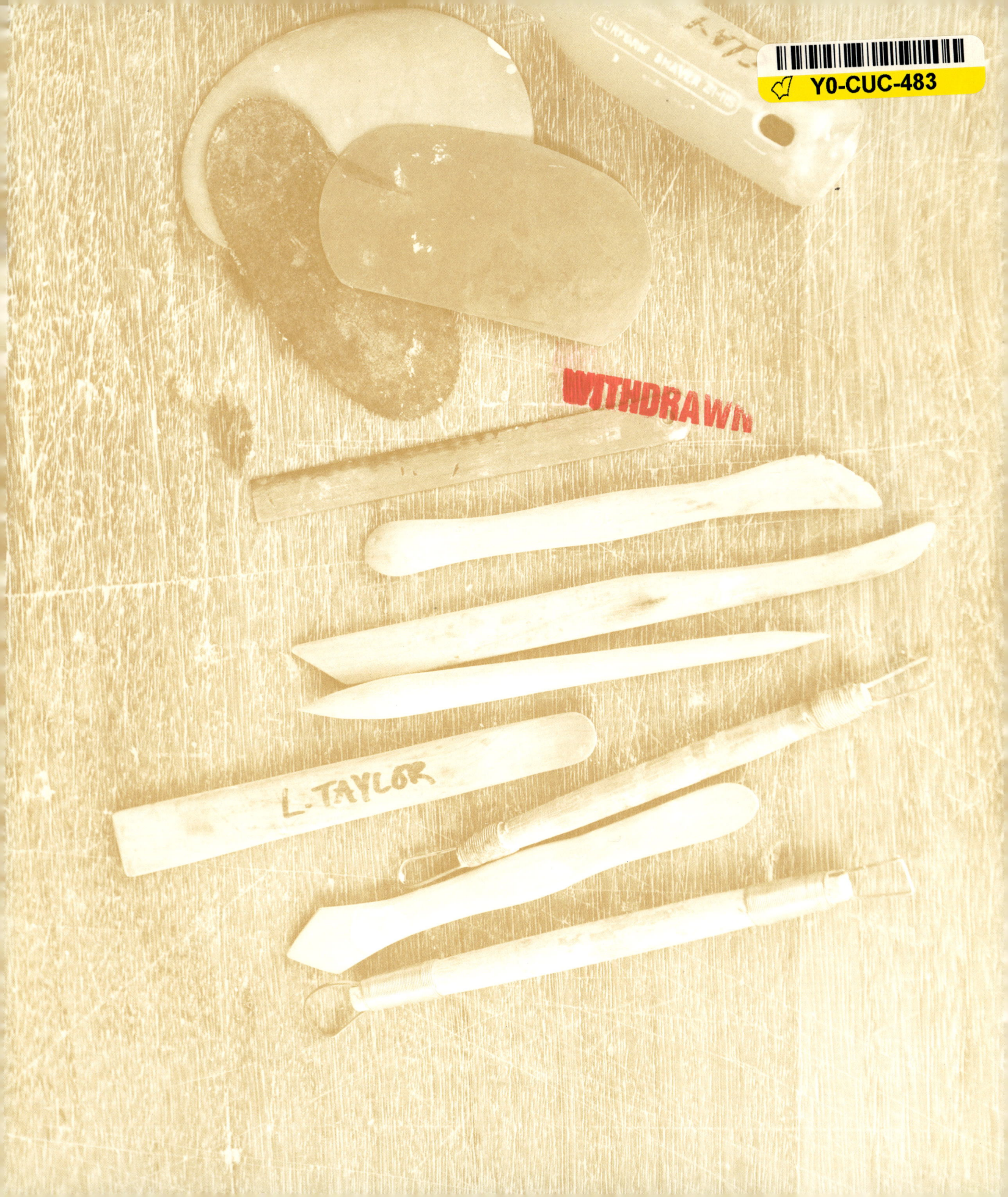

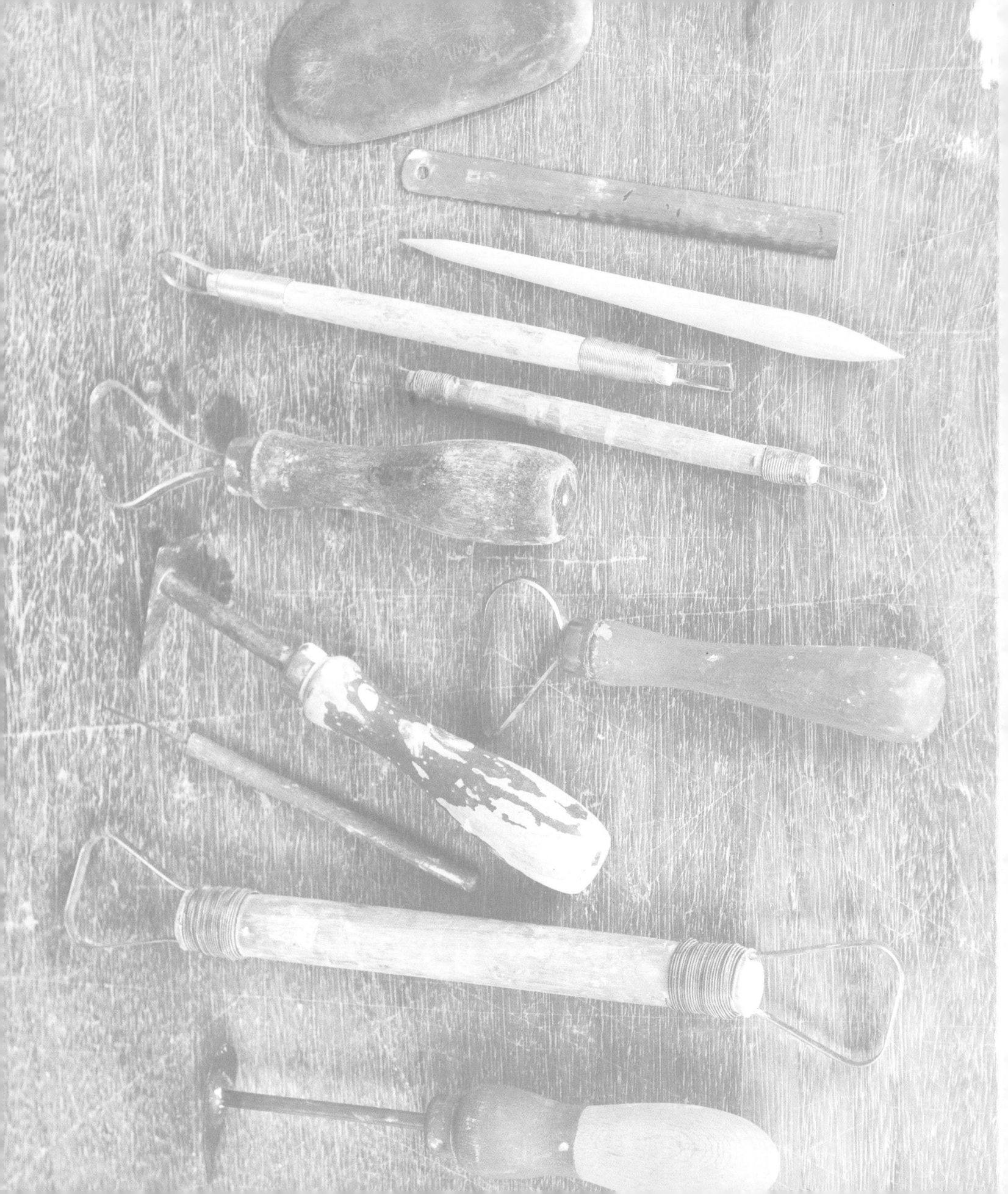

THE CERAMICS BIBLE

THE CERAMICS BIBLE

THE COMPLETE GUIDE TO MATERIALS AND TECHNIQUES
BY LOUISA TAYLOR

CHRONICLE BOOKS
SAN FRANCISCO

First Published in the United States in 2011 by Chronicle Books.

Copyright © 2011 by RotoVision SA.
All rights reserved. No part of this book may be reproduced in any form without written permission from the publisher.

Library of Congress Cataloging-in-Publication Data available.

ISBN: 978-1-4521-0162-0
Cover Design: Lynda Lucas

Art Director: Tony Seddon
Design: www.gradedesign.com
Project Manager: Nicola Hodgson

Typeset in PMN Caecilia
Manufactured in China.

10 9 8 7 6 5 4 3 2 1

Chronicle Books
680 Second Street
San Francisco, CA 94107

www.chroniclebooks.com

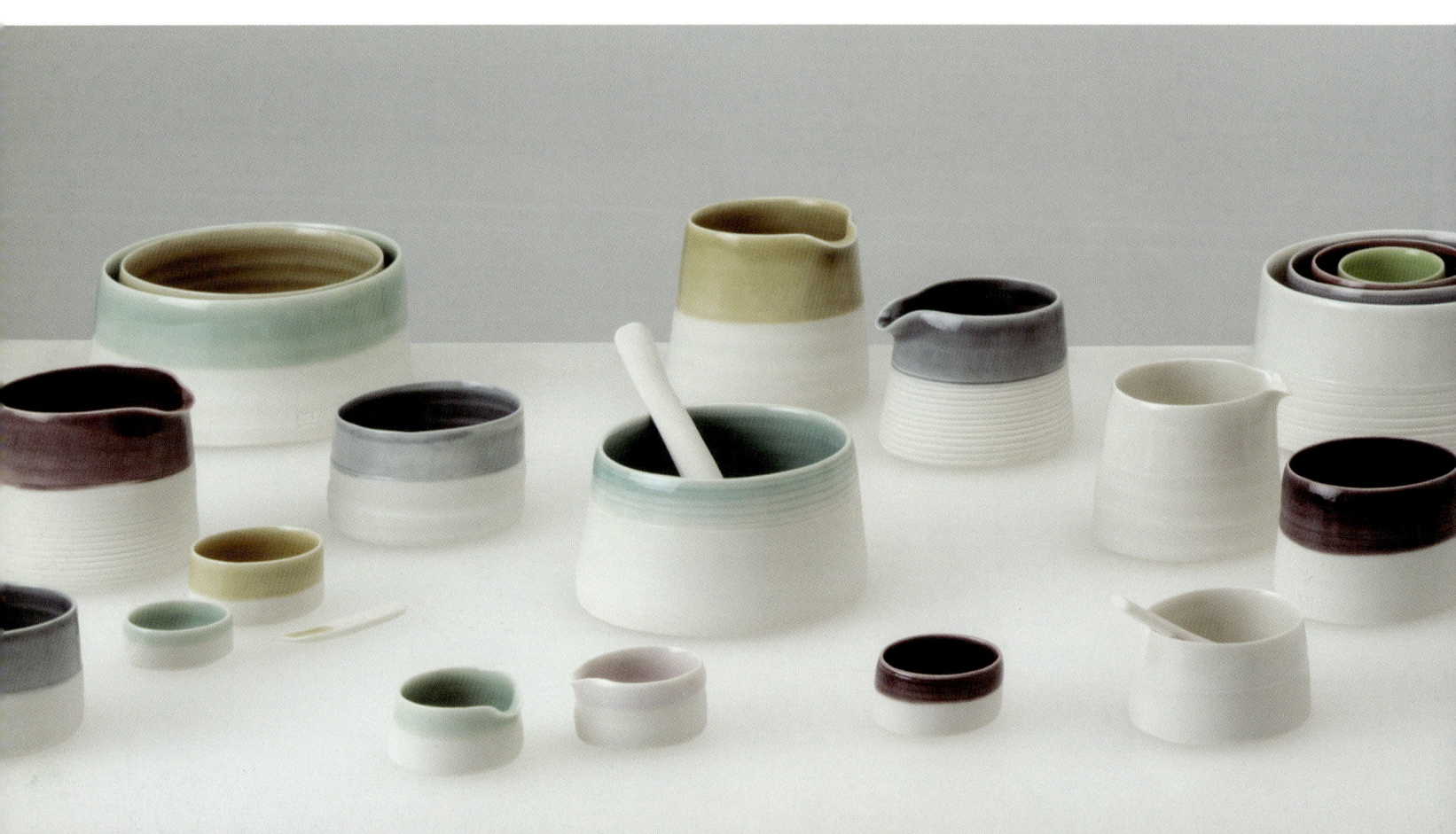

For my wonderful partner, Matt, for all your support and encouragement.

PREVIOUS SPREAD
Natasha Daintry
Ziggurat with Small Expanse of Yellow

BELOW
Louisa Taylor
Mustard pots and spoons

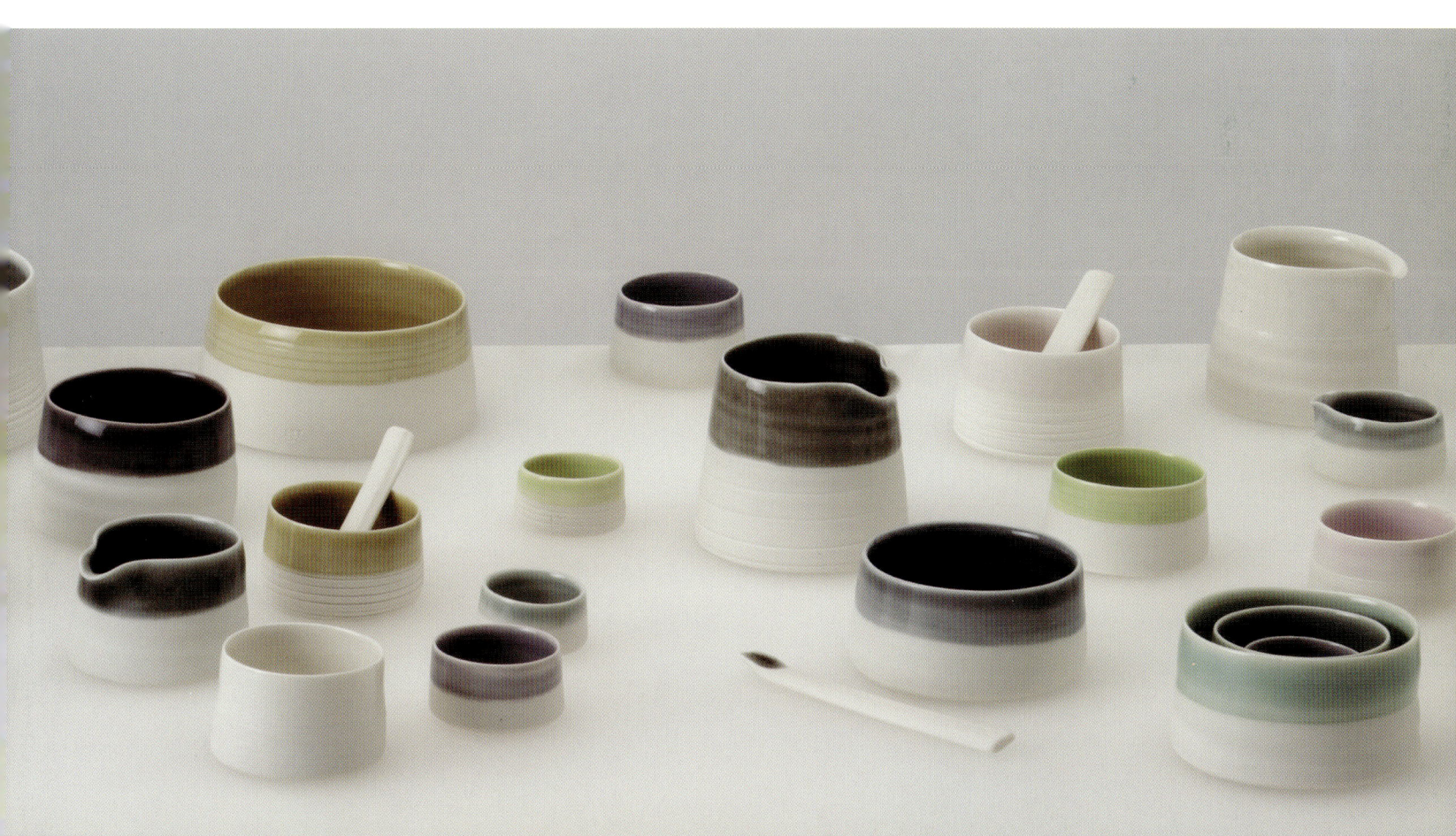

Table of Contents

Introduction 8
Types of ceramic ware 10

SECTION 1:
Materials and tools 12

Types of clay 14
Other materials 18
Clay recipes 20
Preparing clay 24
Cut and stack wedging step by step 26
Ram's head wedging step by step 28
Spiral wedging step by step 30
Drying overview 32
Drying step by step 35
Raw materials 36
Oxides 38
Stains 42
Storing ceramic materials 44
Tools 46
Kiln furniture and accessories 48
Studio equipment 50
Glazing equipment 52
Safety procedures 54

SECTION 2:
Forming techniques 58

Introduction to handbuilding 60
Coiling step by step 62
Pinching step by step 66
Extruding step by step 68
Slab work step by step 70
Gallery: handbuilding 74
Artist profile: Nao Matsunaga 76
Introduction to slip casting and molds 78
Press molds step by step 82
Ready-made molds step by step 86
Making a model step by step 88
Making a two-piece mold step by step 92
Slip casting step by step 96
Gallery: slip casting and molds 98
Artist profile: Heather Mae Erickson 100
Introduction to throwing 102
Types of wheels 104
Centering step by step 106
Throwing a cylinder step by step 108
Throwing a bowl step by step 110
Throwing a bottle form step by step 112
Throwing a closed form step by step 114
Throwing a lidded vessel step by step 116
Making a lid 118
Trimming step by step 119
Pulling a handle step by step 124
Joining a handle step by step 125
Troubleshooting: throwing 126
Gallery: throwing 128
Artist profile: Prue Venables 130

SECTION 3:
Glazing and firing techniques 132

Glazes overview 134
Glaze recipes—earthenware 138
Glaze recipes—stoneware 140
Glaze testing 142
Preparing glaze 144
Applying glaze 148
Troubleshooting: common glaze faults 152
Introduction to kilns 154
Types of kilns 156
Loading the kiln 162
Kiln temperature and kiln programs 164
Introduction to firing 166
Oxidized firing overview 168
Oxidized firing process 169
Gallery: oxidized firing 170
Artist profile: Natasha Daintry 172
Reduction firing overview 174
Reduction firing process 175
Gallery: reduction firing 176
Artist profile: Chris Keenan 178
Salt and soda firing overview 180
Salt and soda firing process 182
Gallery: salt and soda firing 184
Artist profile: Robert Winokur 186
Wood firing overview 188
Wood firing process 189
Gallery: wood firing 190
Artist profile: Janet Mansfield 192
Raku firing overview 194
Raku firing process 195
Gallery: raku firing 196
Artist profile: Ashraf Hanna 198

SECTION 4:
Decorative and finishing techniques — 200

Slip decoration and surface overview	202
Slip decoration recipes	204
Slip decoration and surface techniques	206
Gallery: slip decoration	216
Artist profile: Elke Sada	218
Enamels, lusters, and transfers overview	220
Enamels step by step	222
Lusters step by step	224
Transfers step by step	226
Gallery: enamels, lusters, and transfers	228
Artist profile: Alice Mara	230
Engraving and sandblasting overview	232
Engraving methods	234
Sandblasting step by step	236
Artist profile: Maria Lintott	238
Finishing overview	240
Grinding and polishing methods	242
Post-firing techniques	244
Fixing and display	248
Gallery: finishing	250
Artist profile: Neil Brownsword	252

SECTION 5:
Resources — 254

Training courses	256
Residencies	258
Marketing	260
Trade shows	261
Art gallery and museum collections	262
Representation	264
Guilds, organizations, and associations	266
Workshops and studios	268
Suppliers	270
Useful charts	274
Contributors	276
Bibliography	278
Glossary	280
Index	282
Acknowledgments	288

Introduction

Clay is an extremely versatile and fascinating material. It can be sculpted, manipulated, and shaped into any form imaginable; then, with the application of immense heat, it can be changed into a state of permanence. Unlike other media, there is a sense of unpredictability and mystery surrounding clay once it enters the kiln; it is never fully within our control and outcomes are not guaranteed. It is the investigation into the unknown, the potential of discovery and reward, that challenges artists to keep pushing beyond the boundaries.

About this book

This book is both a practical and an inspirational resource for students, enthusiasts, and anyone intrigued by the material. It offers an in-depth introduction to a wide range of ceramic processes and techniques, which are shown in concise, easy-to-follow step-by-step instructions.

Rather than adopting a prescriptive, manual-style tone, the techniques demonstrated are open to interpretation; they are not intended to suggest that there is only one way to reach a destination. Nor does the book dictate what to make; the step by steps are intended to be component-based to allow for freedom in exploring the potential of the techniques. Traditional methods are challenged by non-traditional methods; we also discuss the latest technologies and working practices. The aim is to encourage the reader to be experimental and inquisitive to create a foundation to build on as his or her confidence grows.

Alongside technique and skill, it is the application and execution of a concept that asserts a strong identity and voice within the material. This visual language can be developed by means of research; drawing, sketching, visiting galleries and museums, or even discussing ideas with others. The work presented reflects this notion and celebrates the innovation, skill, and talent of artists from all over the world. Some are just emerging; others are more established in their careers. At the end of each section, a selected artist offers a personal insight into his or her creative practice and shares with the reader the experiences, inspirations, and motivation behind the work.

I hope this book will take the reader on a journey of discovery and self-development. Throughout the process, it is important to recognize that the acquisition of any skill is a direct result of an investment of time and will develop with practice and persistence. This book has been created to excite and enthuse, and to implement a fresh, contemporary approach to using clay as a means of artistic expression.

Mike Eden (UK)
The Maelstrom, 2009/10
H: 10in (25cm), W: 10in (25cm),
D: 6in (15cm)
Nylon with non-fired ceramic coating;
additive layer manufacturing
(selective laser sintering)
(Image courtesy of Adrian Sasson)

"The Maelstrom is an investigation into the transfer of my craft skills and tacit knowledge from ceramic processes to the CAD/CAM technology that I now employ. My aim is to fully embrace the new technology, not for its own sake, but in order to produce objects with a narrative content that are impossible to make using traditional ceramic processes."

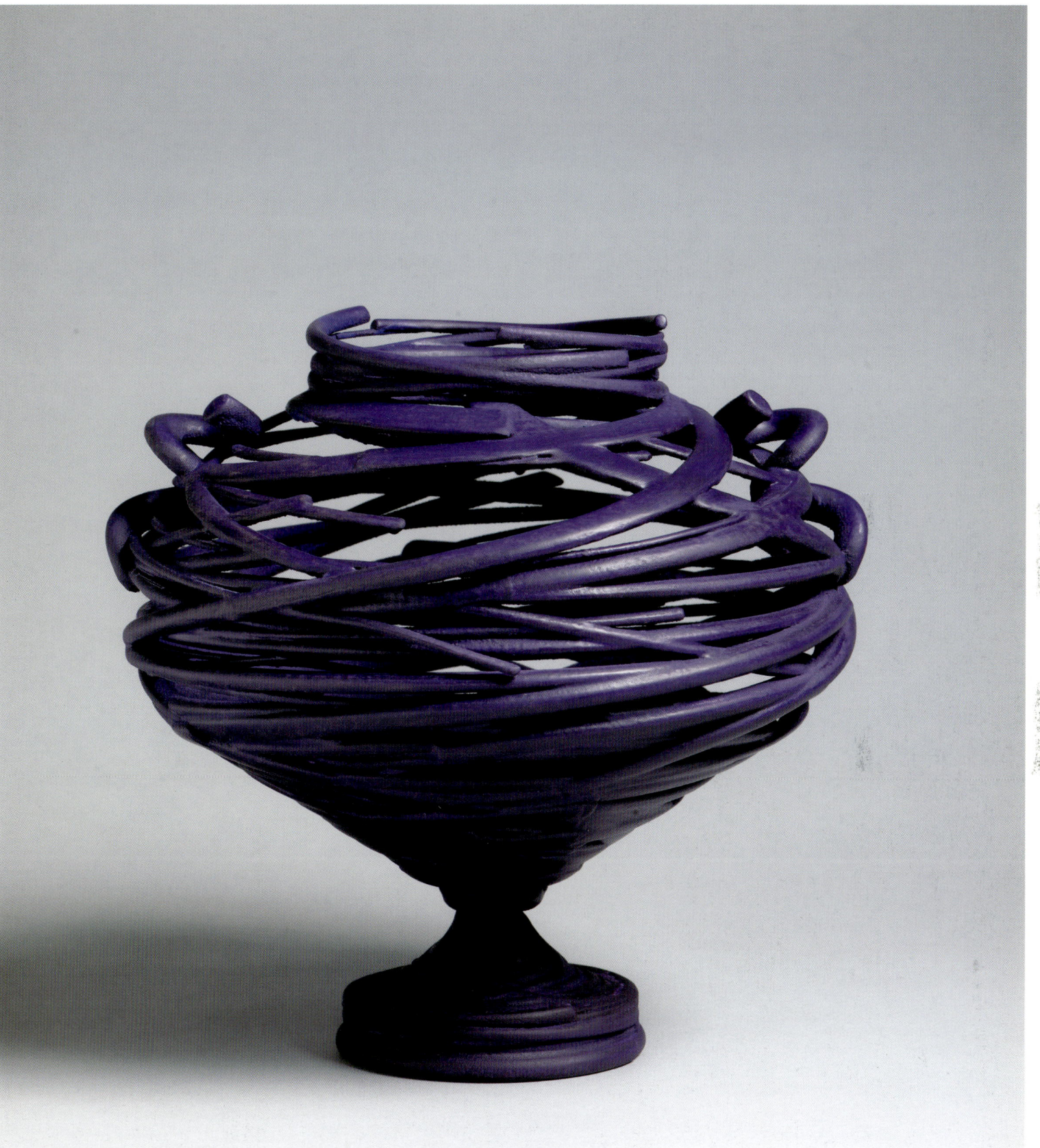

Types of ceramic ware

The subject of ceramics is a diverse field to explore. Types of ceramics range from domestic ware and one-off art pieces to jewelry, lighting, dentistry, and even components for space shuttles. Within studio practice, the work of the clay practitioner can loosely be described by the following subcategories, although this is by no means a definitive list. Arguably the work could bestride any number of these groups, and therefore the categorization is subjective.

Tableware
Objects for use, emphasis on function.

Vessel
Sense of containment, be it functional or nonfunctional.

Decorative
The relationship between surface and form.

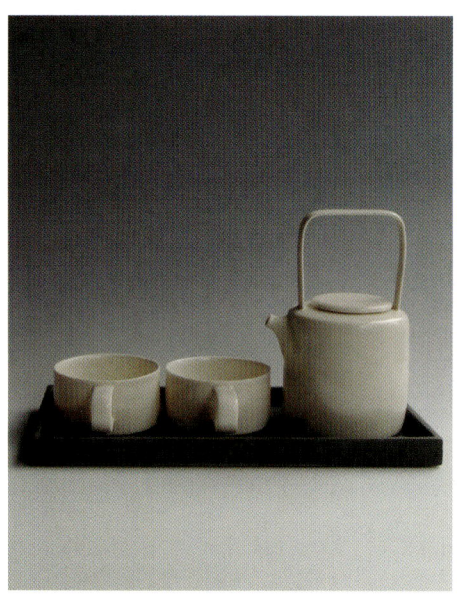

Derek Wilson (UK)
Porcelain Tea Set, 2009/10
H: 8¼in (21cm), W: 7in (18cm),
L: 13½in (34cm)
Handthrown; extruded handles; slab-built tray coated in a dark gray engobe

These forms are inspired by Japanese formalism, mimilism, and reductivist theories.

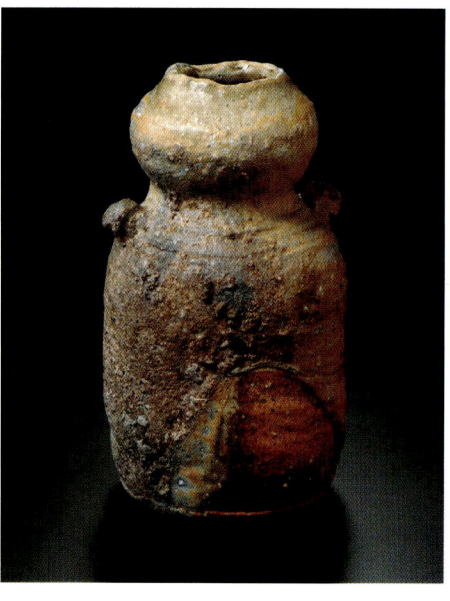

Uwe Löllmann (Germany)
Vessel, 2007
H: 13½in (34cm)
Stoneware, wood-fired in an anagama kiln for seven days; natural ash glaze

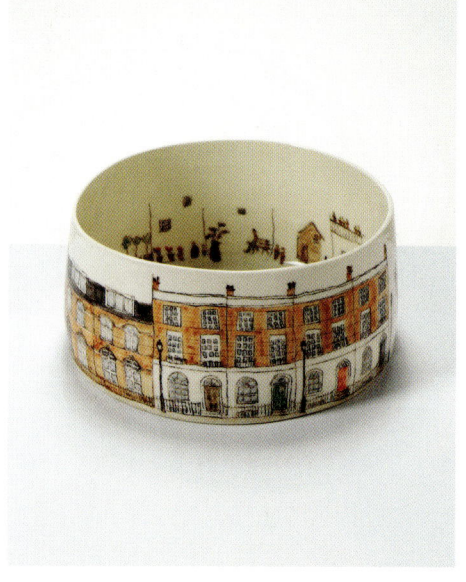

Helen Beard (UK)
Georgian Terrace, 2009
H: 5½in (14cm), Dia: 11½in (29cm)
Hand-thrown and decorated porcelain

A line drawing is applied using paper sheets impregnated with black underglaze stain; washes of color are then painted on, followed by a transparent glaze.

Figurative
The work concerns the figure, be it human, animal, or other.

Sculpture
The expression of an idea using the three-dimensional form. Sculpture does not usually have a functional purpose other than visual and aesthetic.

Installation
The relationship between an object and its environment.

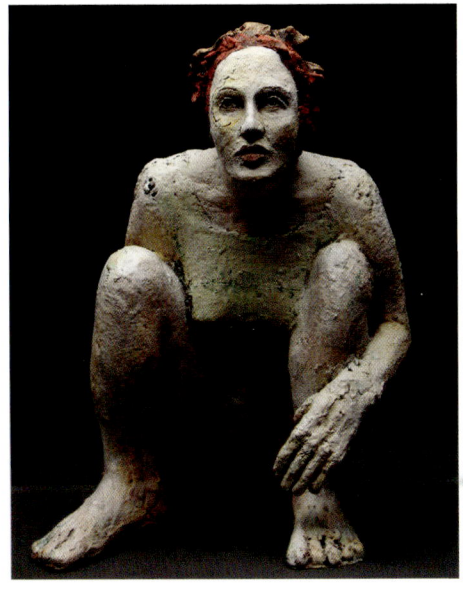

Debra Fritts (US)
Allowing Time, 2009
H: 20in (50cm), W: 13in (33cm), D: 14in (35cm)
Stoneware; handbuilt using coils, slabs, and modeling

This artist took the US recession of the late 2000s as the inspiration for this piece, reflecting the crash in sales from art galleries. The focus is on remaining positive and knowing that things will change.

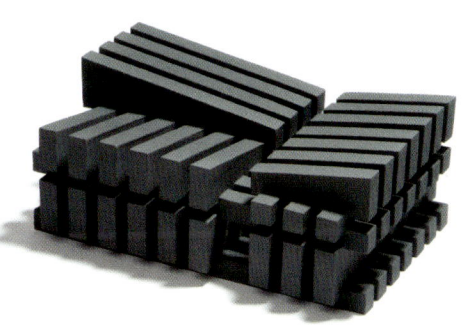

Rebecca Catterall (UK)
Shallow Eaves, 2008
H: 4¾in (12cm), W: 12in (30cm), D: 9in (24cm)
Clay and commercial stains; extruded units, altered with dies and constructed

Logic and order's imminent sensitivity to interruption and interspersion are the starting points for Catterall's complex and geometric forms.

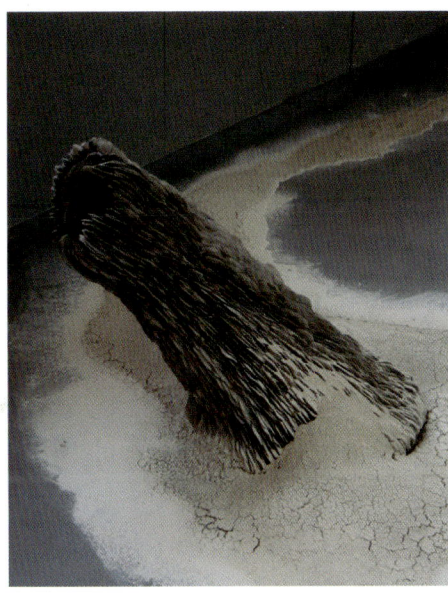

Phoebe Cummings (UK)
Landscape, 2010
Room installation at the Victoria & Albert Museum, London, UK

During a six-month residency at the Victoria & Albert Museum, an evolving temporary installation was created inside the studio from unfired clay. Surface designs and modeled details from objects in the museum's collection were interpreted to create a 3-D environment, exploring how nature has been represented historically through ceramic objects.

SECTION 1
Materials and tools

Types of clay	14
Other materials	18
Clay recipes	20
Preparing clay	24
Cut and stack wedging step by step	26
Ram's head wedging step by step	28
Spiral wedging step by step	30
Drying overview	32
Drying step by step	35
Raw materials	36
Oxides	38
Stains	42
Storing ceramic materials	44
Tools	46
Kiln furniture and accessories	48
Studio equipment	50
Glazing equipment	52
Safety procedures	54

Caroline Tattersall (UK)
The Aftermath installation, 2008
Clay, wood, water, ceramic, brass

A steady drip from the ceiling falls onto unfired tableware on the dinner table below, which slowly erodes over a period of time. Tattersall is interested in formlessness and the point at which form returns back to material.

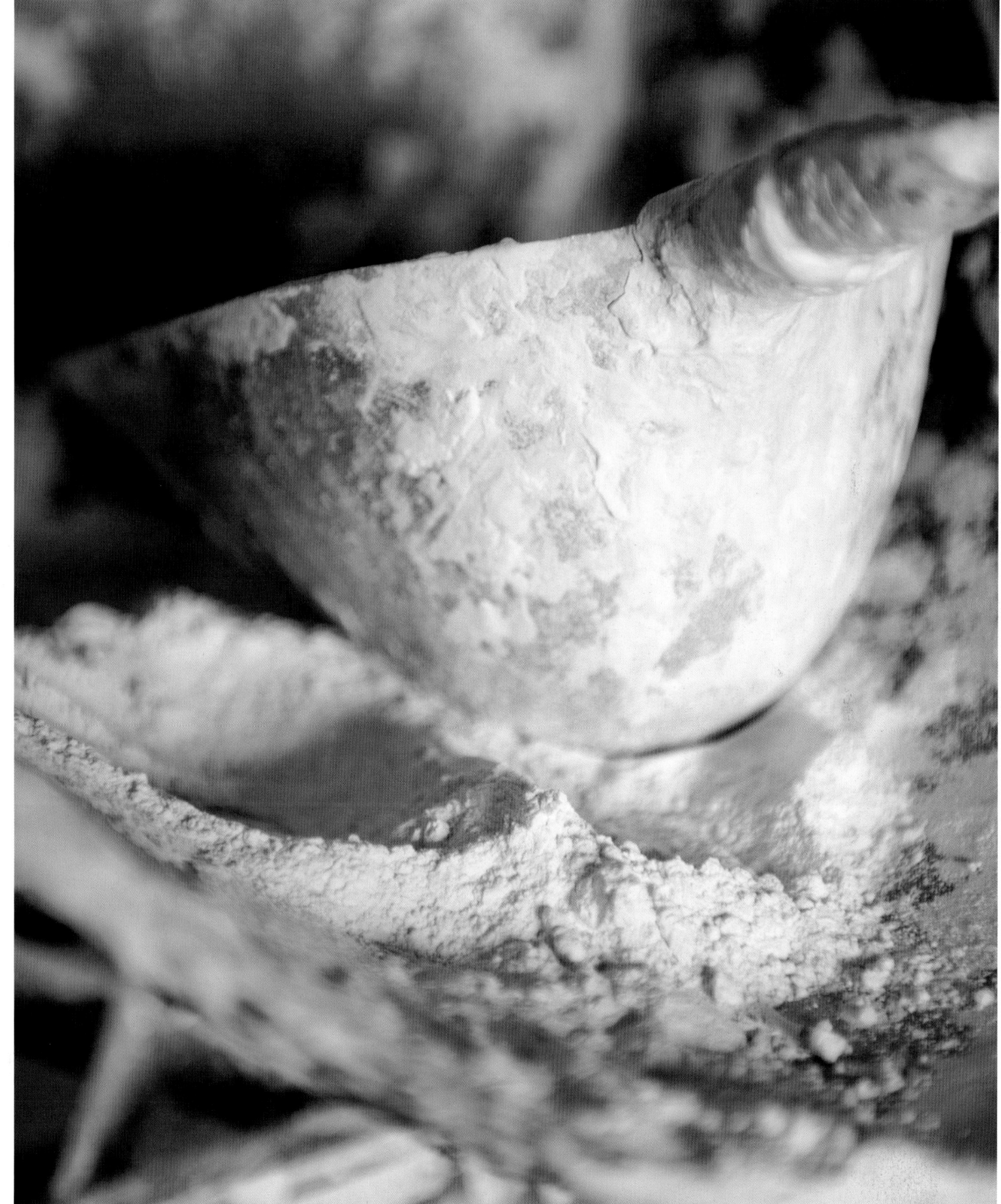

Types of clay

There are hundreds of clays available to the ceramicist. All have their positive aspects and their limitations, so choosing the right one can be difficult. Consider variables such as the applied working method and whether the piece is intended to be decorative, functional, or sculptural. Having a basic understanding of firing temperatures and clay properties will help determine the most suitable body to use.

Low-fired clay
Low-fired clay relates to a clay body with a firing point of less than 1832°F (1000°C). This can include local-dug clays that contain a high amount of iron and that melt into a liquid if temperatures exceed 2012°F (1100°C). These clays are often used for smoke- or pit-firing processes.

Terra-cotta
Terra-cotta clay (also known as red earthenware) is very plastic and versatile. It contains a high iron content (between 5 and 8%) that produces a rich orangey brown color when fired between 1832 and 2102°F (1000–1150°C). Terra-cotta was traditionally used for utilitarian items such as water carriers, garden pots, and roof tiles.

Earthenware
Earthenware clay is relatively inexpensive to buy, easy to work, and can be used for a wide range of ceramic processes. The temperature required for bisque firing is between 1976 and 2048°F (1080 and 1120°C). After bisque, earthenware remains soft and porous. Glaze has to be applied all over to ensure that it is completely watertight; it is then fired at a lower temperature of between 1922 and 2102°F (1050 and 1150°C).

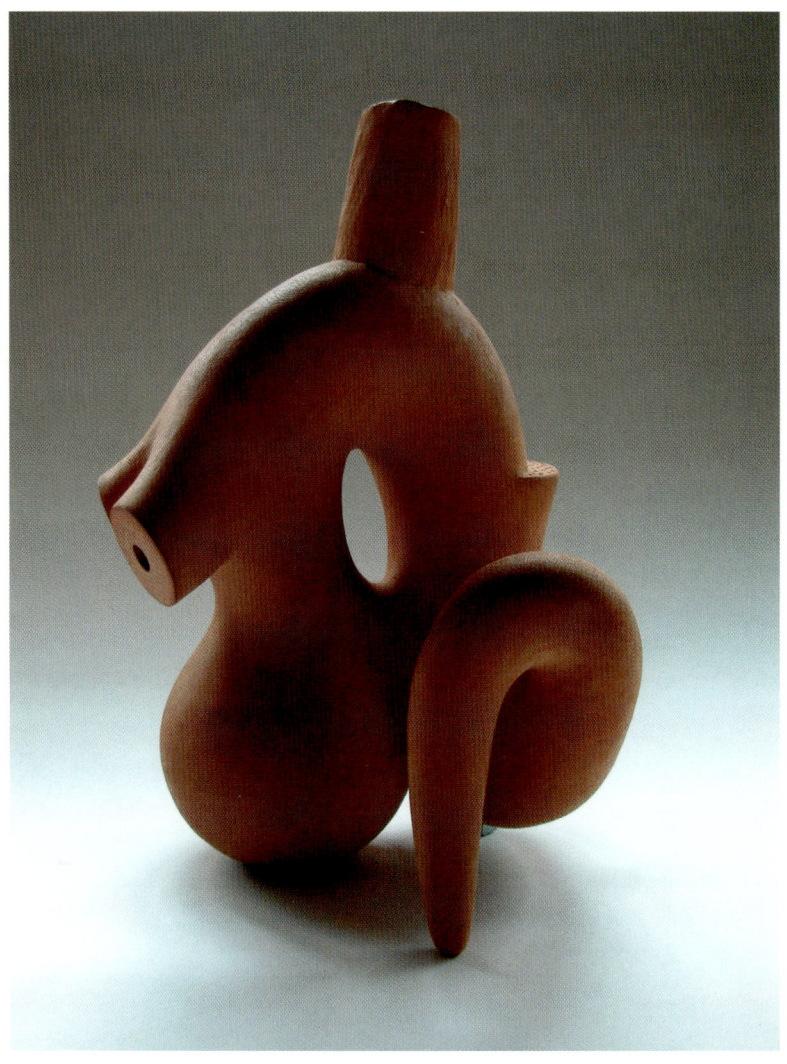

Conor Wilson (UK)
Double Chambered Vessel, 2008
H: 11in (28cm), W: 8in (20cm), D: 6in (15cm)
Handbuilt, terra-cotta

Yo Thom (Japan/UK)
Chawan, 2008
H: 3½in (9cm), Dia: 4¾in (12cm)
Thrown and handbuilt, iron slip decoration and Shino glaze over the slip; wood-fired to 2336°F (1280°C/cone 9)

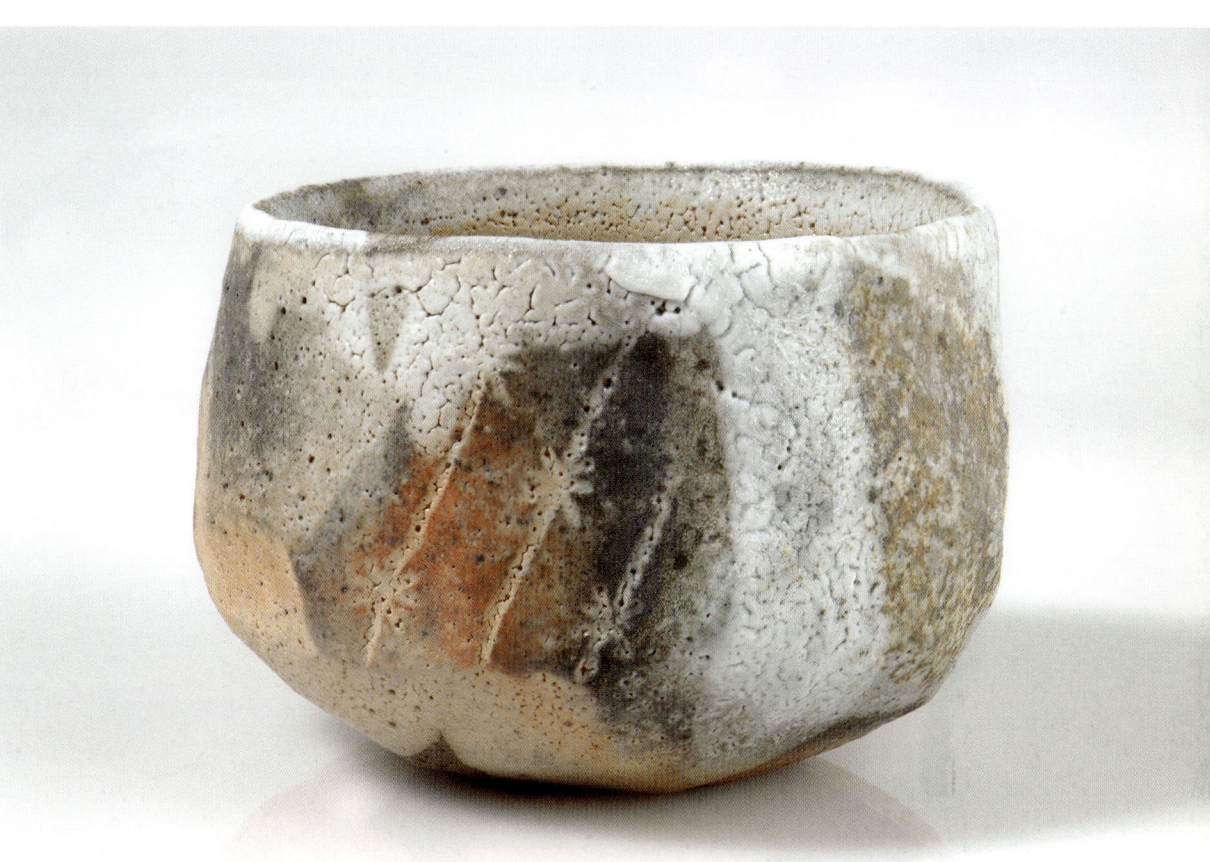

Elke Sada (Germany)
Capriccio Oval Vessel, 2009
H: 8½in (22cm)
White earthenware and body stains; reversed monoprinting; handbuilt

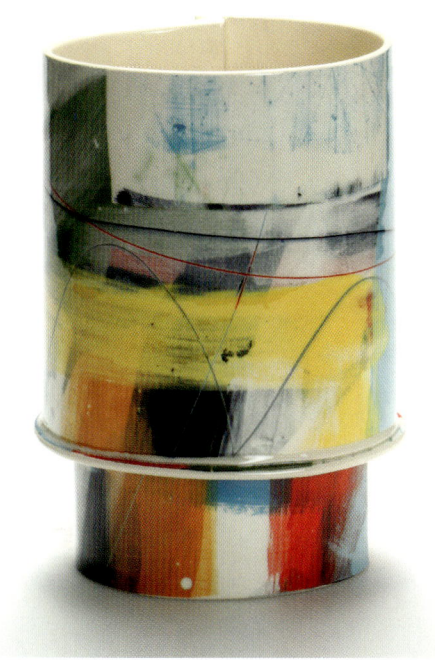

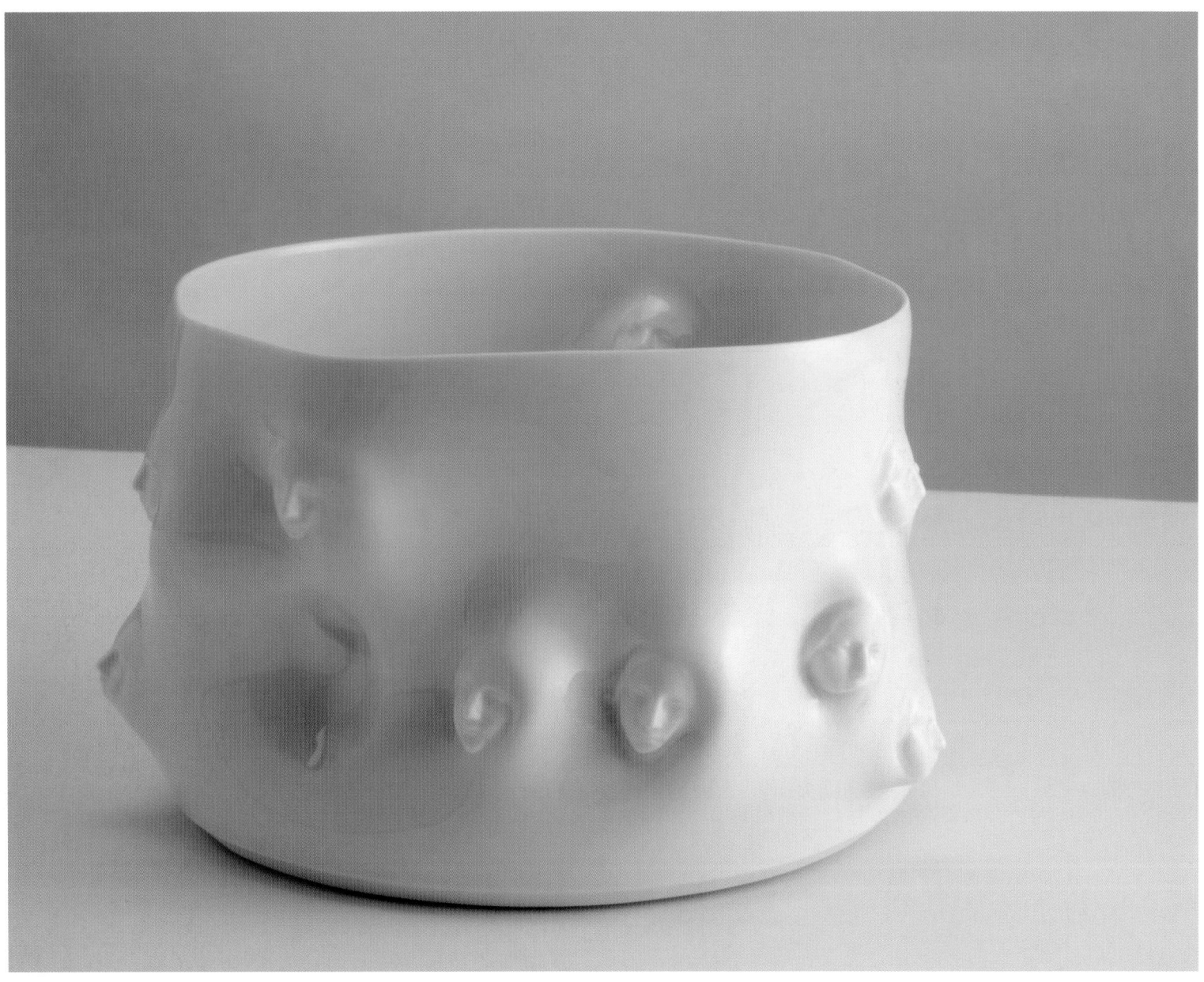

Anja Lubach (Germany)
Madonna Face Vessel, 2010
H: 7in (18cm), W: 10½in (27cm)
Thrown porcelain; the soft clay walls are manipulated with small molds of religious figurative details

MATERIALS AND TOOLS // TYPES OF CLAY

Stoneware
Stoneware is a hardy material, resistant to scratching and impenetrable to water. This makes it an excellent choice for domestic ware and outdoor sculptures. It is fired between 2192 and 2372°F (1200 and 1300°C) and is suitable for an oxidized or a reduction kiln.

Porcelain
Porcelain originated in China more than 2,000 years ago. It is mainly composed of kaolin (china clay) and as a result produces a distinctive white translucent body that is completely vitrified. Porcelain is commonly fired between 2300 and 2372°F (1260 and 1300°C) and, when reduced, develops a beautiful icy tone.

Paper clay
Paper clay is a combination of shredded paper pulp and clay. This strengthens the clay and allows it to be worked extremely thin. During the firing, the paper content is burned away, leaving the delicate ceramic behind. Good ventilation is essential during firing.

Jacqui Chanarin (UK)
Rosettes, 2010
H: approx. 6–8in (15–20cm)
Slip-cast porcelain, porcelain paper clay, cut with scissors and assembled

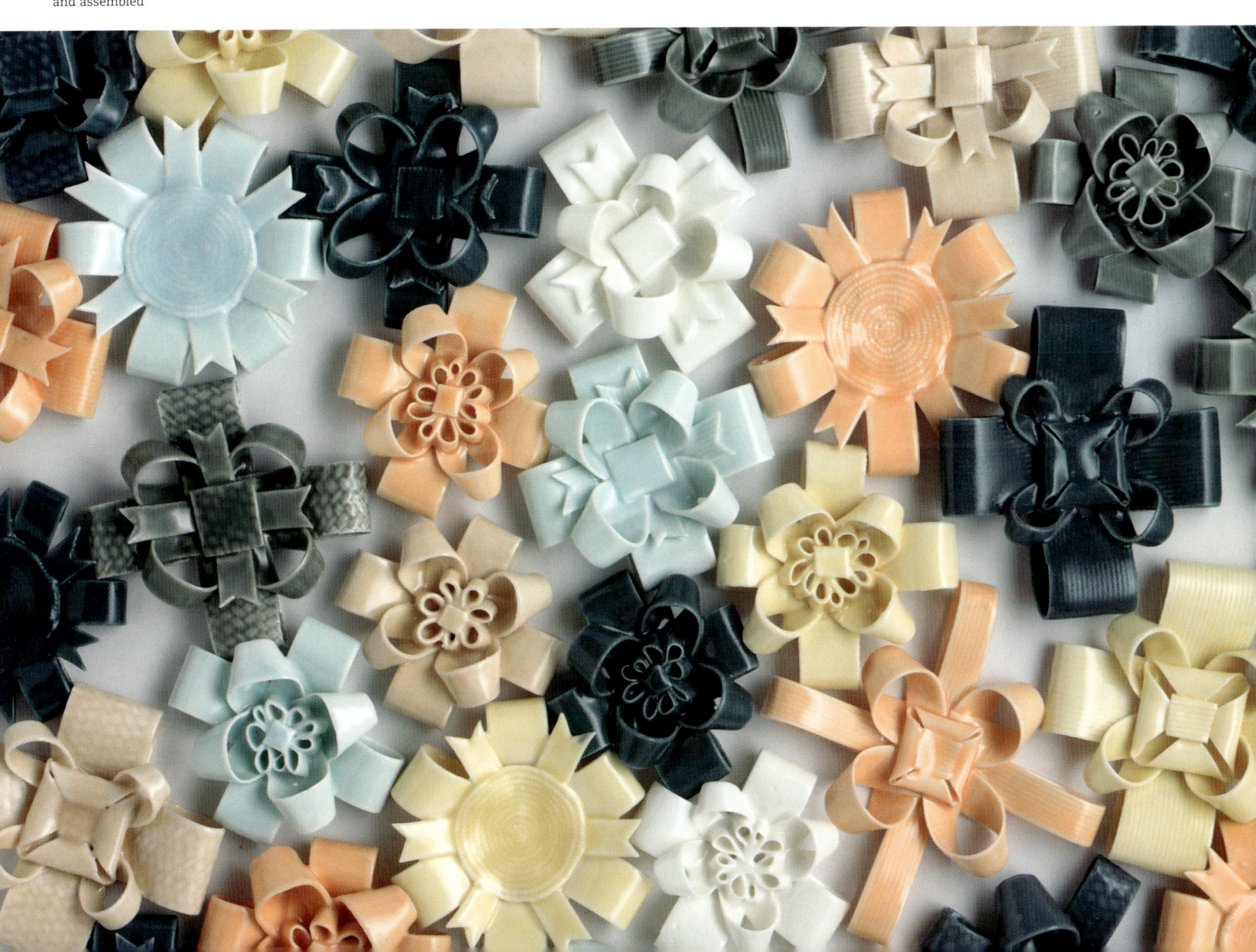

Other materials

Alongside the conventional types of clays discussed on pp. 14–17, listed below are some examples of the other materials that might be used in contemporary ceramic practice.

Egyptian paste
Egyptian paste originated in Egypt around 5000 BCE and was used for bead making, jewelry, and small ornaments and trinkets. It is a self-glazing material, low-fired to 1562–1742°F (850–950°C). An array of colors can be made; copper turquoise is particularly beautiful. See p. 20 for a recipe for Egyptian paste.

Brick clay
Brick clay is a coarse, rugged material suitable for handbuilding and press molding. It is relatively inexpensive and usually available direct from a brick manufacturer. The clay is often dug from local sources, which can result in distinctive iron-rich colors unique to that area. Many ceramicists find the natural, untamed qualities of this material very appealing. Brick clay is generally fired to earthenware temperatures (see p. 14).

Composite/aggregate
Materials such as crushed glass, grog, and minerals are mixed into a clay body to create a unique textural material. The contrast between the clay and the aggregate can be further enhanced by grinding and polishing the piece smooth.

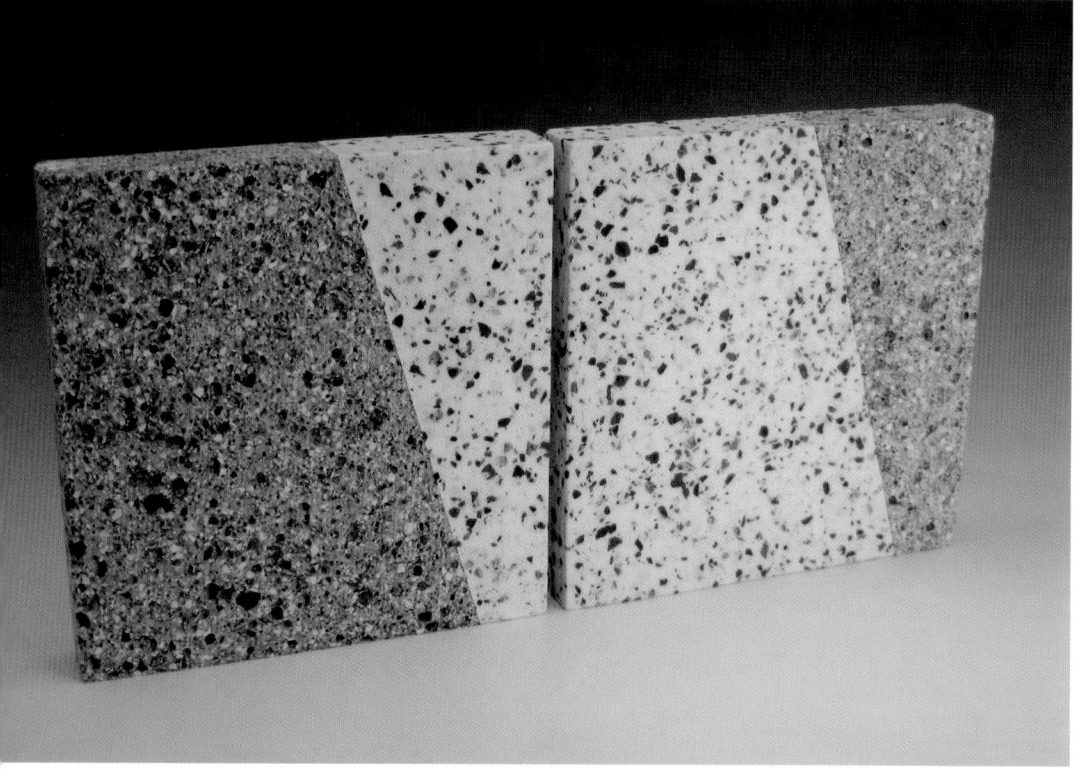

David Binns (UK)
Two-piece Standing Form, 2008
H: 13½in (34cm), W: 26¾in (68cm),
D: 2½in (6cm)
Porcelain with copper aggregate and kiln-cast glass with mixed aggregates

This artist's work is broadly inspired by contemporary architecture, landscapes, and qualities found in geological form.

MATERIALS AND TOOLS // OTHER MATERIALS

Glen Wild (UK)
Untitled, 2010
H: 25½in (65cm)
Black stoneware clay

Wild's handbuilt forms deliberately expose the clay, crude marks, flaws, and imperfections to deviate from traditional craft, where refinement and beauty are key drivers.

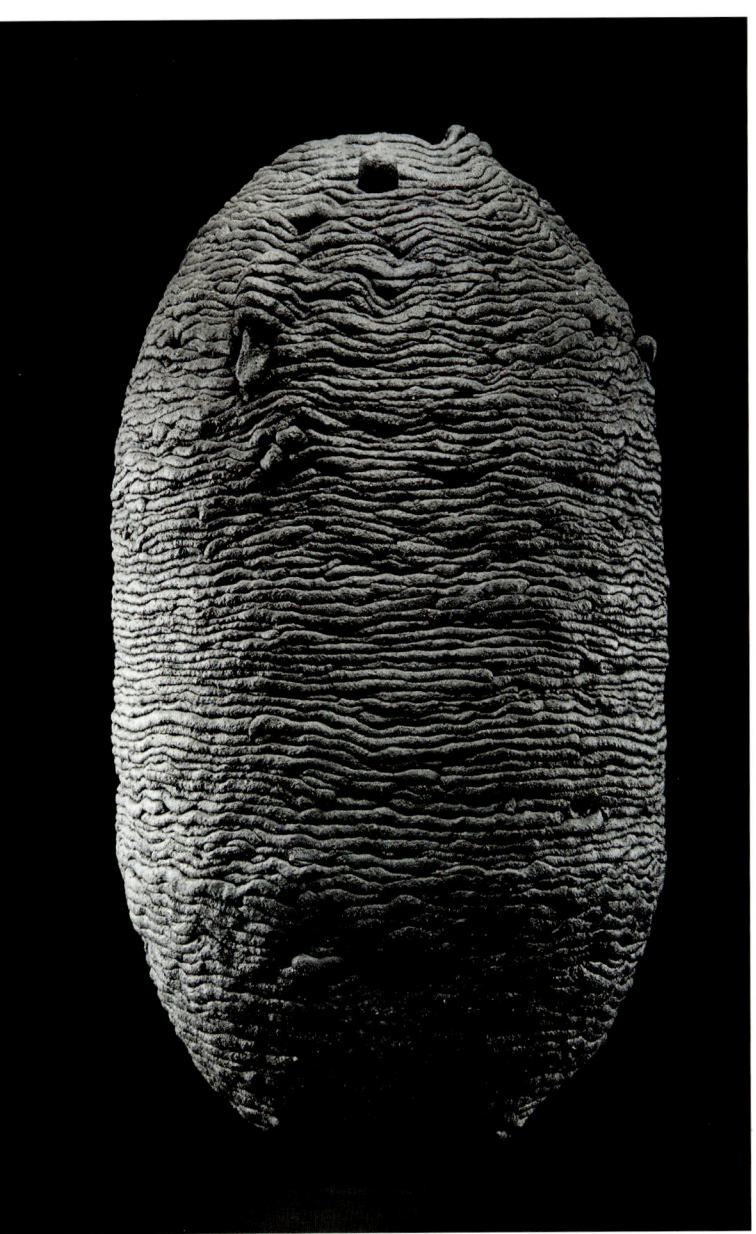

Colored clays

Colored clays can be made by simply mixing a specific amount of oxide or stains into a white clay body, although some prepared bodies are commercially available from pottery suppliers. The use of this material allows the artist to exploit the naked clay. Alternatively some artists explore the contrast of the material against slips and glazes for a cool, contemporary feel.

Air-dry clay

Air-dry clay does not require firing and is ideal for modeling purposes, maquettes, or in situations where there is no access to a kiln. Once the clay has dried, it has to be coated with a special hardener or varnish to seal the surface. It can be further decorated with acrylic paints or lacquer. Air-dry clay is not suitable for functional work.

LEFT
A white clay body can be colored with stain, 17–20 parts to 100 parts clay. Use a wire cutter to slice the clay into sheets. Mix the stain with a little water and paint onto each sheet. Layer up the clay, then wedge and knead until the stain is combined. The color of the clay will intensify once fired and glazed

Clay recipes

The advantage of mixing a clay body from raw powders is that it allows the maker to customize a recipe to best suit his or her needs. It is also more economical, because powders tend to be cheaper to buy than prepared clays. Some makers like to combine different prepared clays together to utilize the attributes of the clays and create their own unique blend (for example, 50% porcelain with 50% grogged stoneware). Below I list some common clay recipes you might like to try.

A dough mixer is used at the Leach Pottery in St Ives, UK, to prepare large quantities of a clay body

Egyptian paste

Fired at 1562–1742°F (850–950°C/cones 013– 08)
This recipe is taken from Daniel Rhodes' *Clay and Glazes for the Potter* (see bibliography for full reference).

Feldspar	40%
Flint	20%
China clay (EPK)	15%
Ball clay	5%
Sodium bicarbonate	6%
Soda ash	6%
Whiting	5%
Fine white sand (alumina)	8%
Hot water to mix	½pt (250ml)
(increase this amount if mixing a larger quantity)	

Additions:

3% copper	turquoise
2% cobalt	royal blue
2.5% manganese	pink
5% manganese	brown
5% chrome	bright green
6% yellow stain	yellow

Mix the materials together except the soda and coloring pigment. These are stirred separately into the hot water. Add the water to the dry materials and mix until it reaches a dough-like consistency. Gently knead on a tabletop or board before use (use a plaster bat). Egyptian paste is a self-glazing material; dust the kiln shelf with alumina sand to prevent it from sticking.

Paper clay

Clay body (made into a slip) or casting slip	11lb (5kg)
Toilet tissue or recycled paper	10–30%
(could also use flax or cotton fibers)	

First, shred the toilet tissue and cover with hot water to turn the paper into a gloopy pulp. A couple of tablespoons of bleach added at this stage will prevent the paper clay from smelling. Leave it to soak for a while, then blitz the paper with a hand blender or drill/paddle mixer. Remove the pulp and squeeze out as much water as you can. Blend the pulp into the thick clay slip, allowing the particles to become fully saturated. Pour onto a plaster bat to drain, then wedge and knead.

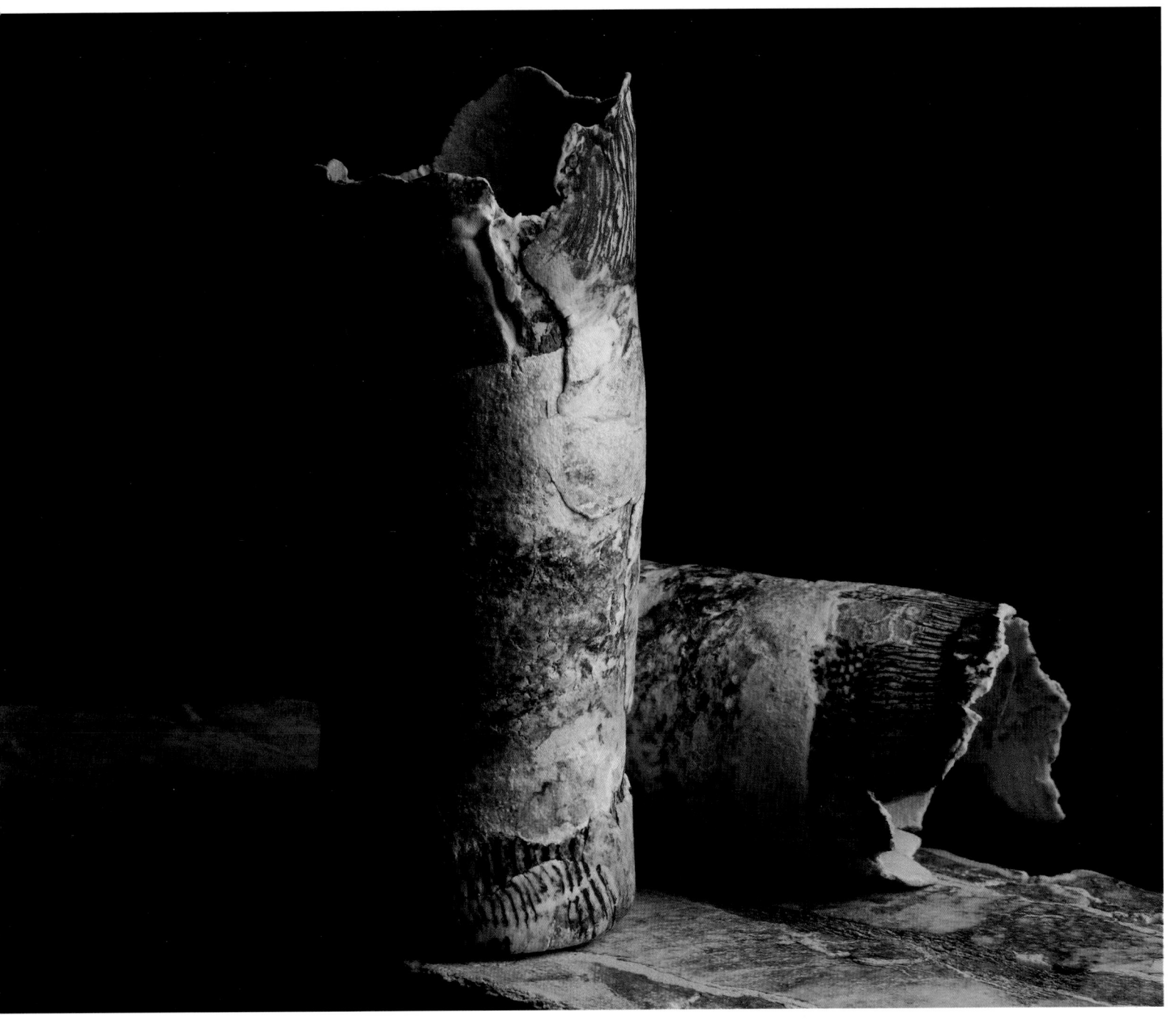

Maggie Barnes (UK)
Paper Clay Columns, 2010
Porcelain paper clay slab:
W: 4¼in (11cm), L: 14in (35cm);
porcelain paper clay cylinders:
H: 6in (15cm), Dia: 2in (5cm);
H: 4¾in (12cm), Dia: 2in (5cm)
Very thin porcelain paper clay slabs, pure porcelain laminated additions, Neriage porcelain inserts

The artist's inspiration stems from East Coast rock formations, minerals, and fossil remains.

Clay bodies

The following clay bodies are mixed as dry powder weights in percentages and combined with water. Drain on a plaster bat and process through a pug mill or by hand.

Raku
Fired at 1832°F (1000°C/cone 06)

Fire clay	55%
Ball clay	25%
Grog	20%

Terra-cotta/red earthenware
Fired at 1976°F (1080°C/cone 04)

Red powdered clay	100%

Stoneware oxidized
Fired at 2336°F (1280°C/cone 9)

Fire clay	50%
China clay (EPK)	30%
Potash feldspar	10%
Quartz	5%
Medium molochite or grog	5%

Stoneware reduction
Fired at 2336°F (1280°C/cone 9)

Fire clay	40%
AT ball clay	60%

Porcelain
Fired at 2336°F (1280°C/cone 9)

Porcelain china clay	50%
Potash feldspar	25%
Quartz	20%
Bentonite	5%

Salt/wood firing
Fired at 2372°F (1300°C/cone 10)

Ball clay	50%
Medium-grog stoneware clay	50%

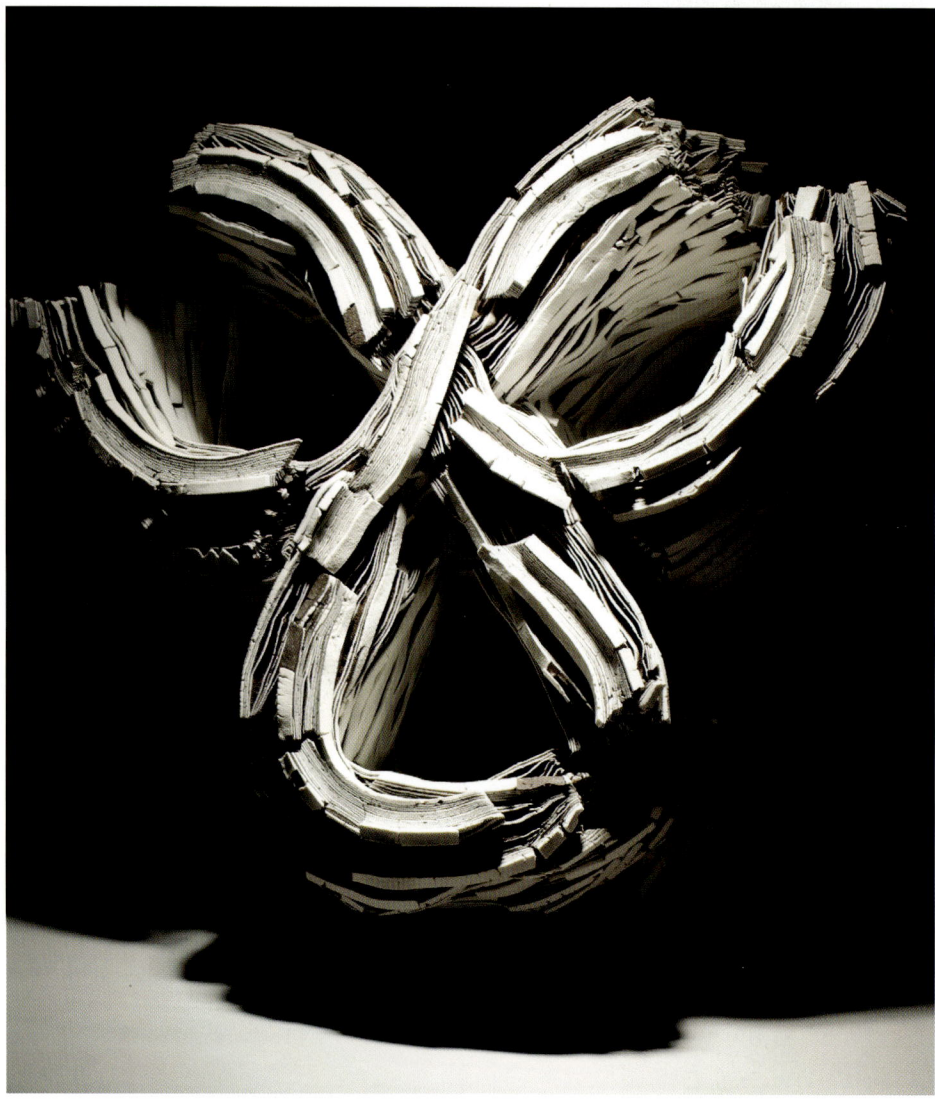

Rafael Perez (Spain)
Vacio Plural, 2010
H: 23¼in (59cm), W: 23in (58cm),
D: 16in (41cm)
Porcelain and artist's own clay,
once-fired to 2102°F (1150°C/cone 1)

Rafael Perez created a clay body to his own specific recipe. The clay grows and mutates with the heat of the kiln. He calls this technique "expansion."

RIGHT
Ikuko Iwamoto (Japan/UK)
Ribosome Flower Vase, 2009
H: 8½in (22cm), W: 4in (10cm),
D: 3½in (9cm)
Slip-cast porcelain

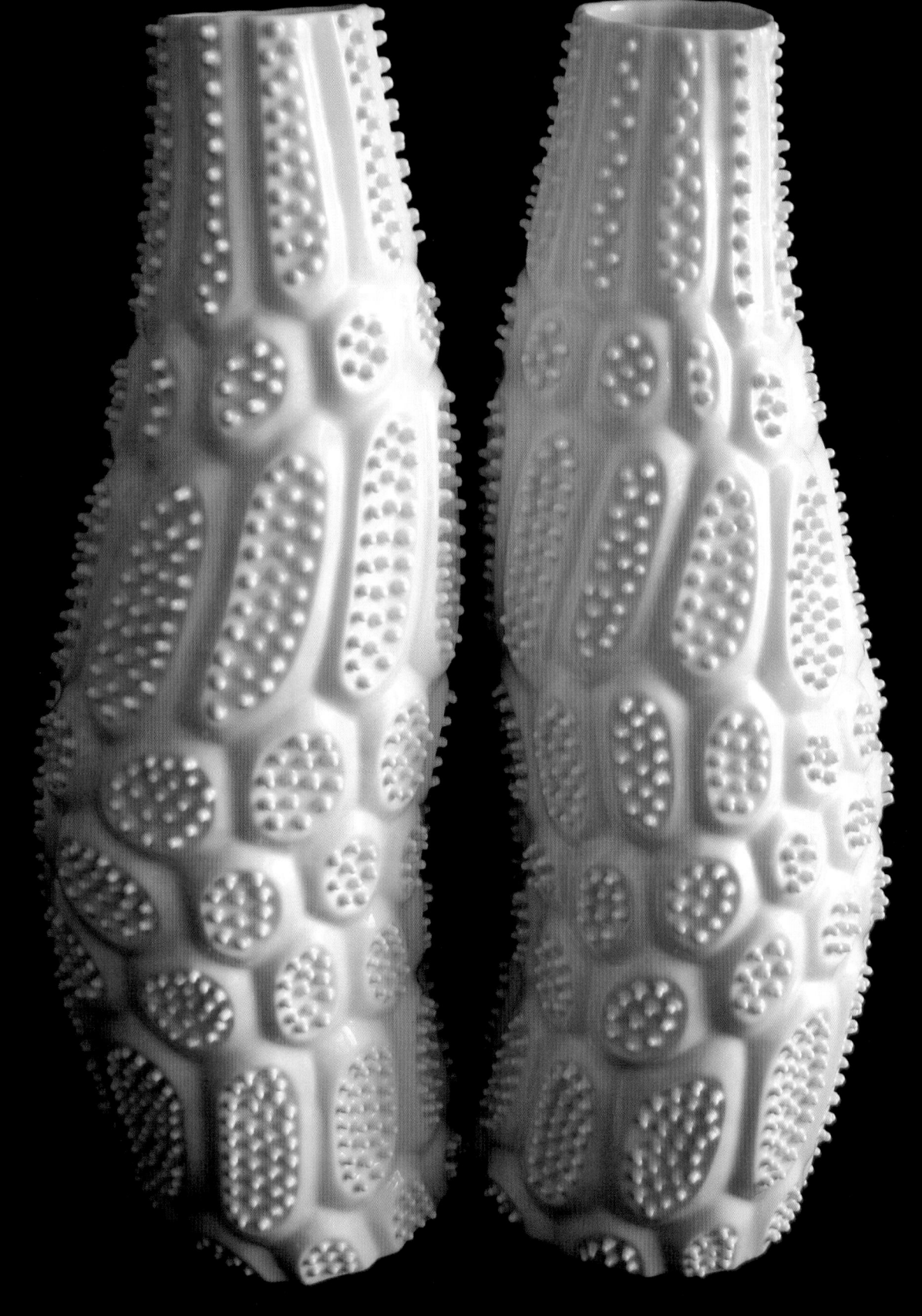

Preparing clay

The structure of clay consists of small hexagonal platelets. When clay is plastic, the platelets are lubricated with water and slide past each other freely. As the clay dries, water evaporates and the platelets become rigid and fixed. The aim of clay preparation is to produce a homogeneous mixture that is neither too wet nor too dry.

Preparation
Before clay is worked, it must be sufficiently prepared either manually or mechanically, using a pug mill. This can be a laborious task, but it is a necessary one: poorly prepared clay can result in technical faults including uneven shrinkage, warping, and cracking. This is caused by the alignment of the particles being too uniform. Preparing the clay thoroughly mixes up the particles and distributes them more randomly.

Preparing by hand
Preparing clay on a natural stone surface such as marble or slate keeps the clay cool and prevents it from drying out as it is worked. Ensure that the bench is at an appropriate height to avoid straining your shoulders and back. Wedging and kneading the clay by hand is highly effective and the most accessible method to use in a studio environment.

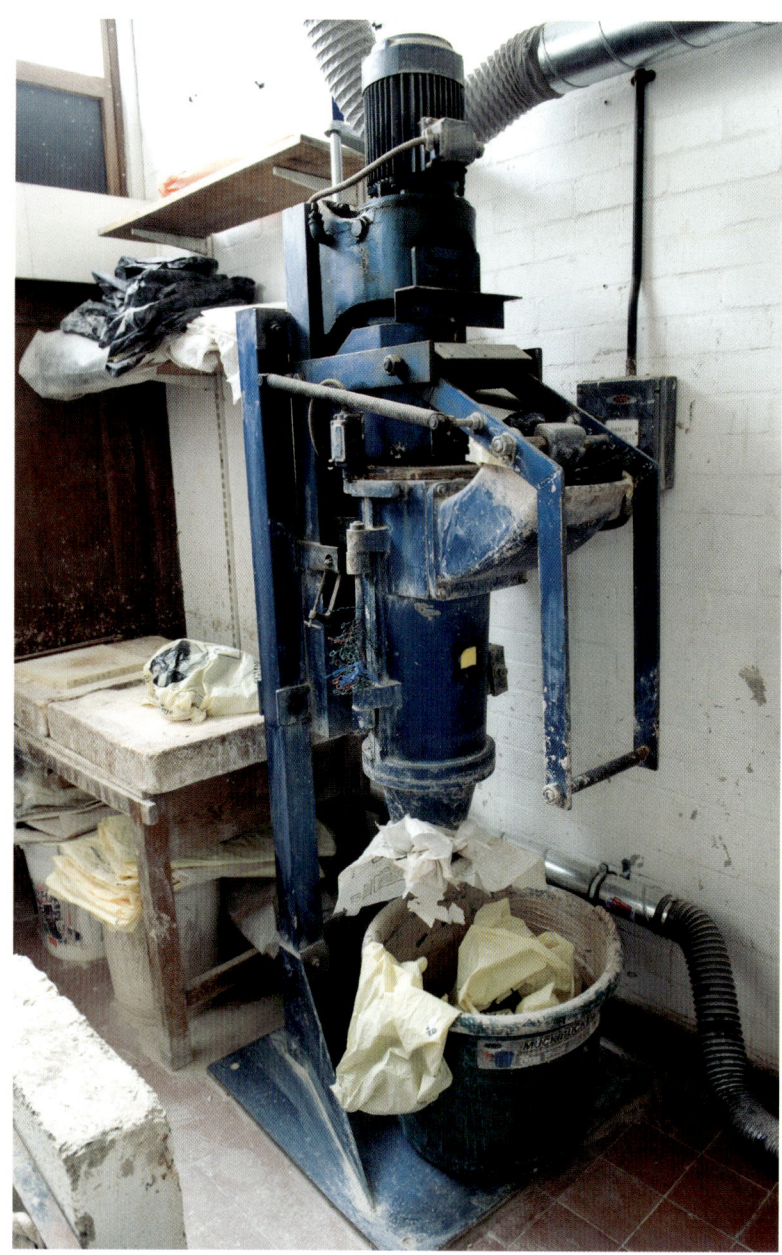

A large pug mill in the ceramics department at the University of Brighton, UK

Preparing mechanically

To prepare larger quantities, clay can be processed by a machine called a pug mill. This churns and mixes clay through a drill-like blade and extrudes the clay as a solid block. A de-airing pug mill is connected to a compressor; this creates a vacuum and removes air bubbles, thus removing the need to prepare by hand.

Recycling clay

Recycling clay where possible is less wasteful and can help to keep costs down. To reuse oversaturated clay, place on a plaster bat to absorb some of the moisture and then wedge until the clay is workable again.

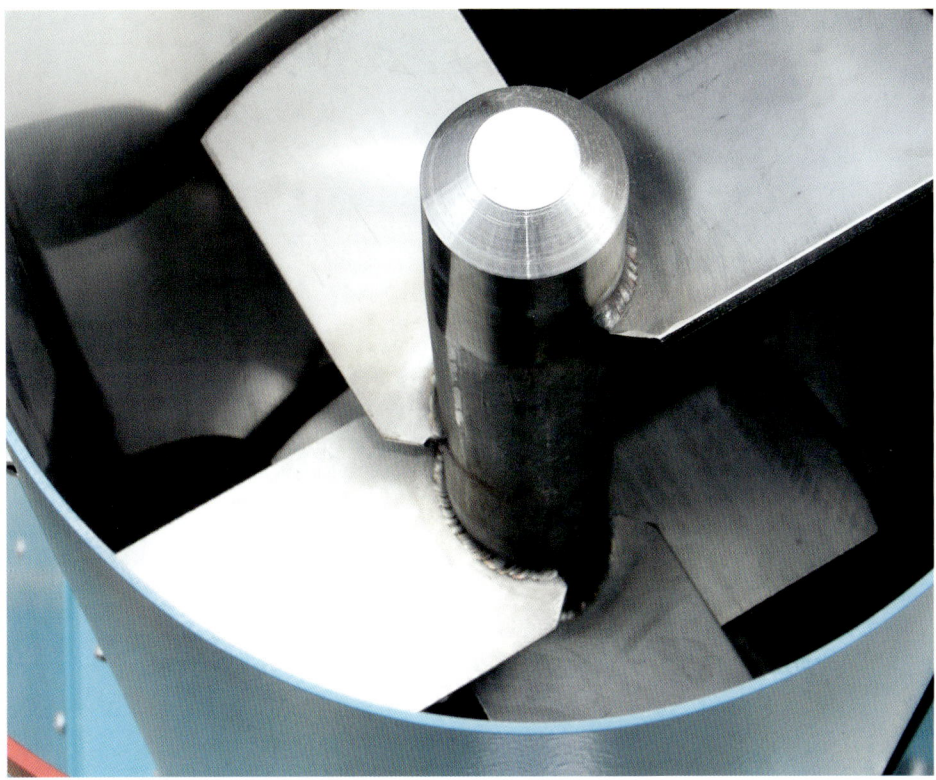

The blades inside the pug mill rotate and process the clay

Reclaiming clay

Scraps of dry clay and redundant pieces can be restored to fresh clay. To reclaim clay, allow the scraps to dry fully. Break up any large lumps before the clay dries solid. Avoid contamination by removing any foreign materials. Transfer the scraps into a large bucket and cover with water. Leave to soak for at least a day. The clay will soon disintegrate into a liquid mass. When ready, siphon off the excess water. Remove the sloppy clay and squeeze out as much water as you can before transferring it onto a plaster bat. Distribute the remaining clay over the plaster bat and aerate by pushing finger holes all over it. Turn the clay over regularly until it has reached a workable state. Wedge and knead the clay thoroughly before using.

Cut and stack wedging step by step

Cut and stack wedging is a particularly effective method for mixing clay that is firm on the outside but soft in the middle.

1 | Peel the bag from the clay and use a wire cutter to remove a manageable-sized piece. Most bought clays are sold as rectangular blocks, although some are cylindrical. If this is the case, lightly shape the piece into a rectangle by tapping the sides on the worktop.

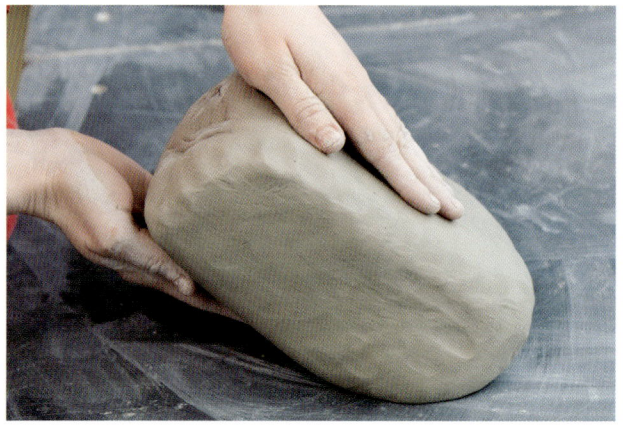

2 | Tilt the clay piece away from you at a 45-degree angle so the block is sloping downward.

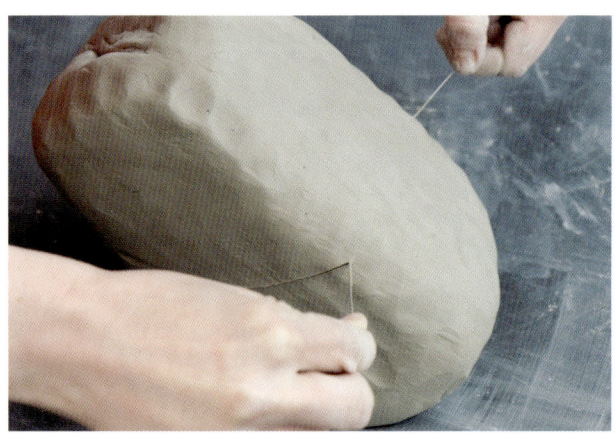

3 | Take the wire cutter and hold it near the base of the block at the side facing you. Drag the wire cutter through the clay upward in a diagonal direction.

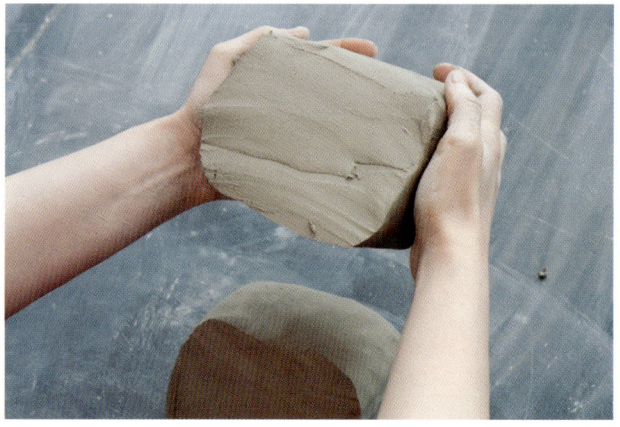

4 | Put the wire aside and place your hands around the sides of the top section of the cut block. Lift the section and flip it around so that the freshly cut side is facing you.

MATERIALS AND TOOLS // CUT AND STACK WEDGING STEP BY STEP

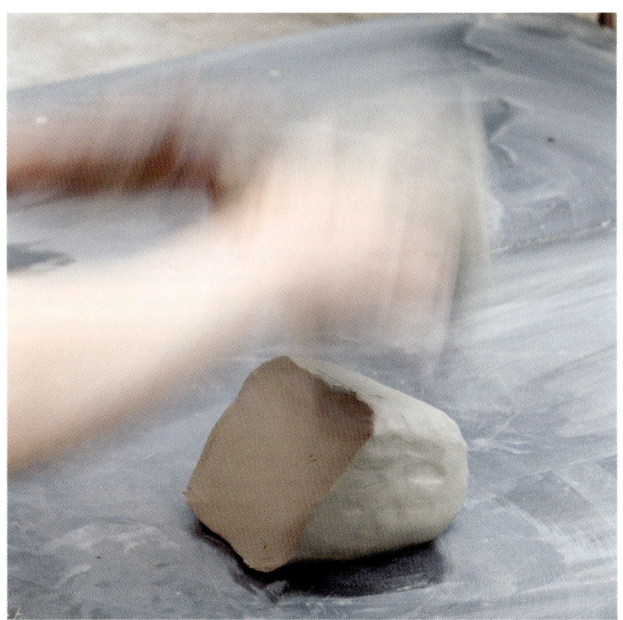

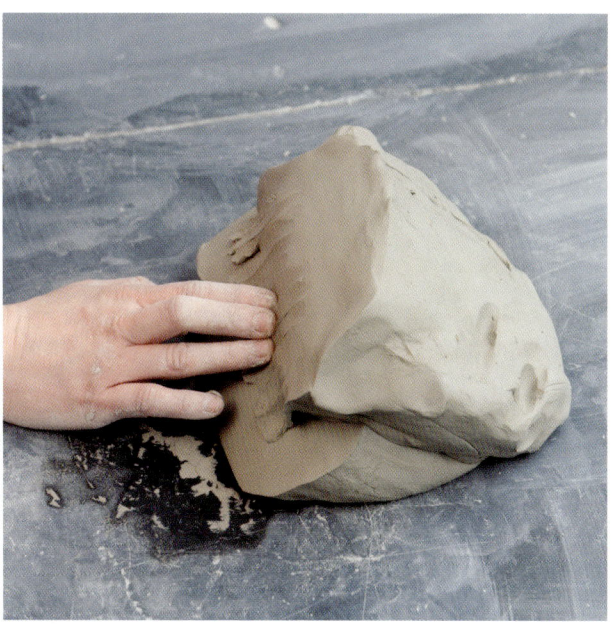

5| Slam down hard onto the piece below. This action knocks out air bubbles, which can be seen if you look closely at the surface. This can take some practice, as it is easy to miss on first attempts.

6| Smudge down the edges where the joins meet. Also smudge any air bubbles that are pushed out.

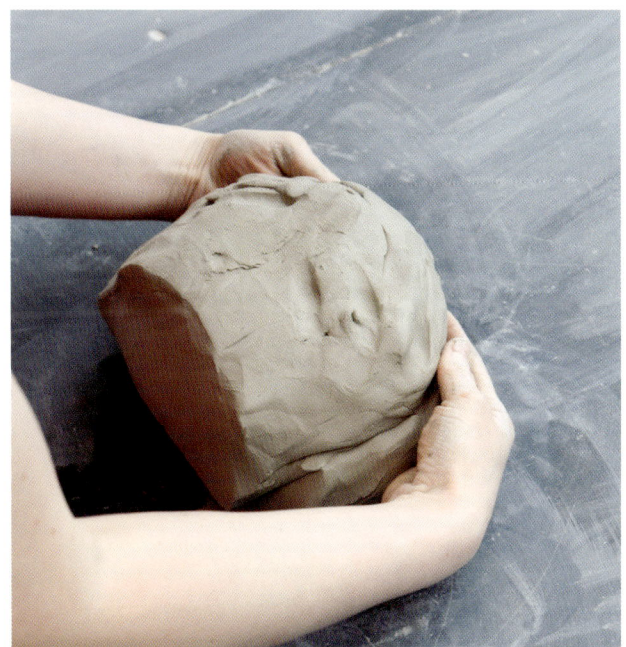

8| Turn the piece to the left. This action changes the direction of the cuts so the clay becomes really well mixed. Make sure the piece remains loosely rectangular, as this makes wedging much easier. You may need to reshape the piece before cutting with the wire.

9| Repeat these steps at least ten times, or until the clay is well mixed and no air bubbles are visible in the clay body. Look for any signs of "swirling" in the clay, as this indicates that the clay is not evenly mixed. It should be smooth and solid.

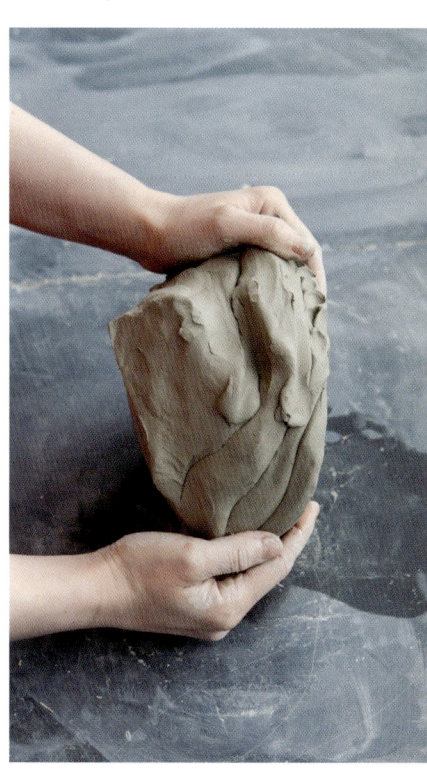

7| Place your hands at the back of the block and roll the block toward you.

26 // 27

Ram's head wedging step by step

Ram's head wedging is a relatively straightforward technique to learn. It is an effective method for mixing the clay, and gets its name from the characteristic "ram's head" impression made by the hands. Practice eventually makes the action of wedging effortless and fluid.

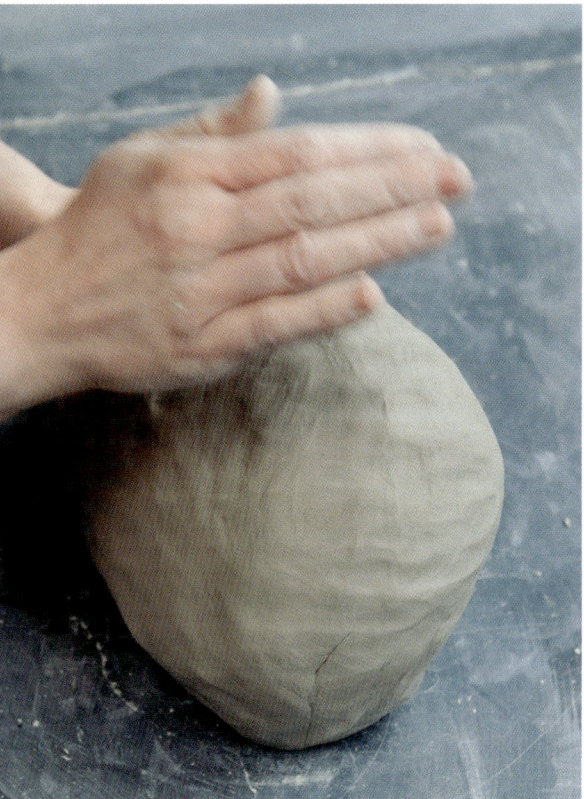

1 Shape the piece of clay into a rounded block.

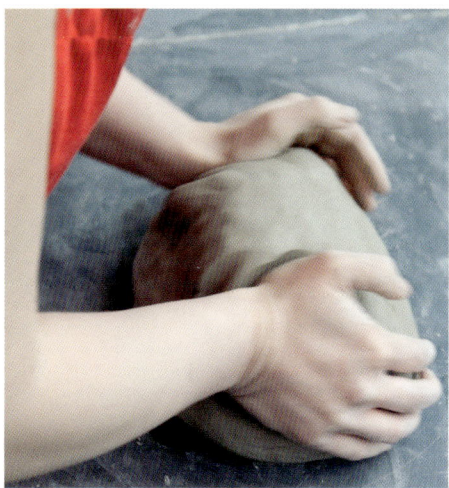

2 Place both hands on the top, near to the sides, with your fingers resting behind the piece.

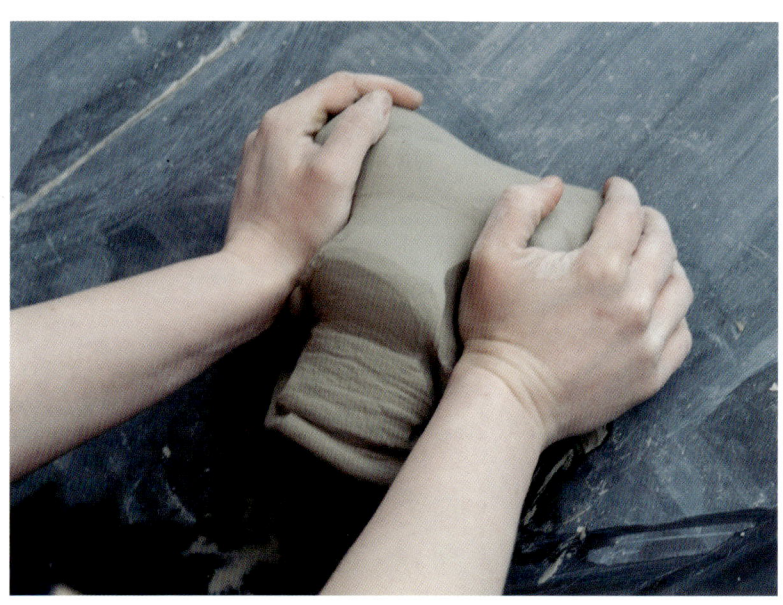

3 Roll the clay toward you, apply equal pressure, and use your palms to push back.

MATERIALS AND TOOLS // RAM'S HEAD WEDGING STEP BY STEP

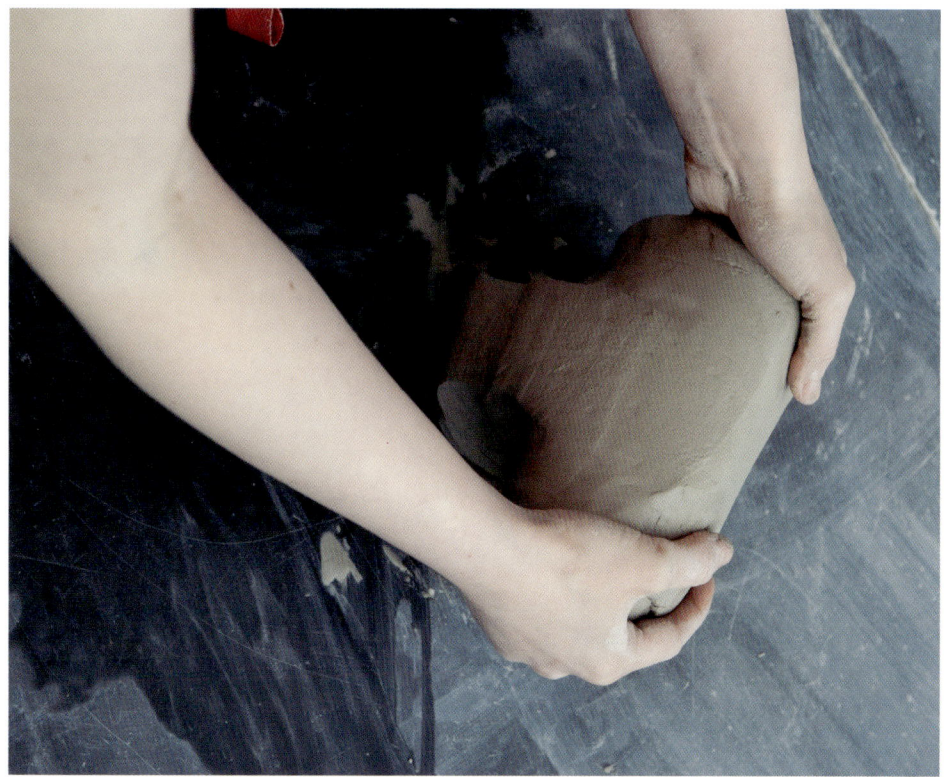

4 | Use your fingers to roll the piece a quarter-turn toward you and then push back again. Repeat this process until the clay is thoroughly mixed, occasionally turning the piece 90 degrees to change the direction of the wedging.

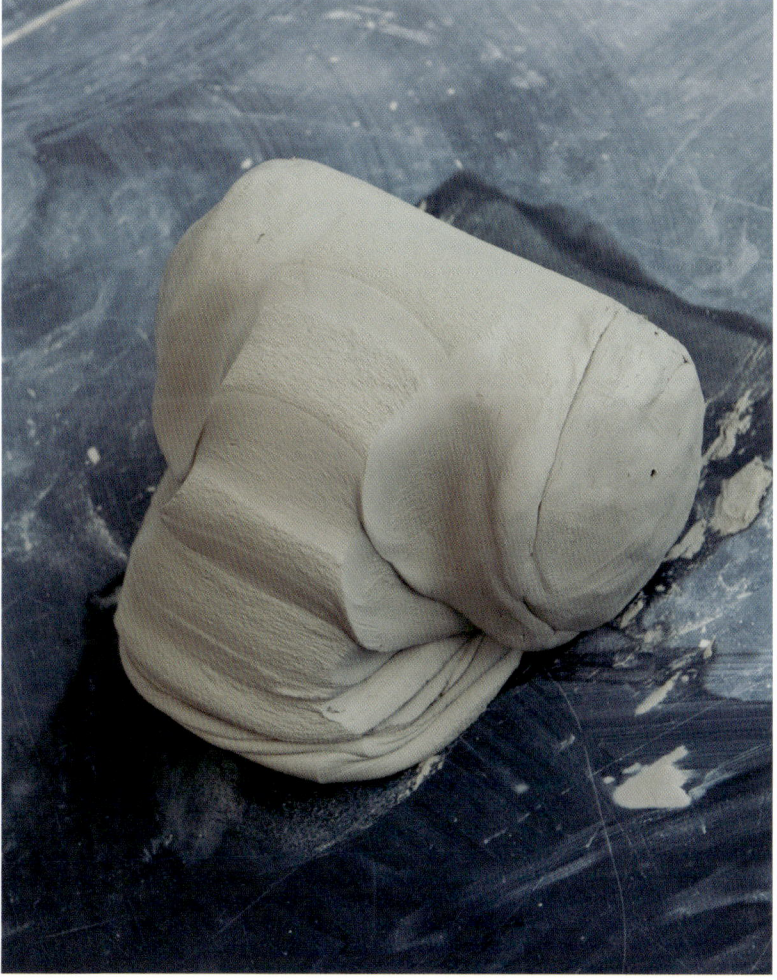

5 | Beginners often find that their clay piece develops "handle bars." To prevent this, place your hands nearer to the sides and tap the clay back into shape from time to time.

Tips
- Make sure your hands are not too warm, as this can dry the clay out.
- Likewise, be careful not to overwork the clay or it will be tired before you have even started.
- Try not to apply too much pressure or be forceful with the clay; the motion should be quite gentle.

Spiral wedging step by step

Spiral or shell wedging is a difficult technique to master and requires some practice. If done incorrectly, it can actually add more air to the clay rather than removing it. However, it is useful for wedging large quantities of clay, and the rhythmical motion of the process puts less strain on the body. The following step-by-step instructions may imply that the technique is right-handed, but the process can be adapted to suit a left-handed position.

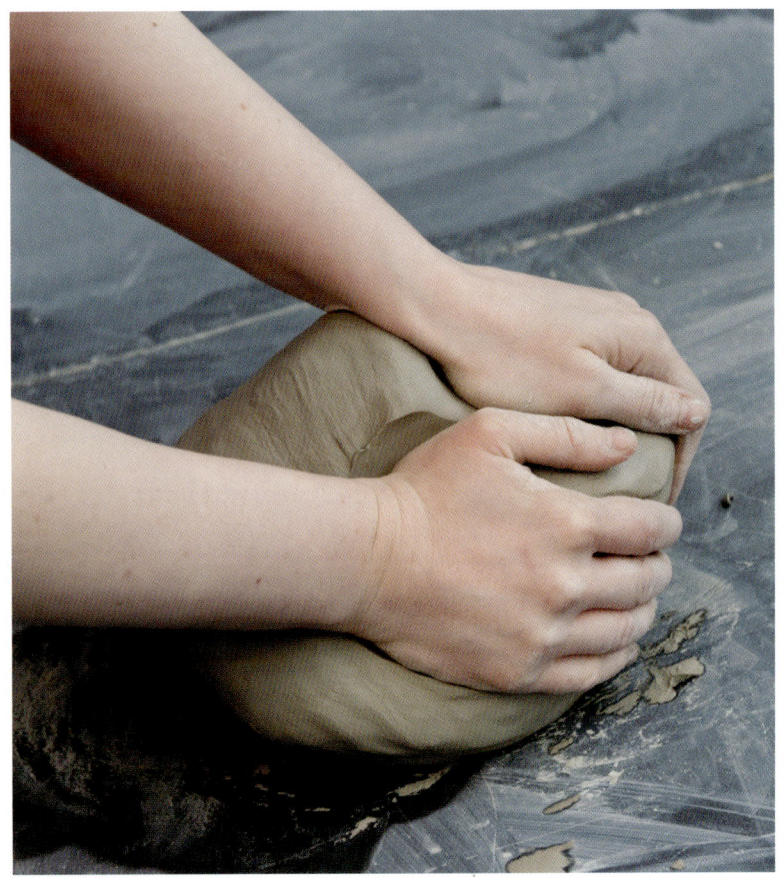

1 Shape the clay into a rounded block. Extend your arms. Place both your hands at the top right side, with your left hand slightly above your right. Lean forward to exert pressure downward onto the clay using the heel of your right hand.

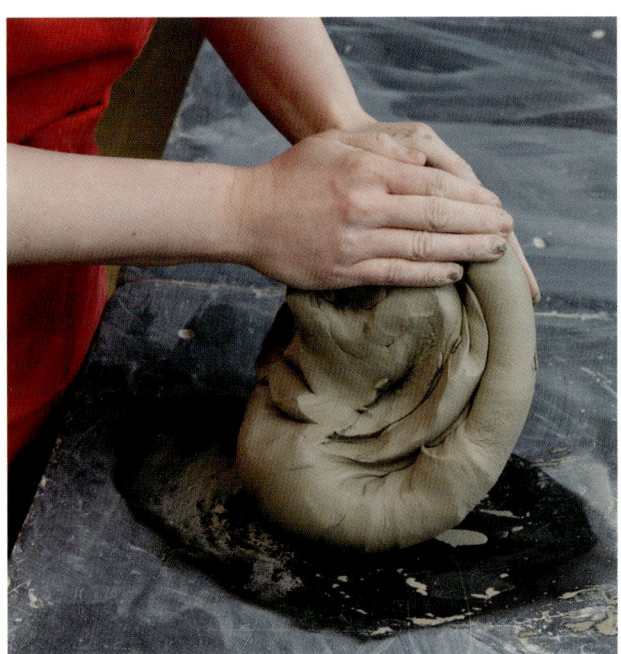

2 Lean back slightly and use your left hand to control the clay and turn it by a quarter-turn. Repeat the previous actions, forcing the clay toward the center. With each press, your left hand should lift and pivot the clay. A compressed fold will appear as you continue to press and turn, producing the shell-like or spiral patterning.

MATERIALS AND TOOLS // SPIRAL WEDGING STEP BY STEP

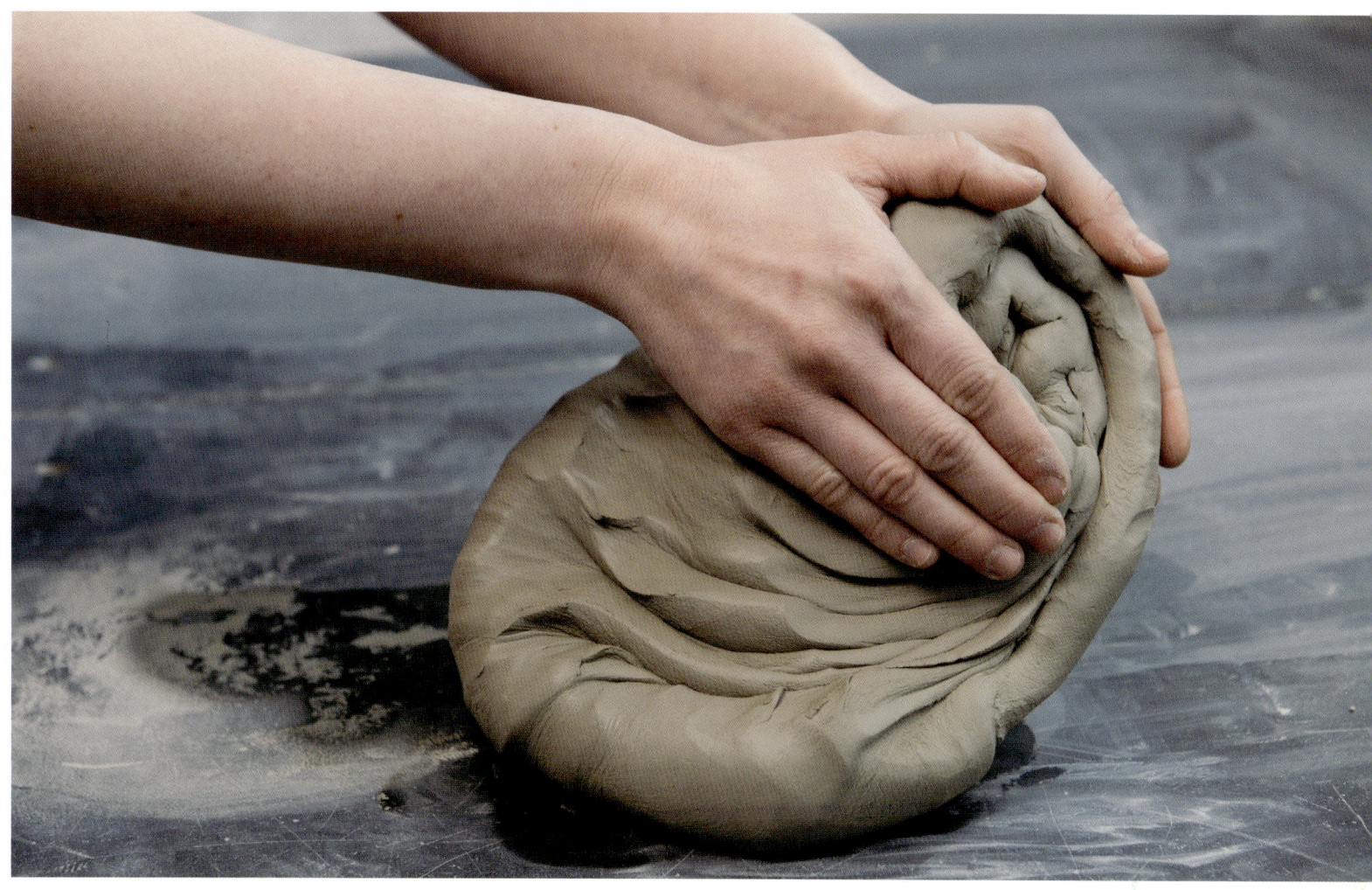

3 Your hands should always remain in the top corners, with the clay appearing as if it is rotating counterclockwise through your hands.

4 Once wedging is complete, tap the clay piece on the bench to neaten the shape. Leave it to rest for a short period before using.

Tips
- If you are having difficulty starting the spiral shape, gently rock the clay back and forth to form a rounded base, and then begin kneading.
- Keep your thumbs together in a central position, your left thumb slightly higher than your right. This is your anchor point for the technique. You should not twist your hands or force the clay to rotate; the action should be smooth and rhythmical.
- Practice the technique on medium-size pieces of clay. Don't knead a larger piece than you can manage as it is tiring work.
- Allow the clay to rest for at least 15 minutes prior to use.

Drying overview

There are three main stages of clay: plastic, leather-hard, and green. Having a basic understanding of these stages will help you determine how to respond to the clay and the optimum time to carry out a process.

Stage 1: Plastic

The clay is in a malleable and workable state. It is easy to join but difficult to support the shape and refine. Forms at plastic stage are susceptible to sagging under their own weight.

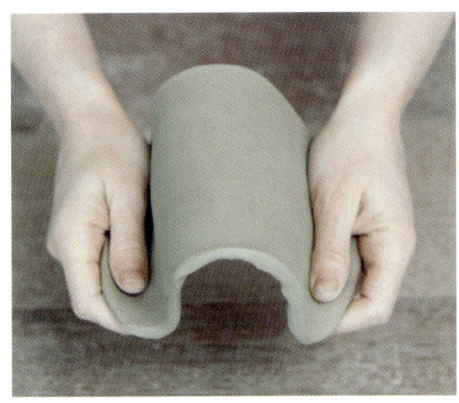

Stage 2: Leather-hard

The clay has become firm and can support its own weight. Joined sections must be crosshatched thoroughly and slip applied to minimize cracking. Leather-hard clay can be manipulated, but it is not as flexible as plastic clay. It is ideal for slab building as well as refining pieces.

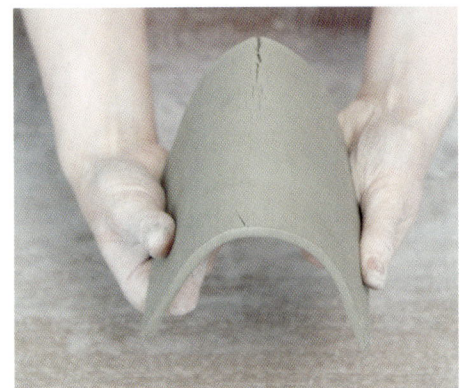

Stage 3: Bone dry

The clay is completely dry and ready to be fired. It is chalky and pale in appearance and cannot be joined to fresh clay. Bone dry ware is very fragile and care must be taken when loading it into the kiln. Rough edges can be fettled with a damp sponge, but excessive water must not be used.

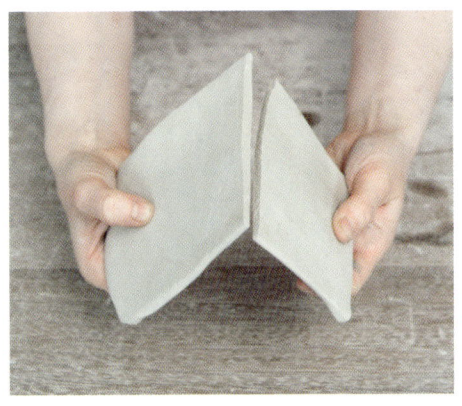

Drying clay

Clay does not like to be rushed during the drying process, as this encourages faults. Use a heat gun or blowtorch only when necessary and do not hold it directly in one area. You should dry clay on wooden boards rather than on metal or plastic surfaces, as wood is porous and will prevent the clay from sticking. Putting a piece in a drafty area or handling it too much can cause pieces to warp. If a piece dries before you have finished, it can be revitalized with a light spray of water from a handheld sprayer.

Plan drying time into your making schedule. Pieces with walls up to ¾in (2cm) thick can take a week or more to dry fully. Large work with walls up to 2in (5cm) or more can take at least four to six weeks. Clay should not be put in the kiln wet or partially dry because the evaporation of steam during the firing can cause the piece to explode. A good indication that the piece is not yet dry is if the base of the piece feels cold when held against the cheek or the back of the hand. Exceptions to this rule are slip-cast pieces: they can be fired from wet because the walls are usually very thin and dry quickly.

Shrinkage

A large proportion of the composition of clay is water. As the water evaporates during the drying and firing process, the clay will shrink. Smooth clays shrink more than textured clays because they have finer particles that become compressed as water is expelled. The average shrinkage of smooth clay can be 6–12%. Porcelain has an even higher shrinkage rate of 15–20%. Textured clays that contain grog and other materials have larger particles, are more porous, and, as a result, shrink less: 4–6%. Take the shrinkage rate into account when making your piece or it could look out of proportion after it has been fired.

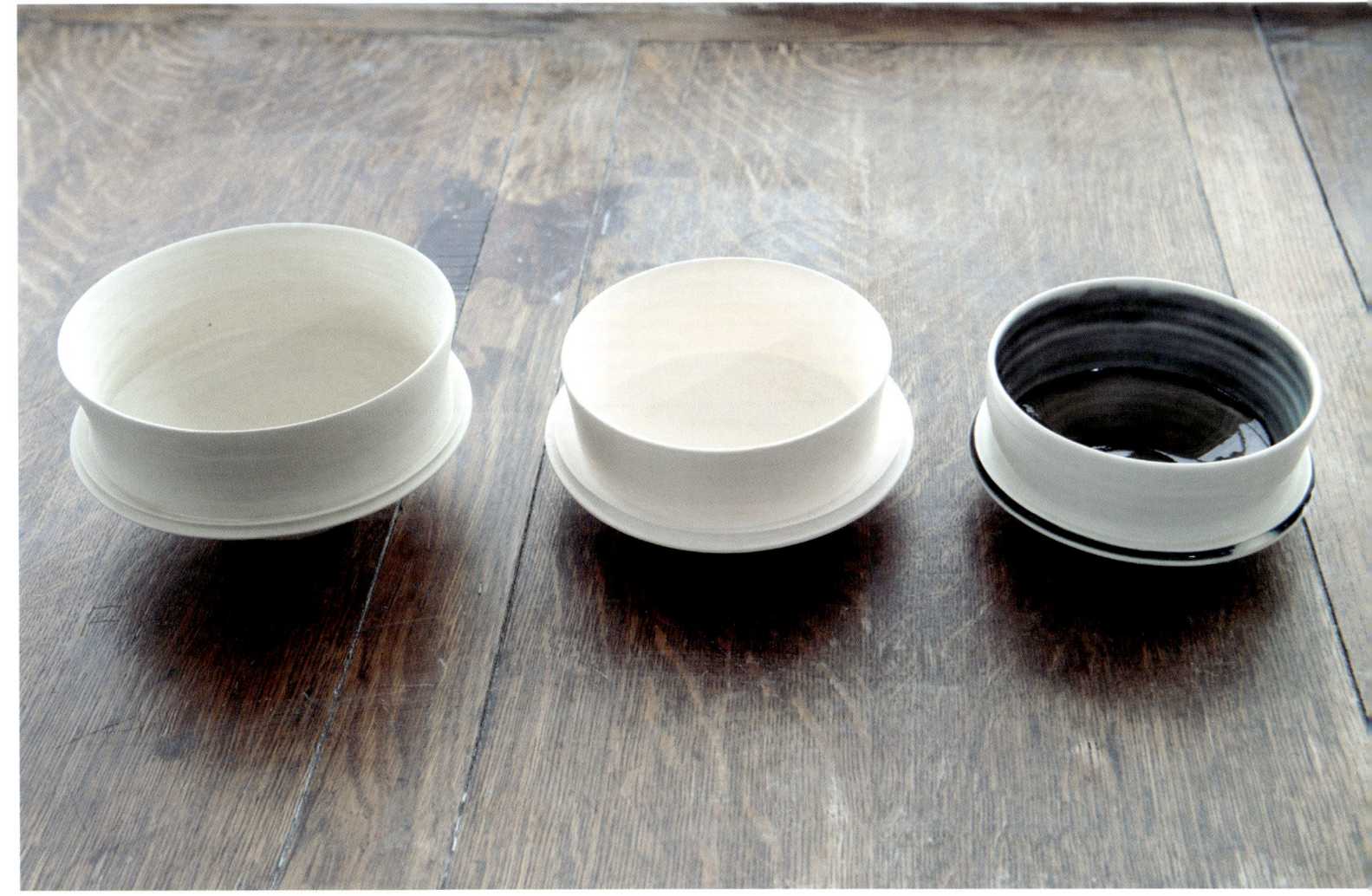

This image demonstrates the shrinkage of a bowl made from 14oz (400g) of porcelain at the green, bisque, and finished stages (shown left to right). This bowl was fired to 2336°F (1280°C/cone 9)

Dealing with cracks

A crack developing in a piece can be extremely frustrating. Clay has a memory and even if it has been repaired, the crack is quite likely to reappear. However, there are a number of things you can do. Keep repeating these actions if the crack returns.

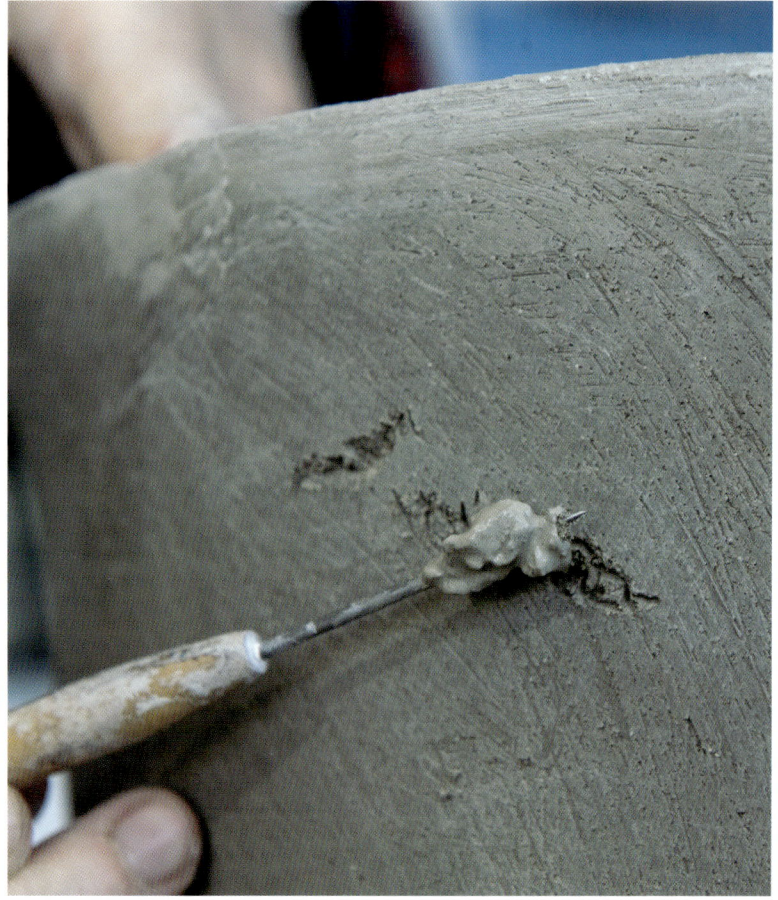

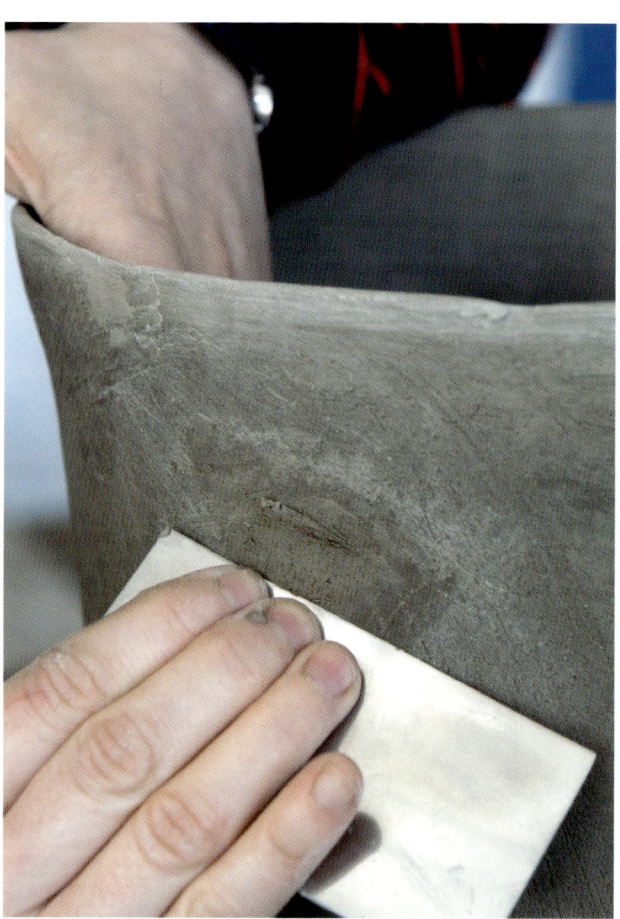

1 Dab the area with vinegar. As vinegar is acidic and clay is alkaline, vinegar will dissolve the clay and alter the particle positions, thus minimizing the risk of the crack returning.

2 Confuse the line of the crack by crosshatching around the area in many different directions.

3 Mix up the crack filler recipe and compress the mixture into the cavity with a rubber kidney or similar tool.

Crack filler recipe
- One part dry clay powder (clay body used for piece, dried and ground)
- One part china clay (kaolin)
- One part calcined alumina powder

Mix to a paste with water or gum arabic.

Drying step by step

Your work needs to be left to dry thoroughly. Thrown and handbuilt pieces have slightly different drying requirements from slip-cast pieces.

Drying thrown and handbuilt work

1 | Decide where you intend to store the work while it is drying. Make sure it is in a cool, dry place and out of direct sunlight. A wooden board or shelf is ideal. Place a sheet of newspaper onto the wooden board or shelf. Although not essential, a good tip is to lightly scatter some calcined alumina powder on top of the paper. The fine granules of the alumina allow the clay to move as it shrinks, and this helps prevent cracking. This is useful for smooth or plastic clays such as white earthenware and porcelain. The alumina does not damage the piece and can be easily brushed off when the piece is dry.

2 | Place your pieces on the board. Support any vulnerable areas with a prop made from scrap clay.

3 | Gently place a sheet of tissue paper or newspaper on top of the pieces; then cover them with some lightweight plastic. If the pieces are fresh, wait until the clay has firmed up before covering. Remove the plastic after a few days, leaving the tissue or newspaper behind, until the pieces are completely dry.

Drying slip-cast pieces
The walls of slip-cast pieces are usually very thin, so they dry quickly. Pieces can be left completely uncovered in a cool position out of direct sunlight. If you are planning to assemble pieces (for example, a handle to a cup), these can be premade and stored in an airtight container, ready to be joined.

Raw materials

The raw materials used in ceramics are mined from rocks and minerals. They are processed and ground into powder form ready for use. The organic nature of these materials means that they vary from each batch and supplier; therefore you should always test before mixing a large quantity. The names of some raw materials vary from country to country. Here I give the terms commonly used in the United States: a conversion chart for international equivalents is given on p. 275.

The raw materials used by the potters at the Leach Pottery, St. Ives, UK

Silica
Silica is the glass-forming element in a glaze and is fundamental to clay and many ceramic minerals. The two main sources of silica used in ceramics are flint and quartz.

Feldspar-type materials
Feldspars are minerals of varying composition. They are used in clay bodies and as a flux and alumina source in glazes. At high temperatures, feldspar on its own will melt into a thick milky glass.

Some examples are:
- potash feldspar/Custer/Bell (contains potassium)
- soda feldspar/Spruce pine 4; Kona F-4 (contains sodium)
- nepheline syenite
- Cornish stone

Clay-type materials
Clay-type materials are a source of alumina and an integral part of a clay body. They are used to stabilize glazes and aid adhesion to the ceramic surface.

Some examples are:
- EPK/china clay (kaolin)
- ball clay; for example, Kentucky ball clay, Tennessee ball clay
- powdered red clay

Frits
Toxic or harmful materials are made safer to use by an industrial process called fritting. This involves melting the material together with silica and then grinding it to a powder. Commercial powdered glazes available from pottery suppliers are also made by this process. Common frits include:
- Ferro 3498/O Hommel 14/Frit 28/Pemco Pb-700
- Ferro 3110/Frit 386/Pemco P-991
- Ferro 3134/Frit 550/Pemco P-926
- Colemanite/Gerstley borate

Other materials
There are many different types and groups of raw materials; the properties of each material are used to promote specific attributes in a glaze (or clay body), be it glossiness, matting, opacity, color enhancement, stability, or strength.

Some examples include:
- barium carbonate—flux, mattness, and tonal contrast in a glaze
- bentonite—is used in clay bodies to improve plasticity. It can also help keep glaze materials in suspension
- bone ash—commonly used in white high-fired clay bodies. In a glaze, it can produce opacity and opalescence
- dolomite—flux, opacity, and mattness
- magnesium carbonate—an opacifier in glazes
- petalite—also known as lithium feldspar; excellent for color enhancement
- soda ash—commonly used as a deflocculant in casting slip
- strontium carbonate—a flux. Can be used as a safer alternative to barium carbonate
- talc—used as a flux in a glaze or low-fired clay body
- whiting—used as a flux and a means to induce mattness
- wollastonite—used for opacity and matt surfaces
- wood ash—strong flux; can add a speckled texture and richness to a glaze

Koji Shiraya (Japan/UK)
Boxes, 2010
H: approx. 4in (10cm),
W: 4in (10cm), D: 4in (10cm)
Porcelain and feldspar

Shiraya contrasts the rich, fluid qualities of feldspar material against crisp geometric box forms. He playfully exploits this material to function as a lid for the container.

Oxides

Oxides of metal can be used in ceramics to color clay bodies, slips, or glazes. Raw oxide powders by themselves tend to produce rich, earthy tones; they can be applied as a wash onto green ware or bisque to highlight texture and detail. When applied under, over, or in a glaze, the color of the oxide can change radically, depending on the base glaze and firing temperature.

A selection of test tiles illustrates different oxides at varying strengths

Chrome oxide
Chrome by itself generally produces a dark green color. In glazes, it is very versatile and can achieve a broad palette ranging from soft red, brown, and yellow, to pink and green. At high temperatures, above 2264°F (1240°C), chrome is quite volatile and can pollute other wares in the kiln. Glazes containing tin oxide are particularly sensitive and can develop pink-brown streaks if placed near a piece containing chrome.

Cobalt oxide
Cobalt is a powerful oxide. Even a very small amount—0.5%—will give you a strong blue. Amounts over 1% will produce a dense blue-black, with 2% being the maximum you should use. The color of cobalt alone can be rather overpowering. Therefore it is best used in conjunction with other oxides such as manganese dioxide (purple-blue) and iron oxide (gray/brown-blue). Cobalt carbonate is weaker than the oxide and better for achieving subtle blue shades.

Copper oxide
Copper is a dynamic oxide with colors ranging from turquoises and greens to reds. The color depends on the type of glaze, firing temperature, and atmosphere. An alkaline glaze will produce turquoise; an acidic glaze will create a variety of green shades. When reduced, copper can produce an intense red color (also known as oxblood). Additions of 5% or more will create a metallic sheen. Copper should not be used on the interiors of vessels intended for food use (see Safety procedures, pp. 54–57).

Iron oxide
Iron is one of the most widely used oxides in ceramics. Black iron oxide, red iron oxide, and yellow ocher are all oxides frequently used in ceramics. Colors range from sandy to rusty browns as well as warm yellows and grays. Adding 4% of iron oxide to an earthenware glaze will produce rich amber and honey colors.

Rutile
Rutile contains titanium oxide and iron oxide. It is used in glazes to create tan brown and fawn colors with additions of 8–10%, rutile can produce a mottled surface and even iridescent glazes.

Nickel oxide
Nickel typically produces gray-browns. It is not a particularly attractive color on its own, so is best used in combination with other oxides to create darker, tonal shades.

Manganese dioxide
Manganese is a weak coloring oxide compared to other oxides; it usually requires additions of 2–3% for a stronger color. In glazes, manganese can produce delicate colors such as gentle violets, plum-purples, browns, and even golds and bronzes.

Vanadium oxide
Vanadium produces a weak yellow color in glazes. Additions of 3% or more can result in mottled, textured surfaces.

Chris Keenan (UK)
Beakers, 2006
H: 4in (10cm)
Porcelain

The celadon interiors of Chris Keenan's beakers are subtly contrasted with a tenmoku exterior, dappled with iron oxide on top to produce a burn-like detail. In high-temperature reduction glazes, a celadon is created with the addition of 3% red iron oxide to a base glaze, while a tenmoku is created with the addition of up to 10% iron oxide.

Kirsten Coelho (Australia)
Ginger Jar, 2010
H: 9½in (24cm), Dia: 6⅛in (15.5cm)
Thrown porcelain, matte white glaze, and banded iron oxide

Coelho highlights the rims and edges her vessels with oxides to suggest the weathering of iron.

RIGHT
Louisa Taylor (UK)
Mustard pots and spoons, 2010
Thrown porcelain

The glazes for these pieces were colored with oxides and stains.

MATERIALS AND TOOLS // OXIDES

Oxide additions for glazes and slips
The percentages listed below are suggested amounts:

Oxide	Amount added	Resulting colors
Cobalt oxide/carbonate	0.25–1%	Mid- to dark blue
Copper oxide/carbonate	2–5%	Light metallic green (turquoise/red)
Chrome	1–5%	Green/brown/pink
Iron oxide	1–10%	Light brown/earthy brown
Manganese	2–6%	Gray/brown/plum
Nickel	0.5–3%	Gray/brown
Rutile	2–10%	Light to dark tan
Vanadium pentoxide	2–10%	Light yellow-brown textured

Opacity oxides
Additions of between 3 and 10% to a base glaze will give you an opaque to strong white glaze:

Oxide	Resulting color
Zinc oxide	White
Zirconium oxide	White
Tin oxide	Bright white
Titanium dioxide	Matte cream

Oxide mixes
To achieve a certain color, try these mixes:

Purple:
Cobalt carbonate	0.75%
Manganese dioxide	3%

Blue-green:
Copper oxide	1%
Cobalt oxide	0.25%

Pink:
Chrome	1%
Tin oxide	5%

Yellow-green:
Chrome	2%
Vanadium pentoxide	5%

Metallic black:
Iron oxide	2%
Manganese dioxide	2%
Cobalt oxide	2%
Copper oxide	2%

Dark brown:
Iron oxide	6%
Nickel	2%

Stains

Stains are commercially produced pigments, a combination of oxides and ceramic material, fritted and ground into powder form. Stains are used to color clay bodies, slips, glazes, and enamels. Underglaze stains are used for decorative purposes. They are painted on the raw or bisque surface and a clear glaze is applied on top.

A reference board of red and orange stained glazes

There is a vast breadth of colors available from stain manufacturers. The advantage of a stain as compared to an oxide is the predictability of the color. Stains are excellent for achieving strong colors such as reds and yellows, they are very stable, and they are good for block coverage. Stains are intended to be used for oxidization and are at their richest at earthenware temperatures. Most will comfortably fire to 2300°F (1260°C), but some colors, particularly pinks, have a tendency to fade or burn out at higher temperatures. It is possible to use stains for reduction firing, but test prior to use.

Application

How much stain you use depends on how intense you want the color to be:

Clay bodies = 15–20%
Opaque glazes = 8–10%
Clear glazes = 5–8%

When adding stains to clays, slips, and glazes, always mix with a little water first and then combine, as dry powder will cause specking marks. To paint with underglaze stains, use less water if you want a strong color and more water to dilute the stain for a washy effect. If painting on top of a glaze, add a pinch of frit to the mixture to help the stain melt into the glaze better. Stain can be included as part of a glaze recipe or added separately to a clear glaze. Stains have a very high melting point; as the percentage of the stain is increased, the glaze will become less fluxed, and you may need to adjust the recipe accordingly. Only a small amount of stain melts or goes into solution; therefore, processing the glaze in a ball mill or very fine sieve will significantly enhance the saturation of the color.

Combining stains and oxides

Stains can appear tonally flat, but it is possible to blend them with oxides to add more depth. Adding 3% iron oxide to a stain will produce a beautiful mottled effect. Colors can be made into pastel shades with a 3–6% addition of an opacifier such as tin oxide.

Testing the quantity of stain added to a base recipe to determine suitable color strength

MATERIALS AND TOOLS // STAINS

Maria Wojdat (UK)
Group, 2007
Dia: 3½in (9cm)
White earthenware, stained engobes, and wax

Maria's work is based on everyday interactions with ceramic objects, specifically focusing on the pestle and mortar. She pounds the clay into solid bowl-like shapes exploring how the action creates the form. The colors are inspired by the character of the forms.

Storing ceramic materials

Allocate an area of your work space to store ceramic materials and always make sure containers and contents are clearly labeled.

Storing clay

Clay should be stored in a cool dry area, out of direct sunlight. It is good practice to store the clay on a pallet so it is raised from the floor. Stack each layer in the opposite direction to prevent the bags from tipping over.

Storing ceramic powders

Ceramic materials need to be kept dry at all times. Raw materials such as frits, ball clays, and glaze powders are usually purchased in large quantities and these should be stored in strong lidded containers that can hold 55lb (25kg).

Oxides and stains can be stored in smaller screwtop containers stored on a shelf or in a cupboard. Any poisonous and potentially harmful substances should be stored separately, preferably in a lockable cabinet.

Store all materials with labels. Stick one label on the side of the container and one on the lid. Request a material safety data sheet (MSDS) when purchasing materials from a supplier. This provides useful information about the substance, including safety procedures as well as storage and disposal of the material. Keep the sheet in a ring binder for reference. It is also wise to keep a record of the date the material was purchased, as some oxides, such as zinc, degrade over time.

Bags of clay neatly stored and ready for use

Large quantities of raw materials are stored in heavy-duty containers with secure lids

MATERIALS AND TOOLS // STORING CERAMIC MATERIALS

Oxides and stains are best stored in smaller accessible containers

Decanting ceramic materials

Decanting ceramic materials in an extraction unit is the ideal scenario, but this type of equipment is not always available in small studio environments. Any indoor working area should have good ventilation but no drafts. Always wear a dust mask and lightly spray the air in the room with water after completing the task. You can also do this outside, although you should still wear a mask.

If the material is in a bag, gently lower the top into a bucket. Slice the corner of the bag and let the contents decant slowly into the bucket. Do not rush this, as the powder could rise up into the air and cause a health hazard. Lift the bag gradually as the powder pours out. Immediately put the lid on the bucket.

Extra care should be taken when decanting poisonous materials such as barium carbonate or lithium into a container. Wear gloves and always use a dust mask even if working in an extraction unit.

Decanting a large quantity of raw material into a container

Tools

A maker's tools are very personal to that individual; they are acquired over time with particular favorites that seem to lend themselves well to any given task.

Pottery suppliers offer a vast selection of ceramic tools, but you don't need to buy a huge array. The essential kit as listed below is ideal for day-to-day use. Many resourceful ceramicists make their own tools from strips of steel, wood, and found objects. For example, a pottery needle can be made from a hat pin pushed through a cork. Old credit cards, cut and shaped, make excellent throwing ribs.

Essential kit
- Wire cutter to slice clay
- Pottery needle to gauge the thickness of clay; useful for cross-hatching
- Pottery knife—a general handy tool
- Serrated kidney for blending clay and shaping and cleaning the form
- Metal kidney for shaping and tidying the form
- Rectangular metal scraper for shaping and tidying the form
- Basic wooden modeling tools
- Natural sponge (better than synthetic sponge as it does not leave scratchy marks in the surface)

As well as the essential kit, you will need the following tools for each process.

Louisa Taylor's toolbox

Handbuilding
- A selection of wooden tools for modeling and shaping
- Surform tool to shape and refine leather-hard clay
- Paddle to hone the form—used at leather-hard stage
- Hacksaw blade to remove lumps and bumps
- Rubber kidney to compress and smooth the surface

MATERIALS AND TOOLS // TOOLS

Throwing
- Set of calipers for measuring openings, galleries, and lids
- Selection of wooden ribs to shape the interior and exterior walls
- Pointed tools to remove excess clay and tidy the form
- Sponge on a stick to soak up water in the base of tall and narrow vessels

Trimming
- Steel strips, each with the end folded at 90 degrees and a bladed edge
- Looped tools for modeling; these are also good for making foot rings and detailing
- Rubber kidney to compress and smooth the surface

A selection of tools used for slip decoration includes slip trailers, toothbrush, natural sponge, and pottery pin

Mold-making
- Metal modeling tools for carving and shaping plaster
- Surform tool for shaping and refining edges
- Calipers to aid in measuring
- Chisels for model-making on the lathe and whirler
- Compass to find the centerline
- Indelible pencil to mark the plaster surface
- Wet and dry paper for sanding and smoothing the form

Slip casting
- Scalpel to trim away seam lines on the fresh cast
- Fettling sponges to tidy up the piece and smooth away seams

Surface decoration
- Slip trailers
- Assortment of brushes from soft to hard, wide to fine
- Scissors
- Palette knives for mixing

46 // 47

Kiln furniture and accessories

The following items are essential accessories for ensuring reliable and consistent firings.

Kiln furniture

Kiln furniture is integral to the firing, allowing the kiln to be packed efficiently and securely. Shelves are made from refractory materials that can withstand extremely high temperatures, but can also be quite brittle. Thicker shelves are better suited for large heavy work but take longer to heat up than thinner shelves. Always coat the shelves with kiln wash to protect them from glaze debris and store them upright against a wall or in a cupboard when not in use.

Posts are also made from refractory materials and used to stack the shelves on top of each other; the most common are tubular. Posts come in an assortment of heights, and small extension parts are available to make best use of the space in the kiln.

Stilts, spurs, and saddles are used in earthenware glaze firings to raise the piece from the shelf and prevent it from sticking. This is particularly important for porous wares that require being glazed all over to create an impenetrable seal. After the firing, the stilt can be tapped off, leaving behind a discreet contact mark. These supports are not intended to be used at temperatures exceeding 2192°F (1200°C).

Various types of kiln posts used to stack the kiln shelves

Castellated posts

MATERIALS AND TOOLS // KILN FURNITURE AND ACCESSORIES

Pyrometric cones

Pyrometric cones measure the heat in the kiln and are considered to be the most accurate way of monitoring kiln firings. Cones are made of ceramic materials designed to melt at specific temperatures in relation to a precise rate of temperature increase per hour.

Cones can be mounted into a coil of clay or on a special cone holder. They are designed to stand at an angle and must be placed left to right in order of increasing temperature points. It is good practice to use three or more cones for each firing. The middle cone is your required temperature and the two to either side indicate 68°F (20°C) below and above this temperature.

During the firing, as the temperature required approaches, the tip of the cone will begin to bend. When it has reached temperature, the cone will arch. If the cone has arched and begins to look soft, this indicates that the temperature has passed. If the temperature continues to increase, the cone will melt completely.

Note: there are various manufacturers of pyrometric cones, but for ease of reference, all the cone numbers in this book refer to Orton cones. See p. 274 for the full Orton cone chart.

TOP
A pack of pyrometric cones stand ready to be placed in the kiln

BOTTOM
Cones are available as large, self-supporting, small, or mini-bar. The cone is stamped with a number that corresponds with a melting temperature, for example cone 9 = 2336°F/1280°C

Studio equipment

A ceramics studio is relatively simple to set up. Access to a suitable space such as a garage, outbuildings, or a rented unit is ideal. If you are on a budget, you don't need to spend a lot of money on equipment; you can buy very good secondhand equipment at a fraction of the cost of brand-new items.

Janet Mansfield's studio in Gulgong, New South Wales, Australia

Basic kit

- Kilns can be bought direct from a manufacturer or pottery suppliers. Reconditioned and secondhand kilns are often advertised in ceramic magazines or on websites
- Good solid table or bench, preferably with a surface that can be wiped clean
- Stool (not covered in fabric)
- Shelving; wooden or metal freestanding shelves or built-in units
- Lockable cabinet to store toxic and poisonous materials
- Toolbox to keep your tools together
- Banding wheel to rotate a piece as you work on it
- Scales for weighing clay and plaster
- Rolling pin for rolling out slabs
- Wooden boards to transfer work and aid drying
- Round bats for throwing. Clip on the wheel to make removal of work easier
- Heat gun/blowtorch to assist drying and firm up clay
- Vacuum cleaner
- Mop and bucket

Optional

- Pottery wheel
- Lathe/whirler for making plaster models
- Blunger to churn and mix casting slip
- Plaster bats for reclaiming clay
- Extruder
- Dremel tool for engraving and removing kiln debris
- Angle grinder to remove glaze drips and spills on kiln shelves
- Damp cupboard for keeping pieces damp so they can be worked on at a later time
- Slab roller. This is a large piece of equipment, but a good investment if you predominantly use the slab-building technique

A small electric kiln

Heavy-duty shelving to store ceramic work

Banding wheels

Rolling pin

Pottery wheel with wooden bat attachment

A lathe

A blunger

Scales and weights for weighing plaster and clay

Glazing equipment

The following items are useful pieces of equipment to have on hand when glazing ceramic wares.

Basic kit
- Small containers. Empty yogurt pots or food tubs make excellent containers for glaze tests and small quantities of powders
- Plastic jugs and bowls
- Lidded buckets for storing glazes
- Wooden slats to support the sieve on top of a bucket
- Sieves, 80 and 120 mesh
- Glaze brush to mix glaze material through a sieve
- Hand blender to blitz up the glaze prior to use
- Set of weighing scales, preferably digital

Small plastic containers are ideal for glaze testing

Mixing a glaze requires a container, sieve, slats, and a rubber kidney

Wooden sieves

Digital scales for weighing precise amounts

MATERIALS AND TOOLS // GLAZING EQUIPMENT

A selection of glaze tests made by Louisa Taylor

Optional
- Paddle mixer to stir large quantities of material. This larger version of a hand blender will clip to the top of a bucket
- Spray booth with a built-in extraction unit and filter. This is a costly item that is ideal for the studio environment
- Compressor to power the spray gun and run air tools
- Spray gun; gravity-feed spray guns are best suited for ceramic glazes
- Ball mill, used to refine a glaze and enhance the color. Glaze is poured into a porcelain jar containing small ceramic balls. The jar is then sealed and placed horizontally on a motorized rolling axis. As the jar rotates, the balls tumble and grind the glaze in the process

An improvised scoop made from a milk container is used for weighing out material

52 // 53

Safety procedures

Working safely in ceramics is a matter of good practice and common sense. Awareness and respect for the material and its processes will minimize the risks to yourself and others.

Emergency stop breaker cuts power to machinery

Dust management and control

One of the most serious threats to your health comes from the clay itself in the form of dust. Clay contains "free" silica, which is a harmful substance if inhaled. The fine silica particles become embedded into the lining of the lungs and cause tiny lacerations. The damage is irreversible, and prolonged exposure will result in a disease called silicosis. Silica dust is not exclusive to clay and can be found in other ceramic materials, including feldspar, quartz, and flint. With this in mind, it is imperative that you manage and control the dust in your work area.

- Never dry sweep. This causes the silica dust to become airborne and poses a serious health hazard. To clean up dust, vacuum the area with an industrial machine fitted with an appropriate filter for fine dust. Mop the area with water afterward.
- Regularly wipe down surfaces and workbenches. Laminated work surfaces are considered to be easier to clean than porous wooden tops.
- Avoid dry fettling of greenware.
- Clean up spills with a damp sponge before they dry. Scraps of clay can soon be trodden on and made into fine dust. Spray the dust with a handheld sprayer to prevent it from becoming airborne.
- Wear suitable work clothes. Overalls and aprons that can be wiped clean are the best. All other fabric types should be rinsed daily, and regularly machine washed.
- In situations where contact with dust is unavoidable, always wear a good-quality face mask with filters. The mask should sit flush against the skin, without any gaps.
- Do not eat, drink, or smoke in the studio.

The artist wears a dust mask while decanting ceramic materials underneath an extraction unit

MATERIALS AND TOOLS // SAFETY PROCEDURES

...elves,
...ge molds
...keep a
...knees,
...your body.
...and avoid
...s. It is
...apped boots to
...et should you
accidently drop ... item.

Tips
If you make large work, consider how you are going to lift it into the kiln. You could build your piece directly on a kiln shelf and slide it straight onto the floor of the kiln. It may also be worth investing in a pallet lift to help maneuver the piece into position more easily.

54 // 55

Repetitive strain

Maintaining one position for long periods without a break (for example, sitting at the wheel for hours throwing pots) can cause painful health problems such as a bad back, carpal tunnel syndrome, and even arthritis in the fingers and joints. Make sure you swap activities, move about, and take regular breaks.

Glazing

All ceramic materials are harmful in one way or another, and care must be taken when weighing out, mixing, and applying glaze. Wear gloves if you have sensitive skin or any cuts or open wounds. Hazardous materials must be locked away. Do not spray glazes containing toxic materials such as barium, lithium, chrome, and vanadium.

Take regular breaks when throwing for long periods

Store poisonous material separately from other materials in a lockable cabinet

Kilns

Keep areas around the kiln free from combustible material (newspaper, wooden boards, and so on). When the kiln is on, it is wise not to be in the same room because harmful gases such as chloride are released during the firing process. If you have to check the pyrometric cones inside the kiln, never look directly through the spy hole with the naked eye. The intense glow from the heat can damage the retina. Only view through tinted safety glass or a welder's mask.

Operating machinery

Water is often used in conjunction with ceramics. This creates a potential danger if using electrical equipment; therefore you must have a suitable power-breaker connected to the machine.

Other points to remember when using machinery are to make sure you have received the relevant training and are confident using the equipment. Always tie back long hair and loose clothing. Hold tools firmly and in the correct position so that you do not get "tool snatch." This occurs when the tool gets caught in between the tool rest and object and grabs violently.

Lead release from glazes

Lead in glazes produces bright, rich colors. However, lead is highly toxic if inhaled or ingested, causing significant damage to the internal organs. Lead is available only as a fritted material (lead bisilicate or lead sesquisilicate). It must not be used on ceramics intended for foodstuffs; the item could potentially leach lead if it comes into contact with acidic foods such as tea, coffee, or citric juices. The risk is even greater when used in combination with metallic oxides, especially copper, because it renders a higher solubility of lead in glazed ware.

It is a legal requirement in many countries to have your ware laboratory tested for lead release. Your pottery supplier should be able to provide you with the details of testing centers.

SECTION 2

Forming techniques

Introduction to handbuilding	60
Coiling step by step	62
Pinching step by step	66
Extruding step by step	68
Slab work step by step	70
Gallery: handbuilding	74
Artist profile: Nao Matsunaga	76
Introduction to slip casting and molds	78
Press molds step by step	82
Ready-made molds step by step	86
Making a model step by step	88
Making a two-piece mold step by step	92
Slip casting step by step	96
Gallery: slip casting and molds	98
Artist profile: Heather Mae Erickson	100
Introduction to throwing	102
Types of wheels	104
Centering step by step	106
Throwing a cylinder step by step	108
Throwing a bowl step by step	110
Throwing a bottle form step by step	112
Throwing a closed form step by step	114
Throwing a lidded vessel step by step	116
Making a lid	118
Trimming step by step	119
Pulling a handle step by step	124
Joining a handle step by step	125
Troubleshooting: throwing	126
Gallery: throwing	128
Artist profile: Prue Venables	130

German artist Anja Lubach press molds Madonna faces into freshly made porcelain-thrown forms

Introduction to handbuilding

Handbuilding clay is an ancient process, originating from prehistoric times. The simple motion of pushing, squeezing, and rolling clay by hand feels instinctive and establishes a firm connection between the maker and the material. There is also a sense of control over the material; the slow and gradual pace of working allows time for thought and consideration as the form progresses.

The four common handbuilding techniques

Pinching
Clay is manipulated into shape by gently pinching and compressing with the fingers and thumb.

Coiling
Sausages of clay known as coils are rolled either by hand or extruded and joined together to form walls.

Extruding
This involves forcing clay through a die to produce continuous lengths of a shape.

Slab building
Clay is rolled into flat slabs by using either a rolling pin or slab roller. Once leather-hard, the slabs can be cut and assembled to create a form.

British artist Ken Eastman constructs a piece using slabs in his Hertfordshire studio

Typically, pinching and coil-building techniques are best suited to organic forms with curves that flow and swell out. Straight-edged or crisp shapes are easier to achieve with flat slabs. Extruding clay can produce a variety of textures and unconventional shapes.

Handbuilding is very accessible to the beginner, but a good sense of form is vital as pieces can often become tentative or contrived. Before starting, draw or make a series of small models of the form you intend to build, as this will help clarify your ideas. Also take into account restrictions such as the internal height and width of the kiln.

When choosing clay for handbuilding, decide on a body that ideally is textured with "grog," which is made from ground-up fired body. This helps strengthen the body and is essential when producing large-scale work. If using smooth clay, it is possible to buy grog separately and wedge the desired amount in. The contrast of the speckled grog within the body can even become a feature; many artists take advantage of this quality. Likewise, very plastic clays such as porcelain can be difficult to work and prone to collapse. To resolve this, the clay can be made into or purchased as paper clay, which is excellent for producing fine, delicate forms.

Jim Thomson (Canada)
It Is What It Is, 2010
H: 5in (13cm), Dia: 17in (43cm)
Stoneware clay and glaze; slab and coil built; oxidation firing

Mieke de Groot (Netherlands)
2010-05, 2010
H: 6in (15cm), W: 11in (28cm), L: 18in (46cm)
Stoneware; handbuilt and fired to 2192°F (1200°C/cone 5)

This artist describes her work as showing a logical, linear history of forms, which precede one another in small variations. The sculptures emerge from a combination of systematization and intuitive choices.

Coiling step by step

Prepare a large quantity of coils prior to starting a piece—it is frustrating to have to stop mid-construction to make more. Wrap the coils in plastic sheeting to keep them fresh.

Making the coils

1 Loosely squeeze the clay into a sausage shape. Dampen the workbench with a sponge as too much rolling and warm hands can soon dry out the coils.

2 Place the clay on the bench and spread your hands on top. Start with your hands in the middle, apply an even pressure, and roll the clay backward and forward through your palms to your fingertips.

3 Part your hands and roll along the coil as it lengthens. Coils should be around ⅜–1¼in thick (1–3cm), depending on the size of the form you intend to build. A common problem for beginners is flat, misshapen coils. If this happens, squeeze the clay back into shape and continue rolling. Cut off the uneven ends.

FORMING TECHNIQUES // COILING STEP BY STEP

Building a coil pot

1 | To make the base, roll out a piece of clay into a flat sheet by using a rolling pin on top of wooden slats. Transfer the slab onto a round wooden bat. A banding wheel is a useful tool for handbuilding, as it allows you to rotate the piece as you work. To create a circular base, put the bat on the wheel head and spin. Position a pottery knife against the clay and allow the movement of the wheel to cut a line. The excess can then be cut away; it does not have to be very clean at this stage.

2 | Before putting on the first coil, crosshatch the edge of the base. Apply slip and rework the crosshatched area. Leave for 5–10 minutes to make it extra-sticky.

3 | Use one hand to hold the coil up high and the other to position it on the crosshatched area. Try not to twist the coil; flick your thumb downward to blend the coil. Add 2 or 3 coils and put another coil in the base to strengthen the form.

4 | As the walls are built up, stop every 4 or 5 coils and blend them together with either your fingertips or a wooden tool. The areas between the coils are the weakest parts and are vulnerable to cracking. Make sure the joins are well blended and fill any gaps with clay.

Coil pot weakness

Coil pots are susceptible to sagging under their own weight. It is important to recognize when the clay is beginning to reach this point. Decide whether to stop, cover the piece and work on it later, or alternatively use a heat gun or blowtorch to firm up the weak areas and continue working. Force-drying has its benefits but can increase the risk of cracking. If joining fresh coils to older coils, dampen the area and crosshatch with slip before joining.

62 // 63

Shaping the pot

The bulk of the piece can be made when the clay is plastic, although it is advisable to wait until the clay is firm (but not past the leather-hard stage) before altering the shape. The nature of the coiling process will cause the piece to flare out. To control the form, tilt your hand in the direction you want to build and keep adding coils.

If this is difficult, the shape can be altered further by cutting out triangle sections around the form. The walls can then be crosshatched and pulled together. Take a serrated kidney or hacksaw blade and use upward diagonal movements from left to right to remove lumps and bumps.

Leather-hard stage

It is easy to fuss over a piece during the construction stage. The walls may look uneven and the shape not very pleasing. However, by allowing the piece to dry to leather-hard, it can be radically transformed.

If the piece has sagged or looks unsymmetrical, a rectangular wooden paddle can be used to pat the form back into shape. Use a gentle but firm action, being careful not to cause any cracking.

Consider the rim. An ill-considered rim can be the downfall in the execution of a beautifully made piece. It should be relevant to the form, proud, and well finished. Thin rims give the impression that the piece is lightweight even if it is not. A wide, generous rim will welcome the viewer to engage with the piece.

FORMING TECHNIQUES // COILING STEP BY STEP

Surform tools and hacksaw blades are very useful to even up the shape and can create lovely textures. Finishing the surface with a rubber kidney produces a smooth, waxy appearance. Likewise, the piece can be "burnished" by rotating the back of a spoon onto the surface and using slips in conjunction with the technique.

A basic coil-built shape. This is a good starting point; from here you may consider coiling the shape inward, changing the rim, or even carving into the surface

64 // 65

Pinching step by step

Pinching is a simple technique to learn and can be adapted to suit a variety of processes. Many artists use pinching alongside other construction methods.

1 Prepare your clay by wedging. Cut a piece around 1lb (450g) in weight. Hold clay in your left hand. Put your thumb in the middle and make a hole, being careful not to go all the way through.

2 Start at the base and gently pinch the clay with your fingertips and the pad of your thumb. Rotate the pot in your hand or on the table as you raise the clay walls.

3 When you have the basic shape, allow the clay to firm up to leather-hard stage. Rework the clay walls with smaller pinching movements.

4 Turn the pot over and pat down the rim onto a flat surface. This will straighten up the rim. Consider whether you want to keep the pinched texture or use a metal kidney or surform tool to remove it.

Tina Vlassopulos (UK)
Loop, 2010
H: 6½in (17cm), W: 6½in (17cm)
Earthenware clay colored with oxides or stains and then coiled, pinched, soft slabbed, and burnished

Extruding step by step

Extruders are available in many different sizes and shapes, from small handheld ones to large wall-mounted or benchtop versions.

Making a die
Pre-cut dies often come with the extruder, but you can make your own designs in wood, metal, or acrylic plate.

By hand
Measure the internal dimensions of the extruder or draw around an existing die. Outline your design or shape in the center of the plate, drill a couple of holes and insert a hacksaw (you will need to remove the blade, thread it inside the holes, and reattach it) or an electric jigsaw to cut out the shape. Sand the edges.

Laser cutting
If your design is more complex or requires crisp edges, consider getting the die laser cut out of acrylic.

A selection of extruder dies for making coils, tubes, handles, and bespoke shapes

Extruding clay

1 Insert the die into the extruder and make sure it is securely fastened.

2 Prepare the clay and shape it into a thick sausage. Avoid using lots of smaller pieces, as this can result in air bubbles in the coils.

3 Insert the clay into the extruder chamber and move the compression bar of the extruder into the chamber. Have a wooden board and pottery knife on hand.

4 Push the handle until you can feel the internal bar beginning to press down on the clay. Keep pushing the handle (this may require some force) until you can see the clay being pushed through the die.

5 Once you have the required length, either cut the clay with a pottery knife or tear it by hand. Put the clay pieces on the board and wrap them up in a plastic sheet until you need them.

FORMING TECHNIQUES // EXTRUDING STEP BY STEP

Stine Jespersen (Denmark)
Bit by Bit, 2009
H: 5in (13cm), Dia: 9in (23cm)
Extruded earthenware, chopped, torn, pinched, and pressed around a plaster mold

The artist's intention is to produce a flow within the forms, like visual music.

68 // 69

Slab work step by step

Slab-built works can be constructed relatively quickly and to a large scale. When building with slabs, aim to use sections that are in the same state of firmness. Dry slowly to prevent cracks from appearing.

Rolling out
You will need two wooden slats at least ⅜in (1cm) thick, a piece of fabric or canvas sheet, and a rolling pin.

1 | Prepare the clay and bash it into a rough flat shape.

2 | Roll the clay onto a canvas sheet using the wooden slats as a guide. Rotate the direction of the slab by 90 degrees and flip over occasionally to spread out the platelets in the clay.

3 | Transfer the slabs onto a board and turn them over halfway through drying to stop them curling up at the edges.

FORMING TECHNIQUES // SLAB WORK STEP BY STEP

Cutting slabs with a bow harp
A bow harp is a C-shaped metal frame with a cutting wire attached between the opening. It offers a simple and fast method of cutting slabs from a block of clay.

1 Prepare the clay thoroughly and shape it into a rectangular block. Lay it flat on a smooth surface. The thickness of the slab is determined by adjusting the wire up or down the notches on the harp frame. Hold the harp upright and draw the wire through the block of clay.

2 Raise the height of the wire and draw through the clay again. Repeat this process until you reach the top.

3 Gently peel off the slabs and place them on a board covered with newspaper to prevent the clay from sticking. Discard the top and bottom slabs, as they will be too uneven.

Using a slab roller
A slab roller is a piece of equipment much like a printing press. Clay is fed through a roller and compressed into a sheet. The height of the roller can be adjusted to make thick or thin slabs, and it saves the laborious task of rolling slabs by hand.

Slab building from leather-hard stage

Once the slabs have become leather-hard, they are ready to be joined. Decide on the shape you intend to build. A simple four-sided box construction with a base is used for this example.

1 | Cut the four sides of the slabs to size using a pottery knife and a set square ruler.

2 | There are a few ways to join slabs. The simplest method is to cross-hatch the end edges and press them together. Another method (demonstrated in these steps) is to cut a 45-degree angle off all the sides on each slab. When assembled, the joins are less obvious.

3 | Crosshatch this cut area. Make sure the surface is really rough. Use a brush to generously apply slip onto the crosshatched area. Rework the slip with a pottery knife or needle. Leave the slip for 10 minutes to dry slightly, as it will become extra sticky.

4 | Lay one piece flat on the surface and assemble the sides together.

FORMING TECHNIQUES // SLAB WORK STEP BY STEP

5 | Press down all the edges, and the slip will ooze out. Allow this to firm until it reaches a cheese-like consistency.

6 | Wipe the edges clean with a metal kidney or similar tool.

7 | To finish the piece, the box can be fettled with a surform tool and compressed with a rubber kidney.

Further ideas
- Try rolling the slabs onto an assortment of textured paper or surfaces.
- Decorate the slabs with colorful slips and then cut and assemble.
- Sprinkle combustible materials such as rice or lentils on top of the clay and roll in. These materials will burn out and leave wonderful textures. (See slip decoration section, pp. 202–215, for further information.)

72 // 73

Gallery: handbuilding

Anders Ruhwald (Denmark/US)
Edge; R-vase #3, 2009
Room-sized installation
Glazed earthenware, handbuilt and coiled

Anders Ruhwald's works appear to be functional but behave like sculpture. Central to his work is an investigation of the space that the work inhabits: The objects often build relationships to the places they occupy.

FORMING TECHNIQUES // GALLERY: HANDBUILDING

Ken Eastman (UK)
For All We Know, 2010
H: 14½in (37cm), W: 17in (43cm),
D: 12¼in (31cm)
Slab-built using white stoneware clay; painted with numerous layers of colored slips and oxides, and fired several times to 2192°F (1200°C)

Susan Collett (Canada)
Labyrinth: Hive, 2009
H: 42in (107cm), W: 23in (58cm),
D: 27in (69cm)
Earthenware paper clay; handbuilt, multi-fired glaze layers

"I am interested in the ascending layers of movement and light through the surface texture and perforations to evolve a perceived fragility and the paths between our interior and exterior worlds."

Eva Kwong (US)
Orange Spotted Acalephoid, 2005
H: 21in (53.5cm), Dia: 15in (38cm)
Stoneware, coil built and wheel thrown; colored slips, glaze

74 // 75

Artist profile: Nao Matsunaga

Born in Osaka, Japan, Nao Matsunaga studied at the University of Brighton, England, specializing in Ceramics and Wood. He then went on to a Masters degree in Ceramics and Glass at the Royal College of Art, London, graduating in 2007. Matsunaga's work has been featured in exhibitions in Wales, England, and Sweden, and in 2008 he was artist in residence at Konstfack in Stockholm, Sweden. Matsunaga is represented by London's Marsden Woo Gallery.

"I am challenged by the unknown, by accidents from which I can extract something beyond preconception. I believe that marks made, lines created by sculpting, and careful juxtaposition of recognizable objects, can have an impact on the subconscious. There is an element of control to this intuitive method of making, however, often by having angular architecture-inspired detail adjoining the raw organic piece. This balance of raw and controlled, stillness and movement is critical to my practice.

"Inspired by Neolithic and modern architecture and its inhabitants, my practice ranges from installation-based work to sculptures made in clay. It is how individuals interact with their surrounding space and objects that is central to my thinking.

"Handbuilding is a relatively slow process; I often work simultaneously on two or three pieces. Inevitably they start to relate to each other, and this becomes the inspiration for my making.

"When the form is made, I begin to put texture on the surface with a wooden tool. This can be seen as my direct response to the form I have created. In essence, I am interested in creating and capturing movement in a still object."

Tank Series, 2010
H: 8in (20cm), W: 4in (10cm), L: 4in (10cm)
White earthenware; handbuilt with coils and press-molded details; polished with a wooden tool, colored ink, and wax

FORMING TECHNIQUES // ARTIST PROFILE: NAO MATSUNAGA

Wall with a Doorway, 2007
H: 19¾in (50cm), W: 10in (25cm),
L: 27½in (70cm)
Brick clay, earthenware; handbuilt using coils and slabs; textured by hand

LEFT
Akira and Okan (from *Ground Cloud* series), 2010
Both forms: H: 23½in (60cm),
W: 12in (30cm), L: 13¾in (35cm)
White earthenware; handbuilt with coils, polished with a wooden tool and finished with wax slabs; textured by hand

Introduction to slip casting and molds

Slip casting and mold-making could be the subject of a book by themselves. This section provides a basic overview of the processes involved and explains how to slip cast simple forms and get started on making molds. For further reading, refer to the bibliography in the resources section (p. 278).

Molds are used in ceramics as a means of supporting and forming clay. They are made from a porous material to draw moisture from the clay. This is commonly plaster, although simple press-molded forms can be made from low-fired bisque.

Plaster has aided ceramic production for centuries but was not commercially mined until the mid-1700s. Plaster is made from the raw mineral gypsum. It goes through a manufacturing process that renders it in a state of permanent thirst. When added to water, a chemical reaction occurs, and it sets as a solid. This transformation from a liquid to a solid defines plaster as an extremely versatile material. It is soft enough to be carved by hand, and the models and subsequent casts can be finished to a very high quality.

There are two main types of molds: press molds and slip-casting molds.

Press molds

Press molds are used in conjunction with handbuilding techniques for making pieces such as functional dishes and bowls, architectural details, large shapes, and sculptures. Press molds allow the maker greater control during construction and suit forms that would be difficult to throw or slip cast.

Kaori Tatebayashi (Japan/UK)
Kohiki teapot and cup and Kuro cup, 2009
Teapot: H: 5¼in (13.5cm), W: 8in (20cm), D: 4¼in (11cm); cups: H: 3⅛in (8cm), W: 2¾in (7cm)
Stoneware

Kaori uses press molds to shape her handbuilt tableware. These pieces were inspired by the relationship she had to nature in her childhood.

A jigger/jolley machine presses forms using a spinning mold. A plastic profile is attached to the pivoted arm. The operator pushes this down onto the mold and removes excess clay to shape the form. *Jiggering* refers to profiling the exterior of a piece and is predominantly used for making plates. *Jolleying* refers to shaping internal profiles such as cups and bowls

FORMING TECHNIQUES // INTRODUCTION TO SLIP CASTING AND MOLDS

Slip casting

Slip casting involves pouring liquid clay (casting slip) into a plaster mold. The water content of the slip is absorbed into the plaster, leaving behind a unified skin of clay. Making molds for slip casting requires a certain degree of accuracy, which some makers find very appealing. It is excellent for producing crisp forms and multiples of an object, each one being identical to the next.

Kuldeep Malhi (UK)
Red Square, 2008
H: 28in (70.8cm), W: 59in (149.5cm)
Slip-cast earthenware and earthenware glaze

Kuldeep's wall installations cross the boundaries between ceramic art and architecture. He draws on a mix of influences from the erotic sculpture found in ancient Indian temples to modernist architecture.

Mixing plaster

Method 1: Plaster-to-water ratio
This will vary according to the type or brand of plaster, so you will need to refer to the manufacturer's instructions prior to mixing. However, the general amount is 1½lb (680g) plaster to 1pt (710ml) of cold water. Simply multiply this amount to make larger quantities. Pour the water into a clean bucket or container. Weigh out your plaster and start sprinkling it into the water. Do not heap the plaster into the container, as this will make the mix lumpy and full of air bubbles. Once plaster is sprinkled in, leave it for a couple of minutes to make sure it is all absorbed. Place your hand into the bottom of the container and waft it underneath the liquid, rather than using a stirring motion. This helps lift air bubbles to the surface. Remove any scum on the surface. Continue to mix. You should eventually feel the plaster thickening. Pouring the plaster is a case of fine timing; don't pour too early or leave it too long.

Method 2: Pyramid technique
This method does not involve any measuring or weighing but does rely on good judgment. Fill your container with the desired amount of water. Sprinkle plaster into the water and keep adding until a peak of plaster breaks through the surface of the water. Allow it to absorb into the water and mix by hand as in method 1.

FORMING TECHNIQUES // INTRODUCTION TO SLIP CASTING AND MOLDS

Casting slip

Casting slip is not the same as decorating slip; the difference is that casting slip contains deflocculants. The purpose of deflocculant is to keep the clay particles in suspension, enabling the slip to flow freely as a liquid with relatively low water content.

Casting slip can be bought ready-made from pottery suppliers. For larger quantities, it may be more economical to make your own slip. A recipe is given at right.

A typical casting slip recipe

Clay (e.g., white earthenware)	110lb (50kg)
Sodium silicate	2oz (60g)
Soda ash	1oz (25g)
Water	10½pt (5l)

Pour the water into a blunger or large container. Weigh out the sodium silicate and soda ash and dissolve them in hot water. Add this to the water in the blunger/container. Add the clay in small quantities and blunge for 1–2 hours (or use a paddle mixer). For best results, leave the slip to stand overnight before using.

Lowri Davies (UK)
Collection of China, 2009
Slip-cast bone china; clear, yellow, and green glazes; screenprinted and digital transfers; gold and silver luster

Press molds step by step

Clay is an excellent material for taking impressions. When plastic, it can be manipulated and formed into shape with the use of a mold. Clay can be pressed into an internal (negative) profile, or worked over a former (also known as a hump mold).

Press molding using a slab
A slab is an effective way of covering the entire surface of a mold in one piece.

1 | Before starting, wipe the mold clean and lightly spray with water to prevent the plaster from drying out the clay too quickly.

2 | Roll out a slab onto a cloth sheet to a thickness of approximately ⅜in (1cm). Larger molds require a thicker slab of ¾in (2cm). Try not to get creases in the slab, as this could cause a weak area. Lift the slab over the mold and peel away the backing sheet.

3 | Use a damp sponge (or a sandbag) to gently press the clay into the mold, making sure to push the clay into any nooks and crevices.

4 | Roughly slice away the excess flange of clay.

5 | Define the edges by holding a sharp pottery knife on its side and cutting a clean line around the rim. Be careful not to scratch the plaster mold.

6 | To finish the piece, compress the slab with a rubber kidney, paying particular attention to the edges. Leave to firm up in the mold before removing.

FORMING TECHNIQUES // PRESS MOLDS STEP BY STEP

Hand pressing

This method is used for press molding large molds or forms that have a lot of tension in the shape (hand-pressed forms shrink less than a slab and are less likely to crack). The mold needs to be slightly damp before starting. This helps the clay adhere better to the plaster surface.

The clay will be easier to press if it is very soft and plastic. Tear a small piece of clay and smear it into the mold. Repeat this action a couple of times until you have completed a small area. This layer now needs to be backed up by a secondary layer of smeared clay, followed by another if need be. The intention is to build up the clay to create one strong layer. Work quickly but accurately. The better the smearing, the less time you will need to spend fettling the finished cast.

One of the most important things to consider when using this technique is the thickness of the clay: it must be even throughout. Use a pottery pin to check that the depth is consistent over the whole piece.

Removing the piece

Timing in ceramics is critical. If you remove the piece too soon, it could sag under its own weight and become misshapen. Too long in the mold, and you risk the piece cracking.

1 | A good indication that the piece is ready to remove is that the edges begin lifting away from the sides of the mold. The clay itself should be leather-hard and feel firm to the touch.

2 | Place a board over the mold and flip upside down.

3 | Tap the mold and gently lift it away to release the form inside.

82 // 83

Hump mold step by step

The same working methods as before are applied, with the slight difference that the clay is laid over the mold rather than pushed inside.

1 | Roll a slab and lay it over the mold.

2 | Gently press down the clay using a damp sponge.

3 | Remove excess clay with a pottery knife and tidy the edges.

4 | Once the clay has firmed, it can be removed from the mold.

Joining multipart molds

A simple drop-out press mold can be replicated and the two halves joined together (providing it is symmetrical) to produce one form.

It is also possible to press mold more complex multipart molds, much like a slip-cast mold. Each segment of the mold is filled with either a slab or hand-pressed clay. The edges should then be crosshatched really well and covered with slip to create a sticky bond. The pieces of the mold are assembled back together and squeezed tight to ensure a good join. After the piece has firmed to leather-hard it can be removed from the mold and tidied up.

Press-molded sections can be joined together by crosshatching the edges, applying slip, and sealing pieces together

Decorative techniques to try

- Roll balls of different colored clays and press them individually into the mold to create unusual patterning.
- Paint slips into the mold prior to laying the slab. The slips will transfer to the clay and give a printed feel to the piece.
- Scratch into the mold to produce a relief texture in the clay.
- Experiment with rolling slabs of clay onto texture bats and then construct the pieces into the mold. Crosshatch the overlapping edges to secure together.

Ready-made molds step by step

A ready-made mold is a straightforward type of mold to make. Models made by hand or found objects such as foodstuffs, buttons, shells, or any simple form can be covered in plaster to make a mold for slip casting or press molding.

Using found objects as molds

1 Roll out a thick slab of clay and lightly push the object into the surface. Make sure there are no undercuts. Neaten the clay seam around the object with a tool.

2 The walls to contain the plaster can be constructed by placing a clay coil or two around the object. This is fine for small molds but crude for larger molds.

3 The tidiest method is to box the outside with wooden boards or plaster bats, or to wrap a flexible plastic sheet into a cylinder (known as a cottle) and place it over the top of the object. Secure the container with clips and cord.

4 Mix the plaster until stiff and pour over the model. Leave to set before discarding the model. Neaten the edges of the mold with a surform or metal kidney.

The finished waste mold

FORMING TECHNIQUES // READY-MADE MOLDS STEP BY STEP

One-piece drop-out molds for slip casting

A one-piece drop-out mold is ideal for cylindrical and bowl-type shapes. Once cast, the piece can be gently released without the need to make complex multipart molds.

1 Make sure the model slightly flares out at the top to encourage the cast to drop out easily. There must not be any undercuts, or the cast will become locked inside the mold.

2 Turn the model upside down so the rim is on the board. If the model is solid, glue it to the board to secure it in place. If the model is hollow, fill the inside with clay. Plaster models should be soft-soaped before the next stage.

3 Cottle up around the form and secure with clips and cord. Add a coil of clay to the base to prevent leaks. Mix the plaster and pour over the model.

4 Lifting the model out can be difficult. Blasting the seams with compressed air can help it release, or you can put a screw in the top of the model and extract with pliers.

Sprigging

Sprigging refers to a technique whereby fine, intricate reliefs are created by pressing clay into very shallow molds. A metal tool is used to gently lift the sprigg from the mold; it is then applied to the clay surface.

Hitomi Hosono (Japan/UK)
Leaves Bowl, 2010
H: 7½in (19cm), W: 10½in (27cm), D: 10½in (27cm)
Porcelain

Inspired by leaves and flowers found in the garden, Hitomi Hosono applies layers of delicate molded spriggs to a thrown body to create beautiful organic forms.

Making a model step by step

The model to be molded can be made from a variety of materials including plaster, plasticine, styrofoam, plastic, wood, and even clay.

Hand carving or sculpting

Models can be made by simply hand-carving a block of plaster into a form. Start by drawing a series of detailed sketches of the piece you intend to carve, including the height and width dimensions. This will help determine what size plaster block you need to begin with. This technique is also useful for making additional parts such as handles and spouts.

The plaster is easiest to carve when it is still fresh and warm. Use a surform tool to sculpt the initial shape and then carve details with metal-modeling tools. Finish the model by sanding the plaster with wet and dry paper until smooth.

Whirlers

This machine is very useful for making large or wide molds. Unlike the lathe, the whirler head must be soaked and soft-soaped prior to use.

1 A whirler works on the same principle as a lathe, but rather than working horizontally, the operator stands to the right side of the machine as it spins and leans on a wooden support while holding a carving tool.

2 Pour plaster into a cottle fixed onto the whirler head and leave it to curd. You should remove the cottle quite quickly in order to exploit the freshness of the plaster. This makes carving the profile much easier.

3 Once the model is shaped and completed, finish it with wet and dry paper. The model can then be recottled and a mold taken.

FORMING TECHNIQUES // MAKING A MODEL STEP BY STEP

Lathes

Lathes are usually associated with woodworking but can be used to turn accurate plaster models.

1 | Prepare the lathe head by carving dovetail or undercut keys into a plaster cup fitted into an internal metal bracket.

2 | Wrap a piece of cottling (plastic sheet) around the head and secure it into position with clips and cord. Join the seals with masking tape and clay to prevent leaks. Mix the plaster and pour it into the container. It must set before you remove the cottling and attach it to the lathe.

3 | Position the tool rest near the centerline; it should just skim the rotating plaster block. Hair must be tied back and eye protection worn. Hold a chisel on the tool rest and remove the plaster in strips. This action carves the plaster until the piece runs true.

4 | As you remove more plaster, adjust the tool rest and move closer, being sure to switch the lathe off first.

5 | Different chisels can be used to shape the piece before it is finished with wet and dry paper.

6 | To remove the model, turn a wide gap between the model and the lathe head. Then cut it off from the lathe with a saw. Tidy up the rough base with a surform tool and sand it.

88 // 89

Sledging

Sledging is the process of extruding plaster using a metal or perspex template.

1 | Cut and fix the profile of the shape to a piece of wood. Construct a bracket and side panel to allow the template to slide across the top.

2 | Mix the plaster and leave it to curd. Once ready, heap it onto the bench. Draw the template through the plaster. Repeat this action a number of times; the sledge is cleaned in between each pull. To clarify the shape, apply a second, thinner layer of plaster to the form and sledge it. The finished sledged sections can then be cut and assembled into a final model.

FORMING TECHNIQUES // MAKING A MODEL STEP BY STEP

Rapid prototyping

A rapid prototyping machine is essentially a three-dimensional printer. The technology is commonly used in industry but is now becoming more accessible for individuals. Designs are drawn using CAD (computer-aided design) 3-D modeling programs and then uploaded to the machine. A mixture of resin and powder is built up in layers until the model is complete. A rapid-prototyped model can be very expensive to produce, but the cost is outweighed by the ease of producing complex forms that would otherwise have to be skilfully hand carved.

Owen Wall (UK)

ABOVE
Murqana cup and saucer rendering, 2008

BELOW
Murquana espresso cup and saucer (gold), 2008
Saucer: H: 1½in (4cm), Dia: 5¼in (13.5cm); cup: H: 3¾in (9cm), Dia: 2½in (6.5cm)
Double-cast earthenware cup and saucer, glazed and luster-fired

Ceramicist Owen Wall designs his pieces using the CAD drawing package Rhino4. The saucer part of the model was printed in 3-D using rapid prototyping; the cup was created using traditional plaster-forming techniques.

Making a two-piece mold step by step

A two-piece or multipart mold is required for more complex models that will not extract from a drop-out mold. The model may demand several parts, so bear this in mind when you are designing it. The following instructions introduce you to making a basic two-part mold that can be used for press molding or slip casting.

Finding the centerline

On a plaster bat or thick card, mark a center point and use a compass to draw a series of concentric circles. Draw a line through the center dot, dividing the circle into two halves. Set the compass at 2in (5cm) and mark two points equidistant from the centerline on the outer circle.

Center the model on the sheet. Place the compass (fitted with an indelible pencil) on the first point and pivot the arm to draw an arc on the model. Switch to the other point and repeat the action to draw a cross. Adjust the arm of the compass to draw another arc above the previous one. Continue to make further crosses up the length of the model. Repeat for the other side. Connect up the crosses with a vertical line to establish the true center.

Find the centerline using a compass and an indelible pencil

Making a plaster bat

You will need two sheets of glass. Place a wooden spacer (⅜–⅝in/1–1.5cm thick) in the four corners of the bottom sheet. Mix up the plaster until it is stiff enough to heap onto the glass. Pick up the second sheet at an angle and sandwich on top of the plaster. Shuffle the glass as you compress down until it comes in contact with the spacers. Allow plaster to set before removing.

A plaster bat is made by pressing a sheet of glass onto fresh plaster before it sets

Spares

A spare is a separate disk of plaster that literally extends the top of the model. The purpose of a spare is to create space in the mold to aid casting. It provides a hole in the mold to pour slip into and a reservoir to top off slip if necessary. Without a spare, rims of subsequent casts will be uneven as the slip levels drop. A spare can be shaped by hand or turned on a lathe. It is then glued to the model to secure it in place before the mold is taken.

Making the mold

1 Soak the plaster model if it is dry. Find the centerline and soft-soap the model all over. Soft soap seals the porous surface of the plaster and should be applied at least three times. Wipe the surface clean with a moist sponge each time. There should not be any soft soap residue left. Place coils of clay onto a wooden board. Lay the model on its side, check that it is level, and adjust accordingly.

2 Layer more coils around the model, crossing over in alternate directions until just below the centerline.

3 Cut the pre-made plaster bats with a handsaw or machine to fit the profile of your model, one for each side. Taper the edge of the bat to allow for a better fit.

4 Place the plaster bats onto the clay and apply pressure until they become level with the centerline. Fill any small gaps with clay, making sure a crisp seam between the model and bat is maintained. Sponge a final coat of soft soap over the model and bats and wipe clean.

5 Slot together walls of wood or plaster bat and hold them tightly with cord to form a neat box around the model. Small wooden wedges can be inserted to tension the cord. Fix clay around the joins to prevent any leaks.

6 Mark a fill line at the top to indicate the depth to be poured. Mix up the plaster and pour over the model.

FORMING TECHNIQUES // MAKING A TWO-PIECE MOLD STEP BY STEP

7 | When the plaster is firm, remove the walls and tidy up the mold with a metal kidney or surform tool. Do not remove the model at this stage because the plaster will swell and the model will not fit back in.

8 | Use a coin to carve notches into the plaster mold. This will provide a location point so that the two halves of the mold will meet exactly. Reapply and clean off soft soap over the model and mold. Board up the outside and pour the second half of the mold.

9 | Once the mold has set, split the sections and remove the model. Ideally the mold should be left to dry in a heated cabinet. Alternatively, it can be placed in a warm room, although it will take longer to dry before it can be used.

94 // 95

Slip casting step by step

A slip-cast object is a satisfying thing. It is the reward of all the investment of time making the model and molds.

1 Prepare the slip by mixing in a blunger or with a handheld blender. Ensure the mold is completely dry and place a tight rubber band or cord around the outside. This will prevent the mold from opening once it is full of slip. If your mold does not have a spare (see p. 93), place a coil of clay around the top of the mold to create a slip reservoir.

2 Fill a plastic jug with slip. For large molds, have a couple of jugs of slip on standby so a continuous pour can be maintained. Pour the slip carefully into the mold. Aim for the center and not the sides. Pouring too fast can cause casting spots or swirl marks. Pouring too slowly risks filling lines or causing variations in thickness. Fill the mold and keep topping off the slip reservoir.

3 Casting times vary on the type of slip, size of mold, and consistency of slip. Allow approximately 20 minutes for an earthenware and semi-porcelain body. Bone china and porcelain take much less time, approximately 3 minutes. After this time, the slip can be tipped out. This should be done steadily—not too slowly, as this can cause draining marks, and not too fast because this can create a suction that can pull the cast away from the mold. If you hear a glugging sound, tip back the mold slightly and ease the flow.

FORMING TECHNIQUES // SLIP CASTING STEP BY STEP

4 | Place two wooden sticks of uneven height on top of a container. The uneven height is important because this allows the slip to run down the sides and prevents stalactite droplets from forming in the base. Turn your mold upside down and place it on the sticks. Leave to drain; do not reverse the mold too soon as this can cause wet areas to run back; the cast should have a matt, waxy sheen.

5 | Once the cast is dry to the touch and has a matte sheen, trim away the spare with a sharp scalpel. A blunt knife will cause the cast to crack. Be careful not to cut or scratch the mold. Tidy and sponge the rim.

6 | Empty the mold after 30 minutes to 1 hour. Discard your first cast as this may be contaminated with plaster.

7 | When the cast has dried to leather-hard or green state, remove seam lines with a sharp knife or scalpel (this is known as fettling) and sponge the area. Handle the piece as little as possible.

Techniques to try

Casting slip can be colored with the addition of 10g stain to 2pt (1l) of slip. Try experimenting with painting or slip trailing colored slip inside the mold before filling the mold with white slip. The finished cast will appear to have a flush decoration in the surface.

To emboss the cast, lightly scratch into the plaster mold and brush away any loose bits of plaster. Secure the mold and fill with slip.

96 // 97

Gallery: slip casting and molds

Christie Brown (UK)
Entre Chien et Loup, 2003/4
Each figure H: 51in (129cm),
W: 10in (25cm), D: 10in (25cm)
Ceramics and mixed media

Brown's work encapsulates an ongoing interest in multiples, repetition, and the metaphors associated with molds.

James Rigler (UK)
Valley, 2007
Approx. 9ft 10in (3m) by 6ft 6in (2m)
Glazed earthenware;
press-molded ceramic; plaster molds taken from sledged/lathed/assembled plaster models, then press-molded, bisqued, and glazed

The layout of the elements means the piece can vary in size and shape to interact with its site.

FORMING TECHNIQUES // GALLERY: SLIP CASTING AND MOLDS

Ruth Borgenicht (US)
Gray Moon, 2008
H: 15in (38cm), W: 13in (33cm), D: 5in (12.5cm)
Stoneware; slip-cast, unglazed, colored casting slip; fired to 2372°F (1300°C/cone 10)

This artist uses the chain-mail pattern and other woven patterns to create ceramic works that conjure up a sense of permanence and defensive concealment.

Sasha Wardell (UK)
Large Shoal Vase, 2008/10
H: 15in (38cm)
Slip-cast bone china, layered and incised with colored/stained casting slips

Maria Lintott (UK)
Bloom Jugs, 2009
H: 3in (8cm),
Dia: approx. 3½in (8.5cm)
Slip-cast fine bone china with hand-applied floral sprigs

Artist profile: Heather Mae Erickson

Award-winning US artist Heather Mae Erickson studied for her Bachelor of Fine Arts in Crafts at The University of the Arts, Philadelphia, and went on to earn her MFA in Ceramic Art at Cranbrook Academy of Art in 2004. Heather Mae has had a solo exhibition at Philadelphia International Airport and has had work shown at galleries ranging from the Freehand Gallery in Los Angeles to Greenwich House Pottery in New York. Heather Mae is currently the Robert Chapman Turner Teaching Fellow in Ceramic Arts at the New York State College of Ceramics at Alfred University.

"I question function through combining understood methods of use, and proposing new formats. I take objects, functions, or aspects, and combine opposing elements through multiplicity, size, or orientation. I continuously pose questions that enhance the guidelines and starting points. By broadening my scope, the possibilities for containing or displaying food become endless. It is easy to get stuck on the idea that a cup or bowl must take on a specific shape in order to serve its purpose. I do not think in those limiting terms. I focus my energies on thinking about a container, without preconceived ideas, and I know that my vessel can be any shape or size that I desire.

"Throughout my undergraduate studies at The University of the Arts, and my graduate studies at Cranbrook Academy of Art, my ceramic journey dealt with functional wheel-thrown and altered objects. I have since had a Fulbright scholarship to Finland and also had a summer residency at Guldagergaard in Skælskør, Denmark. This combination of research and investigation has led me to be interested in plaster prototyping, mold making, and slip casting. The industrial processes enable a high level of refinement. I enjoy working with plaster because the material affords me the ability to use my personal aesthetic while hinting at the ideas of contradiction and the industrial hand.

"My creative approach combines industrial clarity with unique artistic execution that requires intense amounts of handling. Even though it may look simple, it is not easy. The clarity and finish on my pieces is intensive, time-consuming, and laborious. Each piece is generally handled and refined so much that it looks like I never touched it."

FORMING TECHNIQUES // ARTIST PROFILE: HEATHER MAE ERICKSON

Revolve, 2010
H: 5in (12.7cm), W: 11in (28cm),
L: 22in (56cm)
Slip-cast porcelain from hand-carved plaster models, 2264°F (1240°C/cone 6) oxidation

Platter with Vases & Double Volume Bowls, from the *Industrial Hand* Collection, 2008/9
H: 2¼in (5.75cm), W: 6½in (16.5cm),
L: 6½in (16.5cm)
Slip-cast porcelain with black stain from hand-carved plaster models, 2264°F (1240°C/cone 6) oxidation

LEFT
4 Square, 2010
H: 4in (10cm), W: 13in (33cm),
L: 13in (33cm)
Porcelain and wood; slip-cast porcelain from hand-carved plaster models, 2264°F (1240°C/cone 6) oxidation

Introduction to throwing

The act of throwing pots on the pottery wheel is perhaps the image we associate most with ceramics. However, the pottery wheel is a tool just like any other piece of equipment in the studio. It can be used for many tasks beyond making functional wares. For example, thrown cylinders can be cut and used as slabs for handbuilding. Even simple press molds and models can be produced on the pottery wheel.

Learning to throw involves dedication and practice. The ease of the process performed by a master can give beginners an unrealistic expectation of their ability at first. This can be compared to expecting to play a musical instrument proficiently without any experience. With this in mind, remember to take your time and be patient, as this is fundamental to becoming a competent thrower.

Preparation

Before starting, wedge the clay to ensure a homogeneous consistency and to remove air bubbles. Clay is cut and shaped into balls (1lb/450g). A large bowl of water and sponge are required and a selection of tools should be on hand, including a pottery needle, wooden rib or metal kidney, trimming tool, sponge on a stick, and wire cutter. Adopt a comfortable position, brace your elbows into your hips, and rest your arms on the splash pan. This position will help use strength from your whole body.

A "Bailey" wheel fitted with a jigger/jolley arm attachment for producing molded forms

Western potters tend to throw their pieces from individual balls of clay, whereas in Eastern countries such as Japan, it is common for potters to throw single pieces from a large hump

FORMING TECHNIQUES // INTRODUCTION TO THROWING

LEFT
To throw, you will need to prepare a bowl of water, pottery tools, and balls of clay

RIGHT
Centering is considered to be the most challenging part of learning to throw

Assuming the wheel is electric, press the pedal up and down to familiarize yourself with the speed. Electric wheels for Western potters spin counterclockwise; some have the option to spin both ways, which is useful for the left-handed maker. The correct work position is to the right-hand side of the wheel head, allowing the clay to flow freely through the fingers. Use water or slip to lubricate the clay and prevent it from becoming sticky. This motion will eventually become instinctive.

Throwing relies on the principle of centrifugal force. As the wheel rotates, gravity pushes down on the clay, allowing it to be formed into a symmetrical round shape. There are three main steps to accomplish: centering, opening the base, and pulling up the walls. Ultimately, learning how to control and respond to the clay are the most challenging skills to master.

Carina Ciscato (Brazil/UK)
White series of constructed pots, 2009
H: 12½in (32cm)
Porcelain; thrown and altered

Types of wheels

Deciding which type of wheel to use, whether manual or electric, is a matter of personal preference. The most important factor is to be comfortable when working and to have a wheel that suits your needs. Consider where the pottery wheel will be situated in the room and how often you intend to use it. Some wheels are large, like a piece of furniture; others are much smaller and can be stored away when not in use.

Kick wheel

Kick wheels are traditional manually operated machines. They are very simple—usually a wooden or steel frame with a large wheel at the base connected to a smaller wheel situated in a splash pan at the top. The user kicks the base wheel to rotate it: the firmer the kick, the faster the wheel spins. The benefit of kick wheels is that they do not require electricity and are relatively inexpensive to buy. Using this type of wheel does require a certain degree of effort; as a result they are less common, with electric models being the preferred choice.

A treadle wheel at the Leach Pottery, St. Ives, UK

Treadle wheel

A treadle wheel is much the same as a kick wheel in that it is manually operated; however, there is a geared pedal on the base wheel that is levered back and forth. This increases the speed at which the wheel rotates and requires less effort than a standard kick wheel.

A momentum (kick) wheel

FORMING TECHNIQUES // TYPES OF WHEELS

Electric wheel

The advantage of an electric wheel is that it puts less strain on the body and gives the user greater control. There are many different brands and models of electric wheels available. Some models have powerful motors and are ideal for making large pieces. Others are ergonomically designed to make users adopt the best seating position. This is particularly good when batch-producing wares.

A large electric wheel

An electric wheel to suit a smaller space

Special needs wheel

A pottery wheel can be specifically designed for users with special needs. The height of the wheel and splash pan can be adjusted up and down and there is wide access for a wheelchair. Other features include screw-down feet for stability and hand-operated speed control as well as a foot pedal.

A special needs wheel designed to accommodate wheelchair users

Centering step by step

Before the clay is pulled into a shape, it must be centered first, otherwise it will be extremely difficult to control. This process involves your hands and the motion of the wheel to compress the uneven clay into a homogeneous, workable state.

1| Take a ball of clay and slam it into the center of the wheel. Wet your hands and the clay thoroughly.

2| Before the clay can be made into any shape, it has to be centered. To do this, press the pedal down until the wheel is spinning at three-quarter speed. Once comfortable, place your left hand at the bottom left side of the ball and push away from you. At the same time, your right hand should be at the top right side of the ball pulling in toward the center. This can require a lot of physical effort, so keep your elbows locked and your arms on the splash pan to help you stay in control.

3| Cup your hands and gently squeeze the clay upward, allowing it to spiral into a cone shape.

FORMING TECHNIQUES // CENTERING STEP BY STEP

4 | Maintain the position of your left hand but move your right hand to the top of the cone. Compress down until the cone merges into a smooth round shape.

5 | If your hands are too cupped, this can create a mushroom shape, which can trap air in the clay. Allow your hands to flare out as the piece merges and avoid contact between the wheel head and the side of your hand. Repeat the coning process at least three times or until the piece is running true.

6 | Once centered, reduce the wheel speed to a medium pace. Press downward with one finger directly into the center but stop before reaching the bottom.

7 | Maintain the speed. With your right hand, gently pull the clay out to form a wide, flat base.

8 | Stop the wheel and check the thickness by inserting a pottery needle and running your index finger down until it meets the base. When you pull the needle out, the distance between your finger and the end of needle should be no less than ⅜in (1cm). If you are satisfied, the clay is now ready to be made into a form.

Throwing a cylinder step by step

Mastering a cylinder is the key to all thrown shapes. Practice this form over and over; occasionally slice one in half and look at the evenness of the walls. You will soon become proficient enough to progress to more challenging forms.

1 | To make a cylinder, the wheel should be at a slow and steady pace. Ensure the clay is well lubricated with water or slip. Place your left-hand fingers inside the vessel, with your thumb resting on the outside wall.

2 | Curl your right index finger (you can use a piece of sponge) and place it on the outside at the base. Tilt the fingers on your left hand to gently swell out the clay wall. Put your knuckle underneath the swell and apply enough pressure to draw the clay upward.

3 | Move your hands up slowly. If the cylinder becomes wobbly, keep going and maintain control. The clay can easily be knocked off center. Beginners have a tendency to start pulling up the walls slowly but then rush as they get to the top. This will make the pot wobbly and unstable. Continue to pull up the clay until the walls of the vessel are evenly distributed (approximately ⅜in/1cm). It is important to recognize the limits of the clay and to stop before the piece collapses. If the clay becomes tired and unworkable, it is best to remove the piece and start again.

FORMING TECHNIQUES // THROWING A CYLINDER STEP BY STEP

5 | Trim away any excess clay at the base with a pointed tool.

4 | To shape the cylinder, keep your left hand inside the vessel and with your right hand hold a metal kidney or wooden rib upright against the outside wall. The wheel should be spinning at a steady speed.

6 | Use a sponge on a stick to soak up any water inside the vessel.

7 | Stop the wheel and slice the base of the cylinder with a wire cutter. Splash the base with a little water and gently remove the piece from the wheel.

Throwing a bowl step by step

This process is similar to throwing a cylinder, but with some slight differences in how you form the base and finish the piece. Beginners often find that making a bowl is easier than other forms because the clay will naturally flare out as it spins.

1 | First, center the clay. To start, press two fingers of your right hand into the center of the clay to a depth of approximately 3/8in (1cm). Unlike when making a base for a cylinder, rock your fingers gently back and forth across the clay, applying pressure at the same time. The interior of the base should be rounded rather than flat.

2 | Check the depth with a needle tool. A base for a bowl needs to be quite generous—around 1in (2.5cm). This extra clay can later be turned and shaped into a foot ring.

3 | To form the bowl, work to the right-hand side of the clay. Curl your right index finger and place it close to the base.

Tips
- Use a curved rib to swell the inside of the bowl to give a satisfying domed shape.
- Try not to make the base too narrow at this stage, or the clay walls could flop as you pull them up.
- Keep the base quite wide and trim the shape afterward once leather-hard.
- Remember to compress the base with your thumb to prevent an "S" crack from occurring.

FORMING TECHNIQUES // THROWING A BOWL STEP BY STEP

4 | Position your left hand inside, with your thumb resting on the outside of the pot. Apply pressure with your left hand so the clay is forced against your right hand. Use your knuckle to pull the clay up but outward at the same time. Stay in control and don't go too fast.

5 | Use the pads of your fingertips or a wooden rib to define the interior curve of the bowl. Repeat this action until you are satisfied with the profile. Slow down the wheel. Soak up any water inside with the sponge on a stick tool. Trim away any excess clay. Splash with water, wire off, and remove.

6 | Allow the bowl to go leather-hard before turning it upside down to allow the base to dry off ready for trimming (see pp. 119–123).

An example of a bowl is seen before and after it has been trimmed

Throwing a bottle form step by step

Throwing a bottle form involves techniques that shape and reduce the width of the piece. This will challenge your skills because the clay will readily flare out but takes some persuasion to come inward.

1 | Center the clay and create the base in the same manner as making a cylinder. Decrease the speed of the wheel by half. Place your left hand inside the vessel with your thumb resting on the outside. Curl your right-hand index finger and place it at the base. Apply pressure and pull up the wall. Try to keep the shape conical and prevent the sides from flaring out.

2 | To make a bottle form, you need to transfer the weight at the base of the pot to the top in order to apply a technique called "collaring in." The overall thickness of the walls at this stage should be around ¾in (2cm).

3 | To collar in, speed up the wheel. The centrifugal force will help bring the clay toward the middle. Shape your hands as illustrated; hold them against the side of the pot and push upward at the same time. Don't be too forceful, as this will cause the clay to twist.

4 | Collar in a little, then put your left hand back inside, your right knuckle on the outside, and pull up the wall again. This action compresses the wall and prevents the clay from twisting and collapsing in on itself. It also helps draw the clay for the next pull and evens out the thickness.

FORMING TECHNIQUES // THROWING A BOTTLE FORM STEP BY STEP

5 | The rim of the bottle may begin to look very uneven. This happens naturally during the collaring process; the best course of action is to trim away the excess clay and shape the rim with a pottery knife.

6 | Collar in again, followed by compressing the outside wall. Keep repeating this action until you are satisfied with the overall form.

7 | To finish, hold a curved metal kidney against the side of the pot where the curve of the neck begins. Use a straight-edged kidney or wooden rib to shape the sides. Wire and remove from the wheel.

Making a spout
Center the clay and make a wide base. Slow down the wheel and draw up the clay wall. Increase the speed so the wheel is turning very fast. Collar in and then compress and pull the wall up. Keep collaring in until the shape becomes tighter and tighter. The centrifugal force will prevent the spout from spinning out of control. Trim away the top and shape the spout with a curved metal kidney.

When joining the spout to a vessel, slice the base of the spout at a 45-degree angle and attach it to the vessel. This will create a throat to aid pouring.

Creating a pouring lip
Lightly wet your fingers. Spread your index finger and thumb apart by 1in (2.5cm) and position against the rim of the piece. Use the index finger on your other hand to pull the clay forward and downward to create a sharp-edged rim.

Throwing a closed form step by step

A closed form is very versatile. Pieces can be cut, altered, or used as a component in a larger construction.

1 | Center the clay and pull out the base. There are two ways to do this: as a flat base as if making a cylinder, or as a bowl, which is useful if you want to trim the base into an egg-shaped point.

2 | Decide on the shape of the base you would like to make and then pull up the walls in the same manner as if making a cylinder. Taper the walls into a conical shape.

3 | Increase the speed of the wheel and apply the collaring-in technique (see pp. 112–113) to force the shape inward. Be sure to compress the outside and inside of the walls each time.

FORMING TECHNIQUES // THROWING A CLOSED FORM STEP BY STEP

Tip
If the piece is intended to remain as a closed from, a hole is needed to allow the air to escape; otherwise the piece could blow out in the kiln. To do this, insert a pottery needle into a discreet area such as the base. The hole does not have to be very big; a pin-sized hole is usually sufficient.

4 | Collar in tightly until the neck of the form becomes smaller and smaller.

5 | Check the outside shape and look for any signs of twisting. Continue to collar in until the opening is completely closed.

6 | To refine the form, decrease the wheel speed and hold a metal kidney or rib to the right-hand side of the wheel. Compress the surface with a rubber kidney to prevent a crack appearing in the area where the form was closed.

7 | Once leather-hard, the form can be trimmed and shaped (see pp. 119–123).

114 // 115

Throwing a lidded vessel step by step

The container part of the vessel is thrown in the same manner as a cylinder, and a gallery is formed to carry the lid.

Making an inside gallery
This type of gallery provides an internal location for the lid.

1 | Use a pottery knife to level the top of the container. The rim should be no less than ⅜in (1cm) thick.

2 | Maintain a steady wheel speed. Hold the corner tip of a rectangular rib (or an old bank card) directly into the middle of the rim and divide the rim into two halves.

3 | Gradually return the kidney to a 90-degree angle, and the inside half of the rim will split to form the gallery. Use a square sponge to tidy up the edges and remove any water.

Making an outside gallery

An outside gallery is used for vessels where a bowl-type lid is placed over the rim rather than inside it. The previous technique is applied, but the tool is positioned to cut into the exterior wall instead.

Lids

There are numerous ways to make a lid, many of which derive from core shapes. A thrown lid involves careful measuring and precision to ensure a good fit. Lids are usually made upside down and require trimming afterward to clarify the profile. Therefore, it is always worth making a few spares in case something should happen. A set of calipers is useful for measuring first the internal diameter of the gallery and then the diameter of the hole as shown.

A good tip is to make the lid and container at around the same time, otherwise they will be at different drying stages and the shrinkage rate will affect the measurements.

If making a batch run, a handmade gauge indicating the interior and exterior measurements of the gallery will ensure a uniform size; this saves having to make individual lids for each piece.

Making a lid

Cup lid
A cup lid is intended to sit over the rim in conjunction with an exterior gallery. It can be made to sit flush with the container walls or be a feature in its own right.

Bowl/inset lid
A bowl/inset lid fits inside the rim on an interior gallery. It is a simple lid to make and functions very well. It is thrown as a bowl form and turned into shape when leather-hard.

Double inset lid
A more challenging type of lid to make, the lid is started as a bowl and then collared in to make a secondary throat. This type of lid is commonly used for functional pieces where it is imperative that the lid does not fall out as the pot is tipped, such as a tea or coffee pot.

FORMING TECHNIQUES // TRIMMING STEP BY STEP

Trimming step by step

Trimming (in relation to throwing) is a finishing process that involves trimming excess clay with a sharp-edged tool to alter and define a form, or simply as a matter of tidying up. It has to be done at the leather-hard stage when the clay is firm and can be cut cleanly. Too dry and the trimmings will spray into shards and create harmful dust; too soft and the clay will smudge and clog up the tool.

Centering the piece

The piece must be recentered before it can be trimmed, otherwise the thickness of the clay walls will become uneven. To do this, turn the piece over with the rim facing down onto the wheel head. Some wheel heads have concentric circles marked on them to act as a guide.

The form is ready for trimming when you can tear a piece of clay from the base without it smearing

You can draw guide circles directly onto the rotating wheel head with a marker pen

Centering the piece: methods

Rotate the wheel at a steady speed and observe the piece; it should be running true. It is quite likely that it will need further adjustment. Here are a few helpful tips:

2 | A gentle tap with your right hand against the pot as it turns can knock it into center with the help of centrifugal force, although this technique may take some practice.

3 | Restart the wheel. Position either a trimming loop or a pointed tool to the right-hand side of the piece. Remove the flange of clay at the top first before trimming the exterior.

1 | Rest your index finger against the piece as it turns. The pot should make contact with your finger throughout a rotation. If there are gaps or your finger is pushed, this is an indication that the piece is off-center. Gently maneuver the piece into position until centered.

4 | When centered, carefully position three small wads of clay in a triangular formation around the piece to secure it onto the wheel head.

FORMING TECHNIQUES // TRIMMING STEP BY STEP

Trimming a foot ring
A turned foot ring can provide a visual lift, but it also has a practical function as a location to grip when dipping into glaze. When trimming a foot ring, shape the outer wall first. Score a line to indicate the thickness of the foot and then remove the clay inside the line. Follow the profile of the form through to the underneath so the shape looks continuous.

Trimming a lid
The profile of a lid can be transformed by trimming. Handles and other decorative features can also be directly trimmed into the lid to save time in making an additional part.

When trimming a lid, be careful not to press down too hard, otherwise the lid will flatten. Allow a 2mm tolerance for the glaze between the lid and galley.

Decorative techniques
Trimming can be a very effective way of livening up the surface of a dull form. You could try the sgraffito technique: Paint a layer of slip or oxide over the entire surface of the pot. Allow to dry to a matte sheen and then use a tool to remove areas to reveal the clay body underneath. Alternatively, experiment with marks: As the wheel spins, hold the tool and move it up and down the side of the pot at different speeds.

General advice
- Remember the thickness of the base before you start; it is a classic mistake to go right through and create a hole.
- Wipe the wheel head with a damp sponge if you are having difficulty getting your piece to adhere (be careful not to damage the rim).
- Blunt tools will cause a chattering mark on the surface.
- Place a finger of your left hand on top of the piece to prevent the pot from lifting up.
- Hold the tool steady, as it can catch and gouge out a chunk.
- Work dry; do not use water or your pot will stick.

Using a chuck

Shaping a piece upside down on its rim does have some limitations: For example, how do you trim a bottle form or bowls with delicate edges? To overcome this problem, a thrown support called a chuck is used to hold the piece into position and lift it from the wheel head during trimming.

A chuck can be made by throwing clay directly onto the wheel head and letting it firm to leather-hard. Alternatively, it can be thrown separately on a bat or even be made from bisque.

The shape of the chuck depends on the object you are trimming. A bottle form will need a tall hollow chuck to support the shoulders.

A chuck for a bowl should fit like a plug, while forms that have rounded bases will need a cupped chuck.

FORMING TECHNIQUES // TRIMMING STEP BY STEP

Both the chuck and the piece it is holding will need to be centered. Sponging the rim of the chuck can be enough to secure the piece, but it may need a couple of extra wads of clay for support.

A closed form can be trimmed using a cupped chuck to produce an egg-shaped piece

Pulling a handle step by step

There are numerous ways to make a handle including press molding, extrusion, or rolled coils. Pulling a handle from a piece of clay is a traditional skill to acquire and suits thrown ware because of the handmade quality.

1| Place a bowl of water and wooden board close by. The clay should be malleable but not too soft. Cut a piece you can comfortably grip in your hand. Hold the clay in your left hand and raise your arm up. Squeeze the tip and wet your right hand and the clay thoroughly.

2| Position your right hand around the clay in an oval shape. Your fingers should be curled behind and the thumb facing you. Glide your hand down the clay. This is called a "pull." Try not to apply too much force, or the clay will tear.

3| Turn your hand so your thumb is now behind and the fingers are facing you. Apply water and pull again. Repeat this action, making sure to change the position of your hand each time. You should see the clay beginning to form a long length. Don't worry if the piece looks lumpy or even breaks off—just keep going. Once you are satisfied with the length, lay the strip flat onto a wooden board.

FORMING TECHNIQUES // JOINING A HANDLE STEP BY STEP

Joining a handle step by step

It is very important to join a handle well, especially in places where it will be under a lot of strain. This method was shown to me by Prue Venables (see Artist profile, pp. 130–131); it is very strong, crisp, and contemporary.

1 | Once the pulled strips have firmed, peel one from the board. Use both hands to curve it into a handle shape. Allow the handle to firm a little more so that it maintains its shape when picked up.

2 | Hold the handle against the location point and score it. Cut the ends at a 45-degree angle and crosshatch this area. Apply slip, rework with a needle, and allow this to dry to a matte sheen.

3 | Position the handle. Look at it from all angles to make sure it is straight and level. Compress firmly against the clay wall. A clay prop to support the handle will prevent it from sagging.

4 | Don't be tempted to remove the rough slurry from the join just yet. Allow it to firm to a cheese-like consistency and then use a wooden tool to remove this and leave behind a clean join.

Troubleshooting: throwing

Here are some common problems you may experience when learning to throw and how to overcome them.

Problem	The pot is wobbly	The clay is difficult to work	The clay wall twists	The rim flares out and is difficult to control
Solution	Wobbly pots and uneven rims occur when: 1) the clay ball is not properly centered 2) you rush pulling up the clay walls 3) the wheel is spinning too fast The remedy is to simply practice centering the clay and maintain a steady hand.	First check that your clay is not too soft or too hard. If you have been using the same piece for a while, it is quite likely that the clay has become overworked and tired. The aim is not to spend too long centering so you optimize the full strength of the clay to pull up the walls. Discard or reclaim the clay and start again.	A twist in the clay wall is the result of squeezing or pressing too hard as you draw up the sides. The wall may be too thin to cope with the action. Try not to force the clay, keep your fingers an equal distance apart (around ⅜in/1cm), and make sure the clay is sufficiently lubricated with water or slip.	The wheel going too fast is the main cause. Slow the wheel to a steady pace and apply the collaring-in technique (see pp. 112–113).

FORMING TECHNIQUES // TROUBLESHOOTING: THROWING

Problem	The clay snags and collapses	Making each piece the same size for a batch run	Removing a piece from the wheel without disturbing the form	Cracking in the base during drying or in the firing
Solution	Use more water and lubricate your hands. Some makers prefer to use slip because it provides a barrier between the clay wall and their fingers.	Weigh the clay before you start and use the same weight for each piece. Use callipers and set up a gauge tool if need be. Remember, each thrown pot will differ slightly but that is part of its charm. If you want exact copies of each form, slip casting may be a better option.	Throwing directly onto the wheel head can cause a few problems when it comes to removing thin-walled or large pieces. In theory, clay has a memory, and it should spring back into shape; however, in practice this doesn't always happen. Throwing onto a wooden bat attached to the wheel head allows the piece to be lifted off or onto it without compromising the form. Attach a bat to the wheel by throwing a flat plate of clay directly onto the wheel head and scoring it. Place the bat on top, tap into center, and give it a hard knock to secure it. Some wheel heads come with clips that fit into holes on the bats—excellent for production runs.	An S-shaped crack appearing in the base of a thrown pot is a common fault. To overcome this, compress the base thoroughly with your thumb before you make your first pull. Water left inside the vessel will also cause problems; remove it before you finish.

Gallery: throwing

Sanam Emami (US)
Tulip Vase and Dish, 2010
H: 9in (23cm), W: 8in (20cm)
Porcelain; thrown on potter's wheel, handbuilt, and assembled; silk-screened transfer decoration

BELOW
Jonathan Wade (UK)
Construction no. 12, 2009
H: 7½in (19cm), W: 47¼in (120cm), D: 6in (15cm)
Stoneware; thrown in components, altered and joined to a long base in three sections

The form is inspired by urban landscapes and architecture.

FORMING TECHNIQUES // GALLERY: THROWING

Walter Keeler (UK)
Cut Branch Teapot, 2004
H: 11½in (29cm)
Whieldon-style earthenware;
thrown and assembled

ABOVE
Marie Hermann (Denmark/US)
Stillness in Glorious Wilderness, 2010
H: 4½in (11cm), Dia: 39½in (100cm)
Stoneware; thrown and altered, handbuilt

Matthew Chambers (UK)
Spiral, 2010
H: 16¼in (41cm)
Stoneware clay and body
stain, and metal oxides

Many individual sections of clay
are thrown on the potter's wheel
and constructed in different ways
within an outer shell, building
rhythmical symmetry and beauty
in abstract form.

ABOVE
Louisa Taylor (UK)
Oriole Supper Set, 2010
H: 8¾in (22cm), Dia: 21¾in (55cm)
Porcelain; thrown in sections
and freely assembled

SECTION 3

Glazing and firing techniques

Glazes overview	134	Reduction firing process	175
Glaze recipes—earthenware	138	Gallery: reduction firing	176
Glaze recipes—stoneware	140	Artist profile: Chris Keenan	178
Glaze testing	142	Salt and soda firing overview	180
Preparing glaze	144	Salt and soda firing process	182
Applying glaze	148	Gallery: salt and soda firing	184
Troubleshooting: common glaze faults	152	Artist profile: Robert Winokur	186
Introduction to kilns	154	Wood firing overview	188
Types of kilns	156	Wood firing process	189
Loading the kiln	162	Gallery: wood firing	190
Kiln temperature and kiln programs	164	Artist profile: Janet Mansfield	192
Introduction to firing	166	Raku firing overview	194
Oxidized firing overview	168	Raku firing process	195
Oxidized firing process	169	Gallery: raku firing	196
Gallery: oxidized firing	170	Artist profile: Ashraf Hanna	198
Artist profile: Natasha Daintry	172		
Reduction firing overview	174		

A reference board of red and orange stained glazes

Types of glazes
Glazes can be brought prepared and ready to use from pottery suppliers. Alternatively, the other option is to make your own glaze to a recipe using raw materials. Both methods have their benefits and drawbacks.

Commercial glazes
Commercial glazes offer a broad palette of colors and textural effects. They tend to be very reliable and excellent for brushwork. Commercial glazes can be bought as a powder to which you just add water and sieve, or as pre-made glazes, which you apply directly to the ware. The disadvantage is the cost; commercial glazes can be very expensive. This drawback is arguably outweighed by not having to store and mix your own glazes from raw materials.

Making glazes
Making glazes from raw materials allows for greater experimentation and the potential to create your own individual glazes. It requires skill and confidence, but the process can be very rewarding. By comparison, commercial glazes can sometimes look artificial and lack depth, whereas a glaze mixed from raw materials is likely to have more character. It is also more economical to make your own glazes.

Glaze recipes
Glaze recipes can be researched from sources such as books and the Internet. You can also make your own recipes from scratch, but this is more advanced and requires further reading (refer to the bibliography, p. 278). For glaze mixing directions, see pp. 144–147.

Glaze recipes are usually calculated to add up to 100%; this makes it easier to multiply the recipe to make larger quantities.

There are two ways to read a recipe:

1) Base glaze + oxide amount = 100%
2) Base glaze = 100% + oxide additions

All the glaze recipes in this book follow the second method.

Susan Beiner (Canada)
Synthetic Reality (detail), 2008
Installation: Various sizes, highest 60in (152cm) × 16in (41cm) × 16in (41cm)
Slip-cast porcelain, foam, polyfil, and wood

The artist says her inspiration for this installation was her interest in creating *"a hybridized plastic plant environment where we are challenged by our perceptions of what is authentic and what is not."*

Always stir the glaze mixture well before applying to your work to ensure that all the ingredients are suspended in the liquid

Multiplying quantities of glaze

Typical stoneware 2336°F (1280°C/cone 9) base recipe:

	%	Test amount	× 25 = 5 liters	× 50 = 10 liters
Feldspar	70	= 70g	1400g	3500g
EPK (china clay)	15	= 15g	300g	700g
Whiting	10	= 10g	200g	500g
Flint	5	= 5g	100g	250g
Total =	100%	100g	2000g	5000g

Addition
Copper oxide 1 = 1g 20g 50g

Glaze recipes—earthenware

Earthenware glazes can produce deep, rich colors. The following recipes provide a broad palette range to get you started. Earthenware glazes are fired at temperatures of 1922–2012°F (1050–1100°C/cones 04 and 03).

Safety notice: Please refer to the safety procedures section (pp. 54–57) for information regarding the use of glazes containing lead. Avoid using these on vessels intended for food or drink.

Basic shiny glaze

Ferro 3498 (lead bisilicate)	80%
Whiting	20%

An addition of 3% red iron oxide will produce a rich honey glaze.

Shiny transparent glaze
Excellent over colors, slips, and underglaze decoration.

Ferro 3498 (lead bisilicate)	56%
Ferro 3134 (standard borax frit)	24%
EPK (china clay)	11%
Quartz	7%
Bentonite	2%

Leadless shiny transparent glaze
A good, clear glaze.

Ferro 3134 (standard borax frit)	30%
Colmanite (calcium borate frit)	30%
Spruce Pine 4 (soda feldspar)	20%
EPK (china clay)	10%
Flint	10%

Alkaline shiny glaze
Glossy with crackles.

Ferro 3110 (high alkaline frit)	70%
Cornwall stone (Cornish stone)	25%
Kentucky ball clay (ball clay)	5%

Addition:
2% copper	turquoise
1% cobalt	royal blue
6% iron	pale brown
2.5% manganese	plum

Eggshell matte glaze
Smooth, consistent glaze.

Ferro 3498 (lead bisilicate)	60%
Cornwall stone (Cornish stone)	9%
Whiting	11%
EPK (china clay)	20%

Barium matte glaze
Dry matte, slightly silky to touch.

Barium carbonate	12%
Lithium carbonate	8%
Nepheline syenite	78%
Bentonite	2%

Addition:
6% iron	rust brown
0.75% chrome	acid yellow/green
2.5% manganese dioxide	purple brown
0.75% cobalt carbonate	bright blue
1.5% copper oxide	mottled turquoise blue
3% vanadium	mottled pale yellow

Tin glaze
A bright white glaze, excellent for Maiolica decoration. This technique involves painting oxides or stains directly onto the unfired glazed surface, which melts into the glaze during the firing to produce soft, colorful decoration.

Ferro 3498 (lead bisilicate)	60%
Cornwall stone (Cornish stone)	15%
Ferro 3134 (standard borax frit)	10%
EPK (china clay)	5%
Tin oxide	10%

GLAZING AND FIRING TECHNIQUES // GLAZE RECIPES—EARTHENWARE

Sara Moorhouse (UK)
Tall Yellow Form, 2010
H: 9¾in (25cm), W: 5½in (14cm)
White earthenware, underglaze color and glaze; hand thrown pieces turned and painted on the wheel

Glaze recipes—stoneware

Experiment with oxide and stain additions to these glazes to produce your own unique colors. Additions from any of the earthenware recipes can be used.

The following glazes are oxidized-fired at 2282–2336°F (1250–1280°C/cones 7, 8, and 9).

Basic shiny transparent glaze

Cornwall stone (Cornish stone)	70%
Whiting	20%
EPK (china clay)	10%

Semi-matte glaze

Feldspar/custer (potash feldspar)	60%
Dolomite	20%
EPK (china clay)	20%

Matte/dry glaze

EPK (china clay)	30%
Feldspar/custer (potash feldspar)	30%
Whiting	25%
Flint	15%

Barium glaze
Semi-matte in appearance, mottled texture. Not suitable for domestic ware interiors.

Nepheline syenite	55%
EPK (china clay)	5%
Whiting	12%
Zinc oxide	8%
Barium carbonate	20%

Addition:
Tin oxide	2%

Nickel pink glaze
Textured blue-neon pink.

Nepheline syenite	29%
Barium carbonate	35%
Zinc oxide	13%
EPK (china clay)	7%
Flint	16%

Addition:
Nickel oxide	3%

Rustic red matte glaze
Rich rusty red-brown.

EPK (china clay)	70%
Kentucky ball clay (ball clay)	20%
Whiting	10%

Addition:
Rutile	5%

The following glaze is oxidized-fired at 2264°F (1240°C/cone 6).

Bronze glaze
Very runny glaze; be careful not to over-fire.

Manganese dioxide	70%
Red clay powder	30%

Addition:
Copper oxide	10%

The following glazes are reduction-fired at 2300–2372°F (1260–1300°C/cones 8, 9, and 10).

Shiny transparent glaze

Feldspar/custer (potash feldspar)	30%
Flint	25%
Wollastonite	25%
EPK (china clay)	20%

Tenmoku glaze
Black; toffee-brown when breaks over edges or details.

Cornwall stone (Cornish stone)	70%
Wollastonite	20%
EPK (china clay)	10%

Addition:
Red iron oxide	14%

Celadon glaze
Delicate blue-green.

Feldspar/custer (potash feldspar)	40%
Flint	25%
Whiting	20%
EPK (china clay)	10%
Talc	5%

Addition:
Red iron oxide	1%

Shino glaze
Rich silvery brown-red.

Nepheline syenite	70%
EPK (china clay)	10%
Kentucky ball clay (AT ball clay)	10%
Talc	5%
Bentonite	5%

GLAZING AND FIRING TECHNIQUES // GLAZE RECIPES—STONEWARE

James and Tilla Waters (UK)
Gray/orange lidded jars, 2010
H: 3⅛–6¼in (8–16cm)
Thrown porcelain; colored slips applied to knobs and foot rings at greenware stage; glazed in a glassy gray with a small amount of orange glaze applied to the rims

Glaze testing

Unlike paint or other media, the true color of a glaze does not reveal itself until it has been subjected to intense heat. As a result, it is unwise to glaze a piece on a whim without knowing how it will turn out. This underlines the importance of glaze testing, so you can make considered judgments based on experience. You may even make some discoveries along the way.

Louisa Taylor's glaze reference library in her London studio

Test tiles

Test tiles are little snippets of information; they indicate how the glaze will behave on a certain clay body, at a particular firing temperature, and how it runs and melts into textures. Test tiles don't have to be beautifully made; it is more important that they are relevant to your work. For example, if your work is thrown, make some small pots or cut up a thrown pot into sections. If your work is cast, test only on slip-cast pieces. Ideally, tiles should stand upright in the kiln to reflect how the glaze will behave on a vertical surface. It is useful to include some texture on the surface to see how the glaze responds.

A selection of different shaped test tiles is intended to reflect the type of work the glaze will be applied to

GLAZING AND FIRING TECHNIQUES // GLAZE TESTING

Thrown test tiles made from a wide cylinder, are cut and marked with texture detail

Glaze testing tips
- Test tiles should not be too small; a larger surface area will tell you much more.
- Dip one coat of glaze onto the tile followed by another halfway down. This will tell you how the glaze behaves as a thin or thick application.
- Use a glaze pencil or mixture of iron oxide and water to write on the reverse of the tile.
- Be methodical; keep a notebook and record all the details so you can replicate the results in the future.
- Create a labeling system so you can identify the tests easily. Eventually you will build up a library of glazes for reference.

Glaze testing methods
Weigh out 3½oz (100g) of your chosen base glaze recipe and decide on an oxide (for example, copper oxide) to experiment with.

A simple line blend
Mix up your base glaze and add your first quantity of oxide. Remix, sieve, and apply to the glaze tile. Add the same quantity again and repeat the process until you have completed all your tests. This method is effective for analyzing the behavior of an oxide in a recipe.

Bi-axel blend
A bi-axel blend involves combining two different glazes to make a hybrid glaze that offers the best attributes of both.

Select two glazes from within the same firing temperature. We shall refer to them as glaze A and glaze B. Line up a row of 11 test tiles and glaze two of the tiles, one with glaze A and the other with glaze B. For the remaining 9 tiles, imagine that there is a dividing line; the top row of numbers ascend from 1 to 9, while on the bottom row they descend from 9 to 1. This refers to the parts ratio. For example:

Test 1) 1 part glaze A : 9 parts glaze B
Test 2) 2 parts glaze A : 8 parts Glaze B

Use a fixed unit of measurement, for example a teaspoon, to measure a part. Add the relevant amount to a container, mix and apply to a test tile, and then label the test tile. Continue in this way until all nine tests are completed.

Line blend basic

| 0% | 0.5% | 1% | 1.5% | 2% |

Glaze A	1	2	3	4	5	6	7	8	9	Glaze B
	9	8	7	6	5	4	3	2	1	

e.g. Test 1 / 1 part glaze A, 9 parts glaze B

142 // 143

Preparing glaze

Be organized and methodical when preparing a glaze. Make sure you have everything ready and tick off the weighed ingredients as you go down the recipe to avoid mistakes.

Weighing out a glaze

Weighing out a glaze recipe involves good working practice. An ideal situation would be to have an extraction unit as shown, but this is not always possible in a small-scale studio environment. In this case, make sure you are in a well-ventilated room and always wear a dust mask. The most important piece of equipment for this task is a good scale, be it a triple beam scale or digital scale. Digital scales are very accurate, and you do not need to spend a lot of money on a specialist set. It is useful to have two sets: one for weighing out large quantities of raw materials; the other for smaller, more precise amounts, as required for oxides and stains.

Before weighing out, make sure you have all the materials you need for the recipe and place them in your work area. You will need a sufficient size bowl to go on top of the scale (zero the scale before adding materials), and a plastic bucket or bowl to contain the weighed dry materials. This container should be half-filled with water to help prevent particles from dispersing into the air as the powder is tipped into it.

Use a plastic scoop to weigh each material one by one. When you have the correct amount, transfer them into the bowl. Work cleanly to avoid cross-contamination of powders.

When the recipe is complete, add more water to just above the level of the powder. Some raw materials can be quite bulky, so break up any lumps to make them easier to process through the sieve. Let the mixture soak for at least 10 minutes to fully saturate the particles.

RIGHT
A plastic scoop, a scale with a small container, and a large bucket filled with water are required for this task

FAR RIGHT
A digital scale that can weigh to 0.01 of a gram is used for weighing precise quantities of oxides or other materials

GLAZING AND FIRING TECHNIQUES // PREPARING GLAZE

Ceramic materials are weighed out underneath an extraction unit and with the artist wearing a dust mask

A plastic milk container can be made into an excellent scoop by cutting the base away, as demonstrated here

Mixing the glaze

You will need to have two wooden slats, a sieve, a rubber kidney/brush/spoon, and latex gloves.

Sieving glaze blends the raw materials together and removes impurities. A pottery sieve is usually made from wood and has a mesh in the base that is available in different grades. Earthenware glazes require a finer mesh of 100–120. Stoneware glazes can be poured through a wider mesh of 80–100.

Place two wooden slats followed by the sieve on top of the empty container. Stir the mixture and pour into the sieve. This may have to be completed in stages if the raw materials are quite solid. Compress the materials through the sieve using either a rubber kidney, thick brush, or a spoon. Ensure that everything goes through or this could unbalance the recipe. Add a little more water if the mixture becomes thick.

Once the glaze has gone through, tap the sieve on the bucket rim to loosen any glaze underneath. Sieve the glaze at least two or three times to ensure that it is thoroughly mixed. Colorful glazes will become more enhanced if you pass them through an extra-fine mesh of 120 on the final sieving.

Transfer the mixed glaze to a suitable lidded container. Label the side of the bucket and the lid with a description of the glaze. It can also be useful to attach a sample tile to the bucket as a reference.

The glaze is worked through a sieve using a rubber kidney

The glaze is stored in a strong lidded container. It is labeled and has a reference tile attached to the handle

GLAZING AND FIRING TECHNIQUES // PREPARING GLAZE

Glaze consistency

Getting the consistency of the glaze correct depends on how much water you add. Too much water and the fired glaze will appear thin and dry. Too little water will result in a thick glaze that will cause all sorts of technical problems. There is no set water-to-powder ratio, as some raw materials absorb more water than others. However, general advice would be 2.2lb (1kg) of dry powder to 2.6pt (1.25l) of water. If you have added too much water to the glaze, wait for the materials to settle (this may take a few hours) and then siphon off the excess.

Guidelines on glazes

Earthenware glaze = consistency of milk.

Earthenware glazes should be relatively thin but not watery. The ideal thickness of the glaze when it has been absorbed into the bisque ware is around 0.5mm. Any painted detail on the surface of the ware should just be visible through the glaze once it has dried.

Stoneware glaze = consistency of cream.

Stoneware glaze needs to be slightly thicker than earthenware. Once applied to the bisque ware, the glaze layer should be around 1mm thick.

You can check the thickness by using a "drag test"; that is, by scratching a pottery needle in a discreet area of the piece, as shown left. There should be sufficient drag in the line to help you gauge how thick the glaze layer is. This mark can then be rubbed over with a fingertip

146 // 147

Applying glaze

Glaze is best applied to dry bisque, although many glazes are suitable to be used on raw, unfired clay. The surface of the piece should be clean and free of dust. Thoroughly mix and stir your glaze before application.

Pouring

Pouring and dipping are the most accessible methods of applying glazes to use in a studio environment. The interior of a vessel is usually poured and the outside dipped.

1 | Pour glaze inside to just below the rim and then swiftly tip it out. This has to be a quick motion; turning the vessel as you pour out will ensure that the glaze covers the whole interior.

2 | Hold the vessel upside down until the glaze has been absorbed. Wipe away any drips and spills.

It is advisable to wait a while before glazing the outside. This applies especially to thin-walled or slip-cast pieces because they are prone to damp patches seeping through. In that case, they have to be completely dry before you can attempt to glaze the outside.

If the piece is too large to dip or you only have a small amount of glaze, the outside can be poured; this has to be done with confidence, otherwise any overlap in glaze will show. There is potential for this to be used as a feature—overlapping a matt glaze over a shiny glaze is a good example.

3 | Turn the piece upside down and place a support underneath to lift the rim. Solid forms that have no interior can be lifted up on props. Pour the glaze from a jug, allowing the liquid to flow over the piece until all the surface area has been covered.

GLAZING AND FIRING TECHNIQUES // APPLYING GLAZE

Dipping the piece into
the glaze using tongs

Dipping

Once the interior has been poured, the outside can be dipped. It is also possible to glaze a piece all over by submerging it completely in the glaze. Dipping can be done by hand, but glazing tongs are useful for pieces that are awkward to grip.

Hold the piece by the base and plunge it vertically into the container. The interior of the vessel will provide a vacuum and prevent the glaze from going inside. Remove after a few seconds, twist, and flick off any remaining drips of glaze. Wait until the glaze has been absorbed and then turn over and place back on the table.

The foot ring on this bowl provides
a useful area to grip the piece and
dip into the glaze

Other methods of dipping

Here are some other methods of dipping to try. These different techniques will enable you to adapt your skills to suit the requirements of your work and achieve a successful glaze application.

Hold the base by the thumb while your index finger grips the rim. A dab of glaze can be applied afterward to cover the gap.

Hold a pottery needle on the inside, with your thumb on the base, and submerge the whole piece. The needle grips the piece without leaving an unsightly mark on the rim.

Wax-resist the base. Make a fist and place your hand inside the vessel. Flare out your fingers, grip the inside, and dip the piece into the glaze. This is a useful way to achieve a different color on the outside than is on the inside.

Painting

Painting is not a recommended method for applying glaze all over the surface, as it can appear patchy when fired (although commercial glazes tend to be more forgiving). This technique is useful if you intend to have a painterly feel to your work, such as large brushstrokes or gestural marks. Use a thick, soft brush to apply the glaze. Build up several layers of glaze, letting each one dry in between coats. You could experiment with painting glaze underneath or on top of a base coat. See which aesthetic you prefer, as the results will differ.

GLAZING AND FIRING TECHNIQUES // APPLYING GLAZE

Spraying

Spraying glaze is a very effective method to cover large-scale pieces that would be impossible to dip or pour. It requires a spray-booth unit with extraction, a compressor, and a gravity-feed spray gun. These are costly items, but well worth the investment. You could improvise with handmade tools such as a garden sprayer, but the quality is not comparable. You will also need a banding wheel, wooden bat, sponge, pottery needle, and a jug of glaze.

Tip
Remember to wipe the bases clean of glaze before you load the kiln otherwise your work will stick to the shelf.

1 First, if the piece is high-sided or has an interior space, it is advisable to pour the glaze inside rather than spraying it. Once the interior has dried, place the piece on a wooden bat and put on the banding wheel. Fill the container on the spray gun with glaze. A spray gun is powered by compressed air; press the gun handle a few times to check the pressure of the spray before you start.

2 Place one hand on the banding wheel and hold the spray gun in the other at a distance of at least 8in (20cm) from the piece, otherwise the glaze will pool and drip. Press the handle and move the spray gun side to side and diagonally. Keep turning the piece on the banding wheel to ensure an even coat of glaze. Pulse the trigger from time to time to prevent heavy particles in the glaze from blocking the gun nozzle.

3 A disadvantage to spraying is that it can be difficult to judge the overall thickness of the glaze. Check by using the drag test (see p. 147). If unsure, spray the glaze all over one last time.

Wax resist is applied as a liquid to bisque. Once dry, it acts as a waterproof barrier. It can be used in conjunction with decorative techniques or for simply keeping an area free of glaze (such as a foot ring or galley)

Troubleshooting: common glaze faults

Technical faults are often caused by a simple misjudgment of the glaze thickness, but listed below are other types of glaze faults and how to resolve them.

Bloating
Swelling and blisters in the clay body. The common cause for this fault is poor preparation of the clay body. Any trapped air beneath the surface of the clay will expand during the firing and create a raised bump. It can also be caused if the firing is too rapid, as this prevents the gases from escaping gradually.

Blistering or bubbling
Craters and bubbles on a glaze surface. This is an indication that the glaze has over-fired and boiled. It is a difficult fault to remedy because the problem is often exacerbated if refired. Lower the firing temperature the next time you use the glaze, or check that your kiln is not over-firing by inserting a pyrometric witness cone.

Crawling
This problem occurs when glaze pools into droplets or globules, exposing the clay body underneath. This is often caused by excessive handling of the bisque, as well as dust, grease, or applying the glaze too thick. Before glazing, wipe the piece clean with a damp sponge and store in a dust-free area. Make sure hands are clean and free of grease before handling. Small areas of crawling can be made good by filling with glaze and refiring.

Crazing
This can be intentional or unintentional. Unintentional crazing is recognized as a network of fine cracks in a glaze and occurs when there is greater contraction in the body than the glaze. Opening the kiln above 212°F (100°C) can put the work at risk. Intentional crazing is known as crackle effect and is a decorative feature commonly seen in raku (see image opposite).

Dunting
This refers to the cracking of fired objects during cooling. The main causes of dunting are two critical points when silica inversions take place: 1067–1022°F (575–550°C) and 437°F (225°C). Dunting occurs when the cooling is uneven or too fast at these points.

Pinholing
This fault causes a series of small holes or pits in the fired glaze surface. This can have one of several causes: dust; the bisque being underfired; a thick glaze application; or escaping gases. Pinholing can worsen if the piece is refired, but minor flaws can be treated by painting with glaze. Allow the piece to dry and then rub away the excess so that the glaze just fills the holes. A longer soak of 40–60 minutes during bisque will burn off any organic matter present in the clay and can help prevent pinholing occurring.

Check that your glaze thickness is correct

Clean your bisque ware with a damp sponge prior to glazing to remove dust and dirt

Incorrect kiln temperature can cause many technical faults including blistering, dryness, and pinholing

GLAZING AND FIRING TECHNIQUES // TROUBLESHOOTING: COMMON GLAZE FAULTS

Kate Schuricht (UK)
Detail of raku oval
containers, 2008
Slip-cast raku body with white,
clear, and turquoise raku glazes;
linen tread and bead binding for lids

The crackle effect is an intentional
decorative feature of raku.

152 // 153

Introduction to kilns

There are many external factors and variables to control in ceramics; therefore, a good, reliable kiln is an invaluable asset to the ceramicist. It is vital to the quality and consistency of the work, which leads to increased productivity.

The most common type of kiln is an electric kiln. They are relatively straightforward to operate and ideal for beginners and professionals alike. Reduction kilns can also suit a studio environment with a gas or oil supply. Wood and salt or soda kilns are more involved and require a level of skill to operate. It can be tiring work, but the excitement and thrill of the process is very addictive.

When purchasing a kiln consider the following points:

- Type of firing: e.g., oxidized, reduction
- Your temperature requirements. If you mainly high-fire, check the kiln is capable of reaching those temperatures
- The chamber size. It is wise to buy a kiln slightly bigger than you need
- Suitable electrical supply. Large electric kilns require a greater power feed, whereas small kilns can be powered by a domestic supply
- The size of the space where you intend to locate the kiln
- Energy consumption and environmental impact

Kiln maintenance

Maintaining and servicing a kiln regularly should be a top priority. It is an important piece of equipment that underpins a ceramics business. A well-maintained kiln can easily be in service for at least 10 if not 20 years. High firing temperatures will inevitably cause more wear and tear on a kiln, but changing elements regularly or repairing brickwork will prolong its use.

A small electric kiln that can be plugged into a standard electrical outlet is ideal for beginners

GLAZING AND FIRING TECHNIQUES // INTRODUCTION TO KILNS

Some general tips on kilns

- A kiln should be located at least 12in (30cm) away from a wall.
- Vacuum the chamber and remove any debris from previous firings.
- Check the interior bricks regularly for signs of damage and repair any superficial cracks.
- Try not to move a kiln too often; keep it in one location.
- For an electric kiln, do not keep plugging and unplugging it from the socket as this will cause damage to the pins.
- Elements can be tested by inserting strips of paper in between each one, turning on the power, and checking to see if all the strips have been scorched.
- For a gas kiln, clean and service the burners regularly to maintain maximum efficiency.

This gas-fueled reduction kiln was built on-site in a pottery in rural Lincolnshire, UK. It is more than 30 years old and is still being used today

Types of kilns

A kiln is essentially an insulated chamber to contain heat. For centuries, the design of the ceramic kiln has been developed to achieve specific desirable aesthetics. As a result, some kilns are known by the name of the ware they fire. The type of kiln you use to create your work will have a direct impact on the final outcome.

Electric kiln
Electric kilns are the most recent in terms of kiln design. They were developed in the twentieth century as a clean alternative to burning fuels. Electric kilns produce radiant heat rather than combustion. The convenience and ease of the electric kiln soon made it the favored choice for educational institutes, studio practices, and industry. There are two main types of electric kiln: front loaders and top loaders.

Front loader
A front-loading kiln is one accessed at the front via a door that either opens outward or slides upward. They tend to be easier to load and better insulated.

GLAZING AND FIRING TECHNIQUES // TYPES OF KILNS

Car kiln
A car kiln is much the same as a front-loading kiln (see p. 156), with the difference that the floor of the kiln can be rolled out on wheels. This makes packing and unloading the kiln much easier, especially when maneuvering large or fragile work.

Top loader
A top-loading kiln opens at the top with a lid. The work is loaded into the kiln vertically. This is ideal for small pieces but less practical for large work.

156 // 157

Tunnel kilns

A tunnel kiln is a very efficient method of firing used in industry to produce large quantities of wares. The kiln chamber can be very long, up to 164–230ft (50–70m). It consists of three major zones: preheating, firing, and cooling. The center (firing) section remains at top temperature. A train of cars packed with the wares move through the kiln at a very slow pace and is processed through the complete firing cycle. The advantage of this conveyor-type system is that as a car exits the kiln there is another one entering it, which is very economical and productive.

Gas kiln

The advantage of a gas firing compared to electric is greater control over the atmosphere in the kiln, be it oxidized, neutral, or reduction. This in turn has an impact on the color of the glaze and the clay body. The firing cycle is also much faster. Gas is a clean and controllable fuel compared to wood or oil. The kiln can use natural gas from a local utility or bottled gas (propane, butane, or liquid petroleum gas). A degree of skill and knowledge is required to operate the kiln, but modern gas kilns can be controlled by an automated system.

Anagama kiln

An anagama kiln is a traditional wood-fired climbing kiln, thought to have originated from Japan (via China and Korea) during the fifth century. A climbing kiln consists of a long chamber built up a slope, with the firebox at the bottom, chimney at the top, and additional stoking ports at spaced intervals at the side of the kiln. Building a kiln up a slope produces a natural through-draft, essential for temperature increase. Firing this type of kiln is very labor-intensive; with numerous variables to control, firing times are not a given, ranging from 24 hours to many days.

UK-based potter Nic Collins firing his wood-fueled anagama kiln

GLAZING AND FIRING TECHNIQUES // TYPES OF KILNS

Noborigama kiln
A noborigama kiln is similar to an anagama kiln (see p. 158) in principle, the main difference being that the noborigama is a multichamber kiln rather than a singular chamber. A noborigama kiln is deemed to be more efficient because the preceding chamber heats the next; therefore the firing is quicker and requires less fuel.

An anagama kiln amid many other kilns on-site at Janet Mansfield's studio in Gulgong, New South Wales, Australia. The kiln is built on an incline in order to draw air through the chamber

158 // 159

Catenary arch kiln

A catenary arch refers to the curve formed by a chain or cable when held from two equidistant points. When inverted, the arch is self-supporting and extremely strong because all the weight is transferred to the base. This principle lends itself very well to the shape of a kiln chamber, because it is able to cope with the forces and strains of a firing without the need for extra support. Outdoor high-temperature kilns such as wood-fired or salt kilns generally have a catenary arch construction.

A catenary arch kiln at the Leach Pottery, St. Ives, in the UK

GLAZING AND FIRING TECHNIQUES // TYPES OF KILNS

Top-hat kiln

A top-hat kiln is a clever design where an open-based kiln is supported in a frame and can be raised and lowered separately from the kiln floor. Top-hat kilns are typically electric but can be adapted to suit raku firing, where good access to the work is advantageous.

Raku kiln

A raku kiln is basic; usually an insulated firing chamber and a porthole for the gas burner. Bottled gas (propane) is considered to be the most convenient means to heat the kiln, although other combustible fuels can be used. Small electric kilns also lend themselves well to the job. Raku kilns range from small to medium in size but can be built specifically for a larger piece. A smaller kiln will take less time to heat up as well as being more accessible when removing the glowing pieces with tongs.

Pit fires

Pit fires are a very simple method to fire clay from raw to soft bisque as well as creating unique surface effects. A pit around 3ft 3in (1m) wide and 1ft 6in (50cm) deep is dug into the ground. This protects the firing from wind and helps retain heat. The bed is lined with coals, which are ignited and left to radiate. A layer of straw, sawdust, and even dry manure is applied on top. Once smoldering, the wares are placed on the bed and covered with more combustible material. The temperature inside the pit can easily reach 1832°F (1000°C). Pockets of reduction and oxidization occur that can produce iridescent lusters and copper reds on glazed wares. Unglazed pieces painted with slip and burnished capture the fumes, creating swirly smoke flashes.

Loading the kiln

Loading a kiln correctly is crucial to ensure the firing quality and to minimize wear and tear on the kiln. Pieces for bisque can be stacked or placed inside each other to make efficient use of space. Glazed ware pieces should not touch and require a ½in (13mm) gap. If a piece is wide or large, place it in the middle of the shelf so heat is evenly distributed from all sides.

1 | Before the kiln is packed, vacuum inside to remove any debris and dust from the previous firing. Check the kiln shelves for cracks or fired drips of glaze. These can be removed with either a chisel or grinder; eye protection is essential. If any large cracks are found, it is advisable not use the shelf, especially for high-temperature firings.

2 | Once satisfied with the shelf, paint with a kiln wash solution (50% china clay, 50% calcined alumina and water) to minimize damage should any glaze run onto the surface.

3 | Before loading the first shelf, position three to six shallow kiln posts around the floor of the kiln. A gap of 1¼in (3cm) between the floor and shelf is required because the kiln bricks expand and contract with heat. In addition, some kilns have elements in the floor and require good airflow to let the heat circulate.

GLAZING AND FIRING TECHNIQUES // LOADING THE KILN

4 | A kiln shelf can then be placed on top; check that it is sturdy and does not rock. Take care when lifting kiln shelves, as they can be heavy and awkward to load into the kiln. Place your hands at the top and bottom of the shelf rather than at the sides. Tilt the shelf slightly upward and gently load into the kiln. Be careful not to scrape the kiln wall with the shelf, as the soft brick can damage easily. There should be at least a ¾in (2cm) gap between the wall and shelf.

5 | Plan ahead; shorter items should be put in first at the bottom, then medium-size, and finally large items at the top. Ensure there is a 1in (2.5cm) gap between the objects and kiln elements. Once the shelf is full, place three kiln posts in a triangular formation: one at the back in the center, and two in the front corners. Kiln posts should be of even height and at least ⅜in (1cm) taller than the highest piece. The next set holding the shelf above should be directly in line with the posts underneath.

6 | Repeat steps 4 and 5 until the kiln is loaded and is ready to be switched on.

Kiln temperature and kiln programs

Ceramic materials are very sensitive to specific temperatures. A difference in temperature of only 70°F or so could have a dramatic effect on the outcome of your work.

Checking the kiln temperature

Checking the temperature can be as easy as taking a reading from the digital controller during the firing. However, it is important to have an understanding of what the reading means in case there is a problem. Keep a record of the previous firings. For example, a slow firing could indicate that the elements need changing or there is a fault with the kiln itself. When using a digital controller, it is always wise to put in a pyrometric cone to act as a backup and record the temperature should the firing fail.

Other ways of checking the temperature include taking a reading from the pyrometric cones inside the kiln (see p. 49) or by inserting a pyrometer probe into the spy hole of the kiln and taking a reading off a meter. These methods are more commonly used for large outdoor-type kilns.

Opposite are some general kiln firing programs. A programmable section is referred to as a "ramp," which tells the kiln when to increase supply of power over a calculated period of time. Each kiln will behave slightly differently, and the expansion and contraction of the clay body can affect the firing, so you may have to adjust the program accordingly.

Bisque firing programs

The first ramp of a bisque firing should be slow to allow the water content in the clay to be driven off, thereby preventing a blowout.

High bisque and low bisque
High bisque: 1976–2048°F (1080–1120°C/cone 03–02)
Low bisque: 1832–1904°F (1000–1060°C/cone 06–04)

Ramp 1: 140°F (60°C) per hour to 1112°F (600°C)
Ramp 2: 248°F (120°C) per hour to top temperature (e.g., 2048°F/1120°C/cone 02)
Soak: 15–20 minutes

Porcelain
Soaking porcelain for one hour will burn out any organic materials that could cause pinholing and other glaze faults.

Ramp 1: 140°F (60°C) per hour to 1112°F (600°C)
Ramp 2: 248°F (120°C) per hour to 1778°F (970°C/cone 07)
Soak: 1 hour

Bone china
Bone china requires a very high bisque at stoneware temperatures. A long soak will give bone china a beautiful translucency.

Ramp 1: 140°F (60°C) per hour to 1112°F (600°C)
Ramp 2: 248°F (120°C) per hour to 2264°F (1240°C/cone 6)
Soak: 60–90 minutes

Large, thick, or wide pieces
Firings must be very slow to allow the piece to heat evenly throughout. An addition of a cooling ramp can help prevent the piece from cracking.

Ramp 1: 50–86°F (10–30°C) per hour to 392°F (200°C)
Ramp 2: 104°F (40°C) per hour to 752°F (400°C)
Ramp 3: 140°F (60°C) per hour to 1112°F (600°C)
Ramp 4: 176–212°F (80–100°C) per hour to top temp. (e.g., 1868°F/1020°C/cone 05)
Soak: 30–50 minutes

Oxidized glaze firing program

Earthenware and stoneware
Earthenware: 1922–2102°F (1050–1150°C/cone 05–1)
Stoneware: 2192–2372°F (1200–1300°C/cone 5–10)

The same ramp sequence for both temperature points can be used, with the alteration of the final top temperature.

Ramp 1: 176°F (80°C) per hour to 1112°F (600°C)
Ramp 2: 257°F (125°C) per hour to top temperature
Soak: 10–15 minutes

Reduction
The temperature can climb steadily, but reduction should not begin until the kiln has reached 1652°F (900°C).

Ramp 1: 176°F (80°C) per hour to 1112°F (600°C)
Ramp 2: 266°F (130°C) per hour to 1652°F (900°C)
Begin reduction
Ramp 3: full power to 2336/2372°F (1280/1300°C/cone 9–10)
Soak: 15–30 minutes

A collection of pots made by Louisa Taylor, fired to 2336°F (1280°C/cone 9) in an electric kiln

Introduction to firing

Firing is an irreversible process that involves applying heat to convert soft, brittle clay to hard ceramic. This change is effected by a chemical reaction—quartz inversion—that occurs at 1063°F (573°C). The silica in the body undergoes a change in volume when the bound water content in the crystal structure is driven off. The final aim of firing is to bring the clay or glaze to a point of maturity.

In theory, clay can be glazed and fired from green ware in one process. However, in practice there is need for an in-between stage called bisque (or biscuit). This renders the ware strong enough to be handled while remaining porous enough to accept glaze.

Bisque teapots waiting to be glazed, made by Louisa Taylor

From clay to bisque

The clay goes through five important temperature points during a bisque firing:

1) 68–248°F (20–120°C)—water content driven off; known as water smoking
2) 392°F (200°C)—disintegration of organic matter
3) 1063°F (573°C)—quartz inversion
4) 1292°F (700°C)—burning out of sulfates and carbon
5) 1472°F (800°C)—vitrification begins

It is important that the first temperature rise to 1112°F (600°C) is slow to allow the water to be driven off gradually. If heated too quickly, it will turn into steam and can cause the clay to blow out. A kiln will usually have an opening at the top or side for vapor to escape. This should remain open until at least 392°F (200°C) before inserting the brick/stopper.

The temperature at which you fire your bisque is also important. Earthenware is a porous material and requires a high bisque to make it less absorbent. This is followed by a lower-temperature glaze. Stoneware temperatures are much higher, and the clay and glaze will mature together. Therefore the clay requires only a low bisque.

GLAZING AND FIRING TECHNIQUES // INTRODUCTION TO FIRING

From bisque to glaze

Once glazed and packed into the kiln, the first climb of the firing to 212°F (100°C) involves drying off the pieces, expelling water out of the glaze. At around 1472°F (800°C), the glaze materials begin to soften and melt. The clay body continues to vitrify until it has fused with the glaze.

Soaking

Soaking is the term used to refer to holding a kiln at a specific temperature for a given period of time. This helps the temperature in the kiln even out and allows the clay and glaze to mature fully. It is good to soak during bisque to ensure that any organic matter is burned off.

RIGHT
A piece by UK ceramicist Katharine Morling is supported with clay props to prevent it from sagging and cracking during the bisque firing

BELOW
A batch of tableware made by Louisa Taylor is ready to be taken out of the kiln after a 2336°F (1280°C) glaze firing

Guidelines on firing

Earthenware is fired to:

high bisque +	low glaze
2048–2156°F	1940–2012°F
(1120–1180°C/cones 02 & 04)	(1060–1100°C/cones 04 & 03)

Stoneware is fired to:

low bisque +	high glaze
1652–1976°F	2300–2336°F
(900–1080°C/cones 010 & 04)	(1260–1280°C/cones 8 & 9)

Tips
- Cooling should never be rushed. Be patient and allow the kiln to cool to below 176°F (80°C) before you open it.
- You can refire a piece many times. This is especially useful if you intend to build up layers of glaze or rework areas.
- Earthenware pieces should be glazed all over and fired on a stilt to seal them; otherwise the glaze will craze over time and seep.
- Make clay props to support work during the firing.

Oxidized firing overview

Oxidized firing (also known as oxidation firing) refers to a kiln atmosphere where oxygen is present throughout the firing. This type of firing is good for producing consistent, predictable glazes and straddles low and high temperature points.

An electric kiln by nature produces an oxidized atmosphere because oxygen is present in the chamber throughout the firing. A good supply of air will ensure an even firing and prevent bloating of the clay body. Oxidization is not exclusive to electric kilns. Kilns powered by gas or other means can be used for oxidization for a bisque or glaze, although this requires some skill to control. Even so, a reduction firing will still need to be part-oxidized to burn off the carbon before reduction can begin at 1652°F (900°C).

Oxidized firings can offer a wide spectrum of colors, varying from bright "pop" colors to subtle tones. Results tend to be more consistent than other firing methods, and the convenience of the electric kiln makes this type of firing very appealing to the ceramicist. Oxidized firings suit small-scale studio practices because they are relatively straightforward to operate and have fewer variables to control.

Dylan Bowen (UK)
Thrown Form, 2010
H: 10in (25cm) × W: 6in (15cm)
Earthenware, thrown on the wheel, marked, cut, and squashed; slip-decorated and glazed with clear and honey glazes

Oxidized firing process

Listed below are a few examples of ways to conduct an oxidized firing.

Electric kilns
Electricity is supplied to the elements of the kiln, which radiate heat and increase the temperature. Oxidized firings in an electric kiln are the simplest to perform, but depend on your equipment.

Manual kilns/kiln sitter
A pyrometric bar of the desired firing temperature is inserted horizontally into a triangular prong inside the kiln. When the kiln has reached the required temperature, the bar will melt and trigger the kiln to switch off.

Some older kilns have a dial called a "sunvic" that requires the user to turn the dial manually to increase the electrical input. Pyrometric cones are used to ascertain when the kiln has reached temperature.

Using a controller
A kiln controller is a very useful piece of equipment that means you do not have to be present during the firing. The controller is programmed and switched on. Time delays, multi-ramps, and soaks can all be programmed to give the user flexibility and control.

Oxidization in a fueled kiln
To perform an oxidized firing in a fueled kiln (gas, wood, or oil), keep the chimney damper completely open throughout the firing. Additional oxygen may have to be fed into the chamber to prevent a reduction atmosphere occurring.

Bonnie Seeman (US)
Pitcher and Tray, 2008
H: 10in (25cm), W: 14in (36cm), D: 8in (20cm),
Porcelain and glass, wheel thrown, altered, and handbuilt; oxidized fired to cone 10

Katharine Morling (UK)
Poison Pen, 2010
W: 19¾in (50cm)
Porcelain, slab built and handbuilt; line drawing with black stain

Gallery: oxidized firing

Louisa Taylor (UK)
Two-tone condiment jars with porcelain spoons, 2010
H: 8in (20cm), Dia: 3⅛in (8cm); spoon L: 6in (15cm)
Thrown porcelain, overlap in two different glazes

The spoon was pulled and shaped by hand and then polished smooth.

Wendy Walgate (Canada)
White Mantle, 2010
H: 13in (33cm), W: 24in (61cm), D: 6in (15cm)
White earthenware, slip cast and assembled; fired to 1868°F (1020°C/cone 05)

Walgate's work examines our acquisition and display of objects, in particular the representation of animals as objects, subjected to mass production and consumption.

GLAZING AND FIRING TECHNIQUES // GALLERY: OXIDIZED FIRING

Pippin Drysdale (Australia)
Sundance, from *Tanami Mapping Series*, 2010
Installation L: 47½in (120cm), Dia: 23½in (60cm)
Wheel-thrown porcelain vessels and closed forms, fired 2192–2264°F (1200–1240°C/cone 5–6)

The glazing process commences with multiple layers of colored glaze applied to the surface, which achieves a color fusion. The surface is then painted with a resist, followed by incision of linework using blades.

Thomas Aitken (Canada)
Millennium Jug, 2000
H: 16½in (42cm), W: 7in (18cm)
Thrown porcelain, dipped/poured in different colors and fired to a high temperature in an electric kiln

Merete Rasmussen (Denmark/UK)
Yellow Loop, 2010
H: 15¾in (40cm), W: 15¾in (40cm), D: 13¾in (35cm)
Coil-built stoneware with colored slip

"Clear, clean shapes; soft, smooth curves in contrast to sharp edges; concave and convex surfaces; the discovery and strength of an inner/negative space—these are all forms of expression that appeal to me."

170 // 171

Artist profile: Natasha Daintry

British artist Natasha Daintry found a passion for ceramics while living with a Japanese family in Tokyo, where she was introduced to ceramics and the language of materials. She went on to study 3-D Design at the Surrey Institute of Art and Design in Farnham, England, and then took a Masters in Ceramics and Glass at London's Royal College of Art, graduating in 2002. Natasha now works from a Victorian-era studio in the Elephant & Castle area of London, and her work has been shown in both solo and group shows in the United Kingdom, United States, and Australia.

My work is physical, sensual, and quite precise. I make vessels and like strong, reduced forms. I aim for the taut energy and subtle complexity that I admire in poetry. I use Southern Ice porcelain. I find it silky, stubborn, muscular, acutely sensitive, and it provides a white ground for colored glazes. I throw on the potter's wheel, slip cast, and handbuild. I glaze thickly and lusciously to give the bases of my work a plump and juicy quality like buttery lemon curd and make luminous haloes from paper-thin rims.

"I am passionate about color. I find it beautiful and dangerous, like the sea. Like water, color is fluid and fugitive; it shifts and changes depending on light and context. It dazzles and ravishes, but also triggers doubt and uncertainty, as acid yellow becomes lime, or violet at noon becomes gray at midnight. For me, color is a kind of wilderness. I feel exhilarated, perplexed, and alive when exploring color.

"I am influenced most by water, movement, and architecture. I love the powerful elegance of ancient ziggurats and the rock-hewn churches of Lalibela in Ethiopia. I like taking away more than building up so prefer turning to throwing. I am obsessed by space and emptiness as much as clay and glaze."

Small Ocean, 2007
Overall size 43¼in (110cm) x 43¼in (110cm)
Thrown porcelain

Ocean, 2009
1,000 pots; overall size L: 94½in
(240cm), W: 23½in (60cm),
H: 4¾in (12cm)
Slip-cast porcelain

*Ziggurat with Small Expanse
of Yellow*, 2010
W: 3¼in (8.5cm), H: 2¼in (5.4cm)
and W: 4in (10cm),
H: ½in (1.4cm)
Thrown porcelain

Reduction firing overview

In a reduction firing, the kiln atmosphere is starved of oxygen; this results in free carbons in the form of carbon monoxide (CO) and carbon dioxide (CO_2) taking oxygen from wherever it can, including metal oxides present in ceramic materials.

A combustible fuel source such as gas, wood, or oil is burned to raise the temperature in the kiln. To encourage a reduction, the oxygen supply to the kiln is restricted by gradually closing the chimney damper over a period of time. A heavy reduction is noted by the flames licking out of the spy hole, gasping for oxygen to burn.

Every reduction firing will vary, and consistency of firing can be an issue. Some kilns are prone to oxidized pockets or cold spots that can cause significant variations in glaze outcomes. However, what a reduction firing does best is producing beautiful, rich, textural glazes with depth and presence. Typical reduction glazes are celadon, tenmoku copper red, and shino.

A reduction firing can have a radical impact on the color of an oxide. In an oxidized firing, copper oxide will fire green. In a reduction, it can transform into an intense red, as shown in the image to the right.

Sarah Flynn (Ireland)
Slant Vessel, 2008
H: 7in (18cm)
Thrown and assembled; reduction fired to 2336°F (1280°C/cone 9)

Sarah Flynn was inspired by Chinese *sang-de-boeuf* ("oxblood") vessels for the glaze of this piece.

Reduction firing process

The following is intended to be a basic overview of the reduction firing process and will vary depending on the individual kiln (be it an updraft or downdraft kiln), fuel source (natural gas/propane/other), and burner system (atmospheric burners or forced air burners). Keep a record of previous reduction firings. Plot a graph of the temperature rise in relation to the number of hours it takes to reach top temperature. This will be a useful reference for next time.

Manually

When loading the kiln, stagger the kiln shelves so they are at uneven heights. This allows the flames to move around the chamber and produce a consistent reduction. Ignite the burners and start with a gentle flame. Make sure the chimney damper is completely open and drawing air through the chamber. Some gas kilns rely simply on the natural draw from the chimney, but it is common to have a separate air feed as well as a gas feed.

Supply more air and gas to the kiln to increase the temperature. When the temperature has reached 1652°F (900°C), reduction can begin. To do this, close the chimney by a quarter. Continue to add more air to feed the flames.

As the temperature steadily increases, gradually close the damper at a rate of approximately 1–2in (3–5cm or one quarter-turn) every 20 to 30 minutes. Closing the chimney damper completely will produce a strong reduction and the flames will lick out of the flue and spy hole. This should be closely monitored and eased off by adjusting the damper accordingly. Continue to feed air to the gas supply and control the reduction until the kiln has reached temperature.

Computer-controlled kilns

Modern gas kilns can be operated by a kiln controller, similar to an electric kiln. The computer alters the air and gas feed and controls the reduction firing from start to finish. This information is kiln specific; therefore refer to the manufacturer's manual for operation guidance.

Tips
- Copper red glazes require a heavier reduction to achieve a more intense color.
- Reduction glazes benefit from having a thicker application. Too thin and the fired color may not be a true representation.
- Be aware of any cool spots or oxidation areas in your kiln and load your work on the shelf accordingly. You may even use this to your advantage to achieve a distinct variation in the glaze.

Gallery: reduction firing

Matthew Blakely (UK)
Squared Lidded Jars, 2010
H: 7in (18cm)
Stoneware, thrown and altered forms; layers of slip applied to surface and covered with a celadon glaze; reduction fired to 2336°F (1280°C/cone 9)

Tanya Gomez (UK)
Bliss, 2010
H: 17¾in (45cm), D: 16½in (42cm)
Porcelain, thrown in sections and assembled; glazed with stains and reduction fired to 2336°F (1280°C/cone 9)

GLAZING AND FIRING TECHNIQUES // GALLERY: REDUCTION FIRING

Lee Renninger (US)
Lacet de Chanvre, 2007
H: 40in (106cm), W: 108in (274cm),
D: 2in (5cm)
Porcelain, hemp

"While clay is most often associated with fine craft and functional objects, I use it conceptually—stretching the boundaries of the material in an effort to challenge the accepted ideas of how clay should be used. Questions remain about possibilities of the material—how it might be used and in what ways it can speak of our time."

Akiko Hirai (UK)
Dobin Teapot, 2010
H: 6in (15cm), Dia: 6in (15cm)
Stoneware, thrown on the potter's wheel; layer of slips applied and fired in a reduction atmosphere; entwined wooden handle made by artist

Artist profile: Chris Keenan

British ceramicist Chris Keenan originally trained to be an actor. After spending more than a decade working as a professional actor, he was apprenticed to a potter in 1995. He now works from his own studio in south London and exhibits and sells widely around the United Kingdom and internationally. He was awarded a Crafts Council setting-up grant in 1999 and is a professional member of the Craft Potter's Association.

'I started working with clay in my mid-30s, when I began a two-year apprenticeship with the potter Edmund de Waal. We first met in 1989 when I was working as an actor and I bought some pieces from his studio. I grew to love using and living with his work, and when I learned that he was considering taking on an apprentice I wrote to him to make my interest clear.

'That is how it all began and I have now been working from my own studio in south London since 1998. My work is thrown Limoges porcelain, and I currently use two glazes: a glossy, black/brown tenmoku (in conjunction with splashes of the black iron oxide, illmenite), and a vivid, pale blue celadon. The work is reduction fired in my gas kiln to around 2300°F (1260°C). All my pots are designed for domestic spaces and will do a job if you want them to—function still plays a large role in my work. The range includes cups, beakers, bowls, lidded jars, teapots, and pots for flowers. I like clean lines and simple forms, and although I use a limited palette of glazes, I am still finding new ways of working with them to produce fresh decorative effects that complement the forms."

Rocking bowls, 2008
H: 3½in (9cm)
Porcelain, thrown on the potter's wheel; tenmoku and celadon glazes

Teapot, cups, and tray, 2010
Teapot H: 7in (18cm)
Porcelain and mulberry wood, thrown and assembled; cane handle on the teapot woven by the artist

Bowl, 2006
Dia: 8in (20cm)
Porcelain, thrown; tenmoku and celadon glazes

Espresso cup and mug, 2006
H: 2in (5cm) and 3⅛in (8cm)
Porcelain, thrown; tenmoku and celadon glazes

Salt and soda firing overview

Salt glaze is a technique where sodium is introduced into a kiln at a high temperature and volatizes into a vapor. The atmosphere in the kiln reacts with the silica in the clay body to form a distinct orange-peel glaze over the surface. Salt glaze originated in Germany around the fourteenth century and was traditionally used as an industrial method of glazing utilitarian wares. Salt glazing is considered to be a very polluting method because toxic acid and chloride vapors are released into the atmosphere. Soda (also known as sodium carbonate and sodium bicarbonate) is used as a substitute for salt, as it is deemed to be less polluting.

Before embarking on this type of firing, it is wise to shadow an experienced salt or soda firer before going it alone. Many professional artists teach excellent courses and workshops. If you are just curious to try the technique, some artists may be willing to allocate you a proportion of kiln space for a small fee or even free if you volunteer to assist them.

Pots for salt or soda glaze do not have to be glazed prior to the firing, nor do they necessarily have to be bisque. Colors can be achieved by painting or spraying a coat of slip onto the wares. Alumina is resistant to salt and can be mixed with water and used as a resist technique.

This ware shows the "orange-peel" texture characteristic of salt and soda glazes

Slip recipes for salt and soda glazes

Tan orange
Hyplas ball clay	50%
China clay	50%

Base recipe
Potash feldspar	60%
China clay	40%

Color additions
Blue: cobalt oxide	1%
Purple/brown: manganese dioxide	10%
Iridescent: rutile	6–8%

> **Note**
> Alumina kiln wash should be applied to all kiln furniture to resist the salt. Pots should be propped onto pads of alumina wadding to raise them off the shelf and prevent them from becoming stuck.

Wood-fired, salt-glazed wares on display at the Leach Pottery, St. Ives, in the UK

Salt and soda firing process

An early start to the day is required for a salt or soda firing. The kiln will need to be warmed up gently for a few hours before the firing can begin properly.

The kiln is packed as for a reduction firing (with staggered shelves), and pyrometric cones are inserted in view of the spy hole. To help gauge the amount of salt buildup on the wares, ceramic rings are placed in a vertical line alongside the cones and in a location where they can be accessed with a metal cane. The front of the kiln is bricked up and sealed with fire clay and the chimney damper is opened fully.

Salt kilns can be fueled by gas, wood, or oil. The same processes for a manual reduction firing (see p. 175) are followed to fire the kiln, but every kiln is different and a sure understanding of when to increase fuel, air, and closing the damper comes from experience.

While the kiln is firing, packages of salt or soda are made by weighing 2.2lb (1kg) of salt or soda, spraying with water, and tightly wrapping in newspaper. The quantity of salt packages required for the firing depends on the size of the kiln, but 12 to 18 is the usual number. Oxides can be added to the salt packages to achieve flashes of color on the wares. Once the kiln has reached a temperature of 2336°F (1280°C), a brick is removed in the firebox and the salt package is pushed in quickly using a metal rod.

This process is repeated every 10 to 15 minutes. A ceramic test ring is fished out of the kiln and plunged in water. This is a good indication of whether more salt is needed. Once there is sufficient buildup of salt, the fuel supply is disengaged, and the kiln is left to cool.

US maker Robbie Lobell removes a tester ring during a soda firing to determine whether there is sufficient soda coverage

GLAZING AND FIRING TECHNIQUES // SALT AND SODA FIRING PROCESS

Tips
- Leave sufficient space between each piece to allow the salt/soda vapors to circulate freely and reach as much of the work as possible.
- Coarse garden salt is better than table salt.
- Sodium carbonate or bicarbonate of soda is used for soda firing.
- Soak cord or rope in a brine solution (you can experiment further by adding oxide) and tightly wrap around a piece. The rope will burn away, but the salt will continue to react with the silica in the clay. This can create a unique pattern on the surface.
- A similar experiment is to drape or tie a banana skin onto a piece. Banana skins naturally contain potassium, and this can be very reactive in a salt firing, producing flashes and beautiful surface textures.
- Strategically place small pots containing a mix of salt and oxide around the base of a piece to encourage flashes of color up the sides of the work.
- Scallop shells can be used to lift the piece from the kiln shelf as an alternative to wadding. The calcium in the shell acts as a natural resist and can even become incorporated into the ware. This effect is seen in Nic Collins' work on p. 190.

The kiln is upacked after a successful firing at the Leach Pottery, St Ives, UK

Gallery: salt and soda firing

Walter Keeler (UK)
Ionic Teapot, 2009
H: 7in (18cm)
Thown and assembled; salt glaze

Jane Hamlyn (UK)
Empty Vessels Orange Trio, 2010
H: 8¼in (21cm), W: 8¾in (22cm),
D: 7½in (19cm)
Salt-glazed stoneware, wheel thrown and handbuilt

Micki Schloessingk (UK)
Oval-Handled Vase, 2010
H: 5¾in (14.5cm), W: 7in (17.5cm),
L: 5¼in (13.5cm)
Stoneware clay from St. Amand en Puisaye, France; wood fired and salt glazed

"Making wood-fired, salt-glazed pots for daily use is challenging. The firings are unpredictable. The weather, type of wood, and energy of the firers all have an impact and contribute to the making of each piece. My aim is to make pots that enhance but do not adorn."

GLAZING AND FIRING TECHNIQUES // GALLERY: SALT AND SODA FIRING

Robbie Lobell (US)
Two Tea Kettles, 2010
Each approx. H: 10in (25.5cm),
W: 9½in (24cm), D: 7in (18cm),
High-fire flameware clay body,
thrown and altered, glazed and
unglazed, fired in a propane-fueled
soda kiln to 2372°F (1300°C/cone 10)

Matt Kelleher (US)
Hyena Vase, 2009
H: 12in (30cm), W: 7in (18cm),
D: 7in (18cm)
Stoneware, handbuilt—four slabs
of altering shapes attached and
bottom added; covered with
kaolin (china clay) slip; soda fired
in gas kiln

184 // 185

Artist profile: Robert Winokur

U.S. artist Robert Winokur was born in Brooklyn, New York, in 1933. He gained his Bachelor of Fine Arts from Tyler School of Art, Philadelphia, and graduated in 1958 with a Master of Fine Arts from the New York State College of Ceramics. During his long and distinguished career, Robert has participated in many solo and group exhibitions. He was professor of Ceramics at Tyler School of Art, Philadelphia, for almost four decades and is a member of the International Academy of Ceramics of Geneva, Switzerland.

"Having been a potter for a long time, it occurred to me that a house is a unique kind of container. I think the thought grew out of a fantasy I had once in which I made vessels so large that I had to lower myself down over the side on a scaffold, from the top, in order to decorate it. A pot that size would be as big as a house.

"A house is a unique kind of container; one that is imbued with a deep set of profound and multilayered psychic associations. To a child, a house represents warmth, family, love, security, and identity. In the process of my doing houses, they became, for me, a symbol of choice, and I have been working with the form for more than ten years.

"I don't know when it was that I became fascinated and enthralled by artwork done by children and in particular with the drawings and paintings done by them of houses. What I find truly compelling about these works is their innocence, exuberance, and spontaneity.

"Those qualities and elements of children's art that inspired me to work with the house surface every now and then, but the sense of joy, euphoria, playfulness, and spontaneity has been replaced by a kind of somber introspection. Perhaps it is the color of the clay coupled with the construction process I use to make the houses that moves me in this direction.

"The houses have become a form, a kind of abstraction that expresses, on one level, a formal study of variations on the theme and, on another, an exploration of the possibilities that can be wrung from the symbol. The ladders and the asparagus are recent elements that I have taken to. They do all sorts of neat things to modify and alter the way in which the houses are seen.

"The pragmatic description of what it is I do is that I use Pennsylvania brick clay mixed with fire clay to construct the houses out of slabs of clay. I fire the houses to cone 9 or 10 in a salt kiln."

Whyeth's House with Ladder, 2008
H: 18in (46cm), W: 11in (28cm),
L: 29½in (74cm)
Pennsylvania brick clay; handbuilt and slab construction; orange engobe applied to bisque; gas fired and salt glazed to 2336–2372°F (1280–1300°C/cone 9–10); celadon glazes

Bucks County Barn, 2004
H: 12in (30cm), W: 16in (40.5cm),
D: 15in (38cm)
Pennsylvania brick clay, slab built;
gas fired and salt glazed

*Asparagus Endures the
Weight of the World*, 2009
H: 20in (51cm), W: 7¼in (18.5cm),
D: 7¼in (18.5cm)
Pennsylvania brick clay, slab-built,
slip-cast asparagus; gas fired and
salt glazed to 2336–2372°F
(1280–1300°C/cone 9–10)

Wood firing overview

Wood has been used as a fuel to fire kilns for centuries. It is cost effective and a renewable resource. Wood firing has a reputation for being a demanding and labor-intensive process from start to finish, but the reward is the beautiful earthy qualities produced by wood ash being swept across the wares by the flames. Distinctive flashes of color and a warm toasted clay body are also characteristic of a wood firing.

Location is an important factor with a wood kiln: you need an outdoor space, preferably with a shelter and a storage area for the wood. The wood itself must be dry. Softwoods burn quicker than hardwoods, although some potters like to use a combination of both.

Firing a wood kiln can be intimidating and requires a level of experience to operate. However, this should not deter the novice, as there are some very good courses and workshops for makers looking to expand their knowledge and try out the technique.

The wood kiln and the store of wood at Dog Bar Pottery in Westhampton, MA
(Photo: Howard Korn)

Wood firing process

Wood kilns are usually built on-site in rural, outdoor locations. The procedure for wood firing is very similar to a gas firing; the main difference is that the kiln is fueled by wood. The kiln can take days to reach top temperature and requires a team of dedicated people who are prepared to work shifts stoking the flames.

The kiln should be packed with the shelves staggered. A number of pyrometric cones ranging from 1112 to 2372°F (600 to 1300°C) are placed in view of the spy hole. The entrance is then bricked up and sealed with a layer of fire clay. A thermocouple probe inserted into the kiln and a pyrometer are also used to gauge the temperature.

ABOVE
Loading the wood kiln at Dog Bar Pottery in Westhampton, MA
(Photo: Howard Korn)

Firing the wood kiln at Dog Bar Pottery in Westhampton, MA
(Photo: Howard Korn)

The wood is lit and more and more is added to increase the temperature. The same principle as gas reduction applies; once the kiln reaches 1652°F (900°C), the chimney damper is gradually closed to encourage reduction. Over the course of the following days, wood is burned until the kiln finally reaches temperature. No more wood is added and the kiln is left to cool down; this can take up to a week, depending on the size of the chamber.

Gallery: wood firing

Nic Collins (UK)
Large vase fired on scallop shells with natural ash glaze, 2010
H: 26in (66cm)
Stoneware; coil thrown on a potter's kick wheel

"My work is made using a mixture of local clays. The pots are mostly thrown, using a momentum kick wheel. I fire my pots in a wood-fired anagama-type kiln for four days up to 2372°F (1300°C/ cone 10)."

ABOVE
Yo Thom (UK)
Jug, 2008
Approx H: 3½in (9cm),
Dia: 2¼in (6cm)
Stoneware, thrown and handbuilt, iron slip decoration, and shino glaze over the slip; fired in a wood kiln at 2336°F (1280°C/cone 9); total firing 36–40 hours

GLAZING AND FIRING TECHNIQUES // GALLERY: WOOD FIRING

Steve Sauer (US)
Black shino chawan, 2009
H: 3½in (9cm), L: 3¾in (9.5cm), W: 3¾in (9.5cm)
Hand-dug stoneware clay, hand-dug clay slip; wood fired in the "Ochawagama" (Teabowl Kiln); thrown on the potter's wheel and altered

"The study of the wood-fire process and the tea ceremony is a lifelong process of enlightenment. My enlightenment comes through meditation and contemplation of clay fire and tea. Through enlightenment I have found again the simplicity, the freedom, the beauty, and the love that we were all born with."

Sam Taylor (US)
Two Fish Cups, 2009
H: 3in (7.5cm), Dia: 3in (7.5cm)
Stoneware; wood-fired at Dog Bar Pottery, Westhampton, MA, with salt and soda ash; six tile slip finger wipes with helmer and alberta slip fish decoration

Artist profile: Janet Mansfield

Australian artist Janet Mansfield was born in Sydney in 1934. She originally trained at the National Art School, ESTC, in Sydney, and subsequently became well known as a distinguished teacher, author, and publisher as well as an award-winning ceramic artist. She has written a number of books on ceramics and is the publisher/editor of the international journals *Ceramics: Art and Perception* and *Ceramics Technical*.

"To make good pots consistently is the greatest challenge. Sometimes it is possible to fluke a good pot or a fine performance, but to be consistent, that is where experience and temperament play their part. I like to experiment: different clays, different types of firing, and I try out new forms that have relevance to me and the lifestyle of today. I use three different kilns: a trolley kiln for wood-fired salt glaze; a train kiln that is wood fired and also salted; and an anagama kiln that relies on the effects of wood ash deposited on the work during the firing. All these kilns take their time to reach temperature and the results I seek. One firing can last several days and the high temperatures reached put the pots at risk of tumbling and distortion; it is the risk that gives the pots something extra: a richness and a spirit of independence.

"In making numbers of pots, not only for the enjoyment of their forming or to fill the large kilns, it is necessary to find a rhythm and discipline of work. In this way, one can seek out the forms that best suit their particular purpose. After a firing, one can sort out those pots that are successful; understanding the pots and what has happened to them can take more time. Making pottery is a vocation that takes a lifetime. Making ceramic art requires all the senses as well as continual thought in order to make work that is worthwhile—aspects of our vocation that we potters aspire to every day."

Flower container, 2010
H: 15in (38cm)
Stoneware; wood fired in an anagama kiln, natural ash glaze from the firing

Lidded jar, 2009
H: 12½in (32cm)
Stoneware; wood fired in anagama kiln, natural ash glaze from the firing

Flower container, 2009
H: 15¼in (39cm)
Stoneware; wood fired in an anagama kiln, natural ash glaze from the firing

Teapot, 2009
H: 12in (30cm)
Stoneware; wood fired in an anagama kiln, natural ash glaze from the firing.

Raku firing overview

Originating in the sixteenth century, raku is a traditional Japanese low-fire technique. It is an exciting process that involves the wares being quickly fired, taken out of the kiln red hot, and then buried in sawdust and left to reduce.

A raku firing produces a characteristic crackle surface and bright metallic lusters. Raku is best suited to decorative ware rather than functional items because it is not watertight. Pieces for raku should be constructed in coarse, heavy-grogged clay because it is more resilient to thermal shock.

Typical raku glaze recipe

High-alkaline frit	94%
China clay	5%
Bentonite	1%

The addition of 6–8% tin oxide will produce an opaque white glaze.

Pots can be dipped into this glaze and oxides applied directly on top. This will give your pot a clear background with painted detail on top. For all-over color, experiment by adding small quantities of oxide to the glaze to make your own color recipes (see Glaze testing, pp. 142–143).

The raku kiln is a top-hat design. The chamber part has been lifted away and the red-hot piece is exposed and ready to be lifted into the sawdust

Raku firing process

Raku is a fun activity to do as a team. Delegate a role to each person so that everyone is involved. Load the glazed pieces into the kiln. Stagger the kiln shelves to provide easy access to the pieces with tongs.

Prepare the pyrometric cones and position them in a location where they can be viewed. Alternatively, a thermocouple and pyrometer can be inserted into the kiln to provide an accurate reading. Secure the kiln and light the gas burners. Heat the kiln gently until the temperature reaches above 212°F (100°C), then increase the gas to full. Keep checking the temperature of the kiln. There are many variables that could affect the firing; therefore, it may reach temperature in 30 minutes, 2 hours, or longer.

When the kiln has reached a temperature of 1742°F (950°C), get ready to start the raku. Wear full protective clothing, including a face mask and heat-resistant gloves. Check there is sufficient sawdust in the pit and have a spare quantity close to hand. Open the red-hot kiln and use the tongs to lift the work into the sawdust pit. Completely bury the pieces in sawdust and leave to reduce for 2 to 5 minutes. The longer the time in the sawdust, the heavier the reduction.

Remove the work from the pit with tongs and plunge in water. Scrub and clean the pots to reveal the unique crackle surface. Seal in any luster finishes with a coat of beeswax or the colors will reoxidize.

A piece made by Egyptian artist Ashraf Hanna (see pp. 198–199) smolders in the sawdust

Gallery: raku firing

Kate Schuricht (UK)
Pale green raku containers (small raku container with binding), 2008
Raku container with lid off:
H: 4¼in (11cm), Dia: 2½in (6.5cm); small bound container: H: 4¾in (12cm), Dia: 1½in (4cm)
Slip-cast raku body with pale green and white raku glaze and linen thread binding

John Wheeldon (UK)
Luster, 2010
H: 7⅞in (20cm)
Smooth stoneware

"My luster pots are decorated by applying various resinate lusters to a prefired terra sigillata surface. The patterns are achieved using rubber stamps, brushes, and resists, which enable me to build complex surface designs. The decorated piece is fired in a raku kiln and heavily reduced, resulting in a rich surface, enhanced and modified by the smoke."

GLAZING AND FIRING TECHNQIUES // GALLERY: RAKU FIRING

Simcha Even-Chen (Israel)
Triple Balance, 2010
H: 6¾in (17cm), W: 17¼in (44cm), D: 10½in (27cm)
Porcelain and stoneware mix; slab built, burnished, terra sigilatta

"My scientific background has a strong influence on my ceramic artwork. It is expressed in analytical ways that dictate the precise shapes and geometric design of my sculptures."

Susan Halls (US)
Yorrick, 2008
H: 16½in (42cm), L: 7in (18cm), D: 6¾in (17cm)
Slab-built paper clay; raku fired with underglazes

Artist profile: Ashraf Hanna

Egyptian artist Ashraf Hanna was born in El Minia, a small city by the River Nile in Middle Egypt. He originally studied at El Minia College of Fine Art, where he did a foundation course and access course in Expressive Arts. He came to London to study Theater Design at Central Saint Martin's College and graduated in 1994. Ashraf graduated from London's Royal College of Art with a Masters in Ceramics in 2011.

'Growing up in Egypt, I was always surrounded by pottery forms that harked back to antiquity. Forms and methods of making traditional pottery have changed little since ancient times.

'It was through my wife Sue that I had my first encounter with clay. Sue trained as a sculptor at Central Saint Martins, mainly working in wood. She taught me how to handbuild pots, and I remember having an almost instant affinity with the clay material, the malleable responsive qualities that are fixed with fire.

"My passion was truly ignited when we embarked on a ceramic holiday on the island of Evia in Greece in 1998. There we made pots with the Scottish potter Alan Bain. The pots and sculptures we made were pit fired, and that experience ignited our interest in everything to do with fire and smoke! Back in London, I started exploring various smoke-firing techniques, and in 2000 we moved to our current premises in Pembrokeshire. My current work is handbuilt, carved raku-fired vessels and bowls. This body of work is concerned with exploring the sculptural aesthetics of the vessel form; the relationship between geometry and fluidity both in form and pattern designs and how the contrast can be visually stimulating as well as exploring the tactile qualities through contrasting textural surfaces."

Large angular carved vessel, burnished rim, 2008
H: 19¾in (50cm), Dia: 21¾in (55cm)
Raku fired, resist slip glaze,
Ashraf Hanna clay (clay made to his specific recipe)

GLAZING AND FIRING TECHNIQUES // ARTIST PROFILE: ASHRAF HANNA

Two vessels with slanted burnished tops, 2009
Tallest vessel H: 21¼in (54cm)
Handbuilt, carved raku, Ashraf Hanna clay (clay made to his specific recipe)

SECTION 4
Decorative and finishing techniques

Slip decoration and surface overview	202	Grinding and polishing methods	242
Slip decoration recipes	204	Post-firing techniques	244
Slip decoration and surface techniques	206	Fixing and display	248
Gallery: slip decoration	216	Gallery: finishing	250
Artist profile: Elke Sada	218	Artist profile: Neil Brownsword	252
Enamels, lusters, and transfers overview	220		
Enamels step by step	222		
Lusters step by step	224		
Transfers step by step	226		
Gallery: enamels, lusters, and transfers	228		
Artist profile: Alice Mara	230		
Engraving and sandblasting overview	232		
Engraving methods	234		
Sandblasting step by step	236		
Artist profile: Maria Lintott	238		
Finishing overview	240		

Eva Kwong (US)
Man Breathing Fire into the Dragon, 2007
H: 1½in (4cm), Dia: 16in (41cm)
Stoneware; slip, glaze, carved, sgraffito drawing; once fired

Slip decoration and surface overview

Slip is a mixture of clay and water colored with oxides or commercial pigments. This section explores the decorative use of slip and its potential to create rich, dynamic surfaces. Slip can offer the artist freedom to treat the clay as a canvas, be it expressively, precisely, or simply as a way to introduce color.

Slipware

The term *slipware* is given to traditional slip-decorated earthenware pottery coated in a clear lead or honey glaze. It originated in Europe and the United States around the seventeenth and eighteenth centuries. Many of the techniques demonstrated in this section originated in this period, including slip trailing, feathering, and marbling. Slip has a luscious, creamy quality that can be further exploited when used in conjunction with colored clay bodies such as red earthenware.

Terra sigillata

This is a very fine earthenware slip, soft and semi-matte in appearance. It is made by mixing the slip and allowing it to settle in a container for at least 20 hours. The top layer is siphoned off and the process repeated a number of times. This act removes the large particles from the slip so just the finest particles remain behind.

Heidi Parsons (UK)
Snapshot Plates, from Blossom Series, 2009
Dia: 15in (38cm)
Red earthenware, porcelain, underglaze color

The image is screenprinted directly onto wet clay and then formed into a plate using the jigger/jolley process. The artist creates decorative objects that celebrate everyday encounters, commemorating moments in time.

Vitreous slip and engobes

These are halfway between a slip and a glaze. They are applied in the same way as other slips; the main difference is that these slips have a self-glazing quality and can be used on their own as a surface conclusion. They typically produce a dry to semi-matte/satin sheen.

Slips for wood, salt, and soda firing

Slips for wood, salt, or soda firings are decorated onto a piece (without necessarily a glaze on top) to encourage the silica in the clay to react with the vapors/ash in the kiln. This creates a glaze as well as various stunning effects.

Conor Wilson (UK)
Pastoral Landscape; Judge of Hell vs. Egg-Laying Queen (detail), 2009
H: 32¾in (83cm), W: 39½in (100cm), L: 51¼in (130cm)
Coiled and assembled red earthenware; slip; clear, honey, and tin glazes; transfers; luster; mixed media

Carolyn Genders (UK)
Stone, 2010
H: 10¼in (26cm), W: 11½in (29cm), D: 8¾in (22cm)
White earthenware clay, handbuilt and coiled; painted with vitreous slips and then burnished

Slip decoration recipes

A simple slip can be made by adding water to dry clay powder. However, here are some tried and tested recipes.

Typical earthenware slip recipe
(1976°F/1080°C/cone 03)

White base

Kentucky ball clay	70%
EPK/china clay	30%
Zirconium silicate	10%

Stoneware slip recipe
(2192–2336°F/1200–1280°C/cones 5–9)

White base

Kentucky ball clay/ Hyplas 71 ball clay	70%
Flint	18%
Zirconium silicate	7%
Bentonite	5%

Additions:

Red: red iron oxide	4%
Green: copper carbonate	5%
Blue: cobalt carbonate	1.5%
Black: cobalt carbonate	2%
+ manganese dioxide	4%
+ black iron oxide	8%
Yellow: yellow stain	10%

Add water and sift through a 100 mesh sieve.

Vitreous slip/engobe recipe
(2282°F/1250°C/cone 7)

Ball clay	25%
China clay	30%
Nepheline syenite	35%
Borax	10%

Apply to green ware or bisque.

Terra sigillata recipe
(1950°F/1065°C/cone 04)

Warm water	6⅓ pints (3 liters)
Ball clay	2.2lb (1kg)
Sodium silicate	1oz (25g)

Apply to green ware or bisque. Add 3–4 layers for a translucent effect and 7–10 layers for complete coverage. Color with 6–14% stain or 3–8% oxide additions.

Slips for wood, salt, or soda firing

Tan orange

Ball clay	50%
EPK/China clay	50%

Base

Potash feldspar	60%
EPK/China clay	40%

Additions:

Brown = iron	3%
Blue = cobalt oxide	1%
Green = copper oxide	2%
Iridescent = rutile	8%

Apply to green ware or bisque.

DECORATIVE AND FINISHING TECHNIQUES // SLIP DECORATION RECIPES

Tips
- Slips for slipware are best applied to leather-hard clay for better adhesion. Too dry and the slip could flake off.
- Slips are excellent for producing raised textures and lines.
- Add more water for a washy effect.
- Be careful not to oversaturate the clay with slip, as it will crack. Allow each layer to dry off before adding the next.

A white slip painted onto a clay body will produce a better surface finish and enhance the glaze color. It can also be used to disguise a darker/coarser clay body

204 // 205

Slip decoration and surface techniques

The following techniques will provide you with transferable skills that can be experimented with in other stages from raw clay to glazing.

Painting

Use a wide, soft brush (Chinese type) to cover the entire surface or simply to make decorative marks. Painting slip can be used freely or precisely.

Build up layers of slip and scratch back through to reveal the colors.

Sponging

A textured effect can be achieved by dabbing slip with a natural sponge on to the clay. This technique can also be used in conjunction with stenciling.

Sgraffito

Paint the surface of the clay with slip and allow it to dry to a matte sheen. Use a pointed tool to scratch away the slip to reveal the color of the clay body underneath. This is a simple and effective technique; the contrast of colorful slip against the clay works beautifully.

Trailing

A slip trailer is an essential tool for slip decoration and can be used for a multitude of techniques. Pour slip into the rubber bulb part of the tool and insert the nozzle piece into the top. These nozzles are interchangeable and come in a variety of nibs from wide to fine. The slip can be trailed in lines as part of decoration or used to create energetic, expressive marks.

Feathering

Use the slip trailer to draw lines in contrasting colors across the clay; three different colors often work well. Take a pointed tool such as a pottery needle, drag through the lines in one direction, and then return back in the opposite direction. Repeat this process until you have completed the pattern. Experiment with the types of marks you can achieve with this technique, from swirls to peacock markings. Try masking areas and feathering on top to give a controlled look.

Combing

Wet slip can be made into loose patterns by using a coarse comb-like object, including the fingers.

Burnishing

Slips are painted onto the leather-hard clay and left to dry to a matte sheen. Using the back of a spoon (preferably silver), apply pressure and move the spoon in a circular motion. This compresses the clay and produces a dark waxy surface. This technique is used in conjunction with a saggar or smoke firing, as the tight layer traps the carbon emitted by the smoke.

DECORATIVE AND FINISHING TECHNIQUES // SLIP DECORATION AND SURFACE TECHNIQUES

Marbling

Have a few slip trailers filled with different colors to hand and blob the slip onto the clay surface. Pick up your piece and swirl it around, tipping it in different directions. Watch as the colors mix and create a unique pattern. Be careful not to overdo it though, as the slips can soon mix and will appear muddy.

Monoprinting

Paint a layer of slip onto a piece of newspaper and leave the slip to dry to a matte sheen. Turn the newspaper piece over, slip facing down, and lay onto the clay surface. Use a pen nib or end of a paintbrush to draw your design on top of the newspaper and then peel it away. A positive imprint of the drawing will be transferred onto the clay. A negative of the pattern can be achieved by pressing the newspaper back onto the clay and rubbing down. Layers of different colors can be applied to create a rich and dynamic surface.

Resists

Wax, latex, and paper can be used to mask areas and layer up the slips. Wax remains on the surface and will be burned away during the firing. Latex and paper can be peeled off and reapplied to create overlaps of pattern and color.

Stencils

Stencils can be cut or made from masking tape, paper, or card stock. Lightly dampen the paper so it sticks to the clay. Dab or paint the slip on top. Allow to dry, then peel away the stencil. Layers of repeat pattern can be built up with this technique.

Inlay

Gutter-shaped lines are carved into the leather-hard clay and then filled with slip (chunky lines can be filled with colored clay). Allow the slip to firm to leather-hard stage and then scrape away the excess to reveal the pattern underneath. Refrain from sponging or fussing with the detail as this could smudge the delicate mark. Instead, lightly sand the piece once it has been bisque-fired to tidy up the line.

Agate

Roll out two or more contrasting colors of clay (for example, red clay and white earthenware). Layer the sheets of clay on top of each other in alternating colors. Place a sheet of newspaper on top and compress with a rolling pin. Cut and layer again. This will produce striated markings.

Ceramic pencils and crayons

Ceramic pencils and crayons can be purchased from a pottery supplier and are a useful way to get a sketchy feel to the decoration. Crayons can be made by mixing 20% stain into 3½oz (100g) ball clay. Combine with a little water, roll into a sausage shape, and then fire in the kiln to 1472°F (800°C/cone 016). Stain can also be mixed into hot wax, poured into a paper container, and left to harden.

Combustibles

Organic materials such as rice, lentils, or sawdust are a great way to texturize clay and create random patterns. Soak the materials in a little water beforehand as this helps prevent the clay from cracking. The materials can then be wedged into the clay, which will result in "blow-out" type textures. Alternatively, the materials can be sprinkled directly on top and rolled into the clay, which will leave a subtle texture on the surface. The materials can be left to burn out in the kiln, but good ventilation is essential.

DECORATIVE AND FINISHING TECHNIQUES // SLIP DECORATION AND SURFACE TECHNIQUES

Relief and embossing

Relief is the addition of clay to the surface, such as a sprigg mold. An embossed surface can be created by impressing, stamping, or rolling different textures into the clay.

Oxides and stains

Oxides or stains can be painted, rubbed into the surface, and sponged off to highlight detailed or textured areas. This can be done on unfired clay or bisque and is a subtle way to bring color and tone into a piece. To apply the oxide or stain, put 1tsp (5ml) of pigment into a small container and add a little water. Use less water if you want a strong color, or add more water to dilute the oxide for a washy effect.

214 // 215

Gallery: slip decoration

Marc Leuthold (US)
Pagoda, 2010
H: 8in (20cm), Dia: 4in (10cm)
Agate porcelain clay, turned and carved

Marc Leuthold makes sculptures that refuse to plainly identify themselves. While their identities may be unnameable, they are distinct, composite forms suggesting transition: temporal, cultural, male and female, nature, and artifice.

Sandy Brown (UK)
The End of the Beginning, 2006
H: 9ft (3m)
Grogged clay, white slip, colorful glazes; slab built, freely glazed; fired to 2264°F (1240°C/cone 5) in an oxidized atmosphere in a gas kiln

Dylan Bowen (UK)
Three Forms, 2009
H: 8in (20cm)
Slip-decorated earthenware; handbuilt, thrown, and altered; glazed with clear and honey glazes

Dylan takes inspiration from abstract expressionism, English slipware, music, and folk art. He aims to combine making and decorating so they flow together and retain some freshness and spontaneity.

DECORATIVE AND FINISHING TECHNIQUES // GALLERY: SLIP DECORATION

Zeita Scott (UK)
Shuffle Platter, 2009
H: 2in (5cm), Dia: 19in (48cm)
Spanish black earthenware, slab and press molded in a two-piece cuff mold; decorated with colored porcelain slip and transparent and commercial glazes

Kathy Erteman (US)
Deep Ocher Vessel, 2009
H: 9in (23cm), Dia: 14in (35.5cm)
Stoneware; wheel-thrown and altered, vitreous engobes and glaze

"I embrace a modernist attitude about form when making ceramic vessels, and have always been interested in a pared-down aesthetic. I work with various techniques to best suit each idea, and I aim to strike a balance between control and chance. The visual conversation between surface and form is a thread that continues through all my works."

Artist profile: Elke Sada

German artist Elke Sada, born in 1965, was 35 years old when she left her career as a research technician to follow a long-cherished idea. She went to England to study 3D Design Ceramics at Bath Spa University and later graduated with a Master of Arts in Ceramics and Glass from the Royal College of Art in London in 2005. She moved back to Germany that year and since 2007 has worked out of her own studio in Hamburg. Her work has featured in solo and group exhibitions in the United Kingdom, Germany, and South Korea.

'I was always attracted by traditional slipware as well as by eighteenth- and nineteenth-century porcelain. These are two very different styles, yet both have rich qualities, and both have influenced my work from the beginning.

'My work has always been about surface and color. Anything can inspire me, whether consciously or unconsciously. It could be a painting, a song, a bunch of flowers, an image in a magazine, a pot, or an emotion. One of my latest works unites my love for painting and printing with ceramics. I call it *Capriccio*. Here I paint with slips onto a plaster block and then I pour clay onto it. Each time I lift the firm clay, a new print is revealed. I cut it and fold it into unique and cheerful vessels.

'Since 2007, I have lived and worked in Hamburg, Germany. I have my studio in an old schoolhouse where other artists also work. It's a beautiful place, and I enjoy every day since I swapped analyzing data for working in clay."

Capriccio milk jugs, 2008 and 2009
H: 4¾–6¼in (12–16cm)
White earthenware and body stains, reversed monoprinting, handbuilding

DECORATIVE AND FINISHING TECHNIQUES // ARTIST PROFILE: ELKE SADA

Capriccio beakers, 2009
H: 4½in (11cm)
White earthenware and body stains, reversed monoprinting, handbuilding

Capriccio XL bowl, 2009
W: 12¼in (31cm)
White earthenware and body stains, reversed monoprinting, handbuilding

218 // 219

Enamels, lusters, and transfers overview

After a piece has been glaze fired and finished, the surface can be embellished further with one of a number of low-firing decorative techniques: enamels, lusters, or transfers. These media are used to produce rich colors, metallic sheens, or imagery. They can even be used in combination with each other if each layer is fired separately before adding the next.

Ideally, all techniques should be applied to a glazed surface; matte and unglazed surfaces can dull the colors or cause the medium to not adhere properly. A white background will show the true color of the medium; however, you may decide to apply different colorful glazes as part of a background design with the intention of using these techniques to put in detail afterward. To achieve best results, a hard vitrified clay body (e.g., porcelain) will require an additional 86–104°F (30–40°C) on top of the stated firing temperature. Good ventilation during application and firing is essential as the fumes can be toxic.

Enamels
Firing temperature:
1436°F/780°C/cone 016–018

Enamel is a soft melting glass that can be used to decorate entire surfaces or just to rework and enhance small areas. Enamels are commonly used for handpainted illustrations and surface design.

A board of test tiles documenting numerous enamel colors

DECORATIVE AND FINISHING TECHNIQUES // ENAMELS, LUSTERS, AND TRANSFERS OVERVIEW

Lusters
Firing temperature:
1382°F/750°C/cone 014

A luster is a metal compound suspended in an oil-based resin, which reduces in an oxidized firing to a pure metal such as gold, platinum, copper, or bronze. Lusters can also produce beautiful iridescent mother-of-pearl effects that bring a sense of extravagance and luxury to a piece. Lusters are often expensive and are therefore used sparingly for detailing and creating visual impact.

A bon bon dish with platinum-lustered interior, made by Louisa Taylor

Transfers
Firing temperature:
1436°F/780°C/cone 016–018

Transfers (also known as decals) are a great way of incorporating imagery such as photographs, drawings, or text onto a glazed surface. A transfer is made by either screenprinting or digitally printing ceramic pigment onto gummed backing paper. Once dry, it is coated with a layer of a substance with the trade name "Covercoat." This creates a plastic film that carries the image. When softened with water, the film slides away from the backing paper and can be applied to the surface. The Covercoat layer will burn away during the firing, leaving the printed image fused onto the surface.

Lowri Davies (UK)
Small and large yellow vases, 2009
Small vase: H: 10½in (27cm), Dia: 3⅛in (8cm); large vase: H: 11in (28cm), Dia: 6¾in (17cm)
Bone china, clear and yellow glazes; screenprinted and digital transfers, silver luster

220 // 221

Enamels step by step

Unlike glazes, enamel colors tend to fire the same as they appear. They can also help liven up a piece and introduce color to dull surfaces.

1 | Clean the glazed surface with turpentine or methylated spirit to remove any greasy marks before applying enamel.

2 | If scaling up a drawing, use tracing paper to sketch out your design and then transfer it to your piece. You can draw your design onto the surface using a soft pencil. Once satisfied, retrace the line with a permanent marker pen.

3 | Decide on the order you intend to work. For example, you may want to paint the background first before the foreground, or vice versa. Areas can be masked with sticky-backed plastic or latex to create sharp, soft, or block details.

Mixing the enamels

Enamel powders can be mixed with either full-fat milk or fat oil. Stick to one medium and do not intermix. If using fat oil, mix to a thick paste and then thin with turpentine. Enamel must not be too thick, as it could flake off during the firing.

Place 1 dessert spoon (10ml) of enamel powder onto a square glazed tile or plate. Add a small amount of the medium and blend together using a palette knife. Grinding the pigment afterward using a pestle and mortar can significantly enhance the color.

Application

Enamel can be painted or sponged onto the glazed ware. Experiment with both techniques and compare the type of marks they create.

Color can be removed by using a clean dry cloth or with cotton balls dipped in turpentine.

Occasionally, some enamel colors are not compatible with each other, so check the product information before application. If this has been a problem, fire the layer in the kiln before applying the next color. The design does not have to be completed in one stage; layers of enamel can be built up with multiple firings.

Lusters step by step

Lusters are available in many beautiful colors and effects. Metallic lusters tend to be more expensive, but a little goes a long way. After firing, lightly buff the lustered surface with a polishing cloth to brighten the sheen.

1 Massage a very small amount of liquid soap into the bristles of the paintbrush. This will help preserve the brush and make cleaning much easier.

2 Wipe the surface with turpentine or denatured alcohol before applying the luster.

3 Paint the area with the first coat of luster. Lusters, especially metallic lusters, require a second coat to ensure a consistent application. Make sure there are no drips or finger marks, as they will show.

DECORATIVE AND FINISHING TECHNIQUES // LUSTERS STEP BY STEP

4 | You can remove mistakes or spills by putting turpentine onto a cloth and wiping the area clean. A cotton ball soaked with turpentine is useful for intricate areas. You can use turpentine as a decorative technique by using it to draw through the luster and erase areas.

5 | Keep the cap screwed on the container to prevent the luster from becoming thick and gloopy over time. If this happens, dilute the luster with a little turpentine and shake the container before use. Thinners can be purchased from pottery suppliers and are an economical way to make the luster go further.

The finished piece. The gold luster was fired to 1508°F (820°C/cone 014)

Transfers step by step

There are two methods of producing ceramic transfers. One is to screenprint your designs; this is good for producing batch runs, but is not always practical. The other is to prepare your transfers digitally using a computer and then send them to a company that will produce the transfer for you. The only disadvantage is that the quality of image is not as rich as a screenprint. The following step by steps focus on digital transfers, as they are the most accessible for small batch runs or one-offs. Alternatively, there is a huge range of ready-made transfers to choose from that can be purchased from pottery suppliers.

Creating the transfer

Upload your design, be it a drawing, photograph, or collage, onto your computer. You will need to use software such as Adobe Photoshop or Illustrator to prepare the file. Most companies supply the transfers on a sheet that is 11¾ × 16½in (A3-sized). Therefore it is more economical to manipulate your design so you can fit as many repeats as you can onto a sheet. Save your image as a JPEG, TIFF, or Illustrator EPS file at a resolution of at least 300dpi and in the CMYK format (if you want your transfers to be in color). It can then be emailed or sent to the manufacturer on a CD. If you are not confident with computers or don't have the programs, most companies can do this part for you for a small additional charge if you send them the originals.

Applying the transfer

You will need scissors or a scalpel, a dry cloth, a rubber kidney, and a shallow bowl filled with water.

1 | Clean the surface of your piece with turpentine or denatured alcohol. Cut close and neatly to the edge of your transfers.

2 | Place the transfers on the surface of the water, face up. Watch as the edges curl and then flatten back down. Leave to soak for a minute or two.

3 | Pick up the transfer and gently slide it between your fingers. It should easily come away from the backing paper.

4 | Place the transfer onto the piece and move it into position. You will have a bit of time to do this while it is still wet. Once satisfied, use a rubber kidney or dry cloth and press the transfer down to ensure proper adhesion to the surface.

Gallery: enamels, lusters, and transfers

Felicity Aylieff (UK)
Yellow Flower Jar, 2009
H: 57½in (146cm), Dia: 30in (76cm)
Glazed porcelain, Fencai enamel colors, handpainted

Claire Curneen (UK)
Stick Figure (detail), 2008
H: 17¾in (45cm), W: 8in (20cm), D: 7in (18cm)
Porcelain, gold luster, red cotton; handbuilt, fired to 2300°F (1260°C/cone 8)

DECORATIVE AND FINISHING TECHNIQUES // GALLERY: ENAMELS, LUSTERS, AND TRANSFERS

Sun Ae Kim (Korea/UK)
Date Lesson 102, from *Since Eve Ate Apples, Much Depends on Dinner*, 2010
H: 9½in (24cm), W: 3⅛in (8cm), D: 3⅛in (8cm)
Bone china, underglaze, enamel; hand modeling, casting, drawing, transfer print, enamel painting

"*My images are a reflection of today's marriage by presenting the personal life of Queen Eve (an ordinary lady in London). That story is placed onto the plates and centerpieces on the dinner table.*"

Jason Walker (US)
Stacking a Skyline, 2009
H: 24in (60cm), D: 12in (30cm), L: 16in (41cm)
Porcelain, painted underglaze, and luster

Here the artist explores the dichotomy between culture and nature.

Artist profile: Alice Mara

Alice Mara has been designing and making ceramics for more than 15 years. In 2003 she completed her Masters in Ceramics at London's Royal College of Art. Since then she has shown work at many galleries including the Crafts Council, the Richard Denis Gallery, and the Eagle Gallery. Mara has won the Queensbury Hunt Prize for innovative use of ceramics and the Ella Doran Prize for best new designer at the East London Design Show.

My first experience of clay came when I was around 8 years old. I used to go to a kids' pottery club, and I remember really enjoying making things with my hands. I come from a creative family; my late father, Tim Mara, was a prominent figure in the discipline of printmaking. His life and work have been hugely influential in my own practice.

Having lived in Walthamstow, London, most of my life, I enjoy walking around the place and taking pictures of buildings that interest me. Using a process of photography and digital technology, I produce images that depict the urban landscape. Using a computer, I enhance the photographs to create scenes that are surreal, fantastical, and have a nostalgic familiarity about them. I like the viewer to be able to recognize the environment that I choose to decorate the plates with, either through a sense of having visited the place or a general recognition of the London theme. By placing these images onto plates, I transform the identity, function, and value of the plate into a decorative work of art that becomes readable for the viewer.

"I have two distinct ranges within my work. One is quite commercial—I purchase industrial blank ceramics and decorate them with my transfer imagery. The other is more bespoke art pieces, which I make from scratch using molds and slip casting. The shapes of these forms directly reference the imagery they depict. Both ranges are fed by the same thought processes.

"Typically, I use the dynamics of the piece in conjunction with the imagery to transform functional, everyday ceramic ware into attractive objects imbued with humor, color, and surrealism. The resulting work has a retrospective core, enhanced with contemporary digital techniques to produce creations that not only provide the viewer with evocative and familiar themes but are also highly attractive and distinctive works of art."

Dog Track Urn, 2010
H: 13¾in (35cm), W: 7½in (19cm)
Stoneware, digital print

DECORATIVE AND FINISHING TECHNIQUES // ARTIST PROFILE: ALICE MARA

Appliance Tiles, 2007
4in (10cm) square
Earthenware; digital print

Sink Plate, 2008
13¾in (35cm square)
Bone china; digital print

House #6, 2010
H: 13in (33cm), W: 7½in (19cm)
Earthenware, slip cast;
digital print

230 // 231

Engraving methods

There are a number of methods you can use for engraving work, including laser cutting and using an engraving tool.

Laser cutting/engraving

Laser cutting/engraving is a relatively new technology that is becoming more widely used within studios. At present, the machine can cut a wide range of materials such as paper, fabric, plastics, and sheet wood, but it cannot cut hard materials including ceramics, glass, or stone. However, the surfaces of these hard materials can be engraved by up to 5mm. Laser cutting is ideal for producing intricate patterns on sticky-backed paper that can be used as a resist or stencil in conjunction with sandblasting.

Typically, the design is prepared using computer software (usually Adobe Illustrator) and saved as a vector file at 300dpi. This file is uploaded to the laser-cutting machine, which then plots the line and begins cutting/engraving. If you do not have access to a laser cutter, there are many companies that offer this service.

Power engraving tools

A handheld engraving tool is a useful gadget to have in the studio. It can be used at any of the fired stages of clay, from bisque to glazed ware.

Protect the piece by placing it on a large sponge or towel. Insert a diamond-coated steel bit into the tool and tighten it up. These bits are extra-strong and the most suitable for engraving onto ceramics. Some tools have the option of attaching a flexible shaft. This offers excellent control and enables the user to get into awkward spaces. Always wear eye protection (and a dusk mask if necessary).

Moisten the area to be engraved. Reapply water with a sponge if the area dries out. This lubricates the tool bit against the hard ceramic and helps prolong the bit's use.

A selection of diamond-coated drill bits, all shaped differently to suit the job in hand

DECORATIVE AND FINISHING TECHNIQUES // ENGRAVING METHODS

Uses for engraving tools
An engraving tool has a number of uses:

Freehand designs
Draw your design onto the piece using a marker pen. Use the tool to engrave fine detail onto the surface. Once finished, wash and dry the piece. It can be left as it is or you could experiment with rubbing in oxides, enamels, or lusters and then refiring.

Sgraffito
Mix stain or oxide with water and coat a layer onto the piece. Use the tool to draw into the surface to reveal the color of the clay body underneath. (This is the same as the slip decoration technique; see p. 207.)

Signing or personalizing work
Draw with a marker pen first and then trace the line with the engraving tool.

Repair
The engraving tool can remove debris that has fallen onto the ware during the previous firing. Gently drill away the affected area, dab some glaze on top, and refire.

234 // 235

Sandblasting step by step

Sandblasting is great for introducing pattern and textures into your work. Experiment with resist techniques, try overlapping previous sandblasted areas, or varying the depth of line.

Tips
- Sandblasters are notorious for giving the user static shocks, which can be painful. Standing on a rubber mat or wearing rubber-soled shoes can help prevent this.
- If you are unhappy with the outcome of a glaze, it is possible to sandblast the glaze off completely and start again.
- Different grades of sand will create softer or coarser textures on your work.

1 | Draw your design on the surface of the piece using a water-based felt-tip pen. Mask the areas you intend to keep by applying a resist of wax, latex, or masking tape. Alternately, you can apply a laser-cut stencil.

2 | Place the piece inside the sandblasting chamber and shut the door. Make sure all the clips are securely fastened. Fill the machine with the sand. Different grades of sand are available from coarse to fine; which you use depends on the object you are sandblasting. If you are unsure, start with a medium grade.

3 | Wear suitable clothing and a respirator. Switch the machine on and start the compressor. Place your hands inside the rubber gloves and check that you can see through the window into the chamber. The sandblasting hose is usually operated by pressing down on a foot pedal. Do a few test blasts to familiarize yourself with this.

4 | Point the hose at the piece, press the foot pedal down, and begin sweeping the sand across the surface. Keep turning the piece and stop from time to time to check that the sandblasting is consistent.

5 | When finished, remove your piece from the sandblaster and peel off the resist. Wash with water and clean with a dry cloth.

DECORATIVE AND FINISHING TECHNIQUES // SANDBLASTING STEP BY STEP

UK-based artist Maria Lintott sandblasting a piece of work in her Hertfordshire studio

236 // 237

Artist profile: Maria Lintott

British ceramic artist Maria Lintott set up her studio on completing her Bachelor of Arts at Central Saint Martins College of Art, London, and her Master of Arts at London's Royal College of Art, graduating in 2006. Maria has participated in exhibitions throughout the United Kingdom, and has worked on a freelance basis for both Teroforma and Wedgwood. All her collections are handmade in fine bone china in her Hertfordshire studio and bear the Maria Lintott mark.

"I create collections that use the expressive potential of tableware, that are not only functional but also engage the user on an emotional and sensory level. Using playful forms and texture I actively encourage interaction with my pieces. They are designed to bring a touch of beauty to our everyday lives.

"I find inspiration in a variety of places; my collections often reference traditional ceramics and the natural world. I want my pieces to create curiosity and have a sense of fun. I hope that they summon people to pick them up and enjoy the tactile experience. I love the idea that objects have stories to tell and that narratives can be formed through a lifetime of use. An object such as a teacup can become as comforting as an old friend."

Relief and elevated presentation bowls, 2006
H: 5¼in (13.5cm), W: 10¼in (26cm)
Slip-cast bone china, earthenware glazes

Maria uses a sandblaster to "cut" through the glazed surface to reveal the bone china surface beneath, creating an intricate pattern.

Bloom rose bowls, 2008
H: 3⅛in (8cm), Dia: 5⅛in (13cm)
Slip-cast fine bone china with
hand-applied relief floral sprigs

Loving cup and Twist cups, 2006.
Loving cup: H: 3⅓in (8.5cm),
Dia: 6¾in (17cm); Twist cup:
H: 3⅓in (8.5cm), Dia: 5¾in (14.5cm)
Slip-cast fine bone china

These cups have the capacity
of a mug yet combine the refined
qualities of a china tea cup.

Large Bloom vases, 2008
H: 9in (23cm), Dia: 4in (10cm)
Slip-cast fine bone china with
hand-applied relief floral sprigs

The location of the bloom sprigs
allows the user to place the flower
stems as if they are growing out
of the sides of the vessel as well
as the top.

Finishing overview

RIGHT
A stack of bisque plates made by the potters at the Leach Pottery, St. Ives, UK. The bisque stage provides a good opportunity to sand down any rough edges prior to glazing

Ceramic items are tactile and by their nature encourage interaction between the user and the object. A ceramic piece may be a functional object that will be used in everyday life, or it may be more conceptual, in which case the display and context can be as meaningful as the object itself. Poor execution of a piece can undermine the quality of the ideas; therefore, the way a piece is finished should always be an important consideration of the making process.

Unfired stage

It is best practice to do as much of the finishing at the unfired stage, when the clay can be more easily worked. Rough edges should be fettled with a sponge, otherwise they will be sharp after firing. If your pieces are intended to be functional, consider the shape of the rims; they should be thin and welcoming. A blunt, flat rim will not be very comfortable to drink from. The pieces themselves should not be too heavy as this can be detrimental to the overall design. You may need to trim thrown pieces or carve excess clay out of handbuilt forms to remove weight.

Finally, personalizing your work with a signature or stamp can make your work look more professional and even add a collectability value. Stamps can be made by simply scratching your initials in reverse into a small block of plaster and using this to press into the clay.

Robert Cooper (UK)
Trophy 2, 2009
H: 9in (23cm)
Stoneware, casting slip, found ceramic cups, glaze, transfers, lusters, assemblage

DECORATIVE AND FINISHING TECHNIQUES // FINISHING OVERVIEW

Bisque

The bisque-fired stage provides another opportunity to work a piece prior to glazing or other finishing techniques. This can prove useful if the piece is too delicate to handle when raw. Often makers use this stage to sand their pieces so they are ultra-smooth and refined.

The edges of a slip-cast piece are fettled using a natural sponge

Post firing

After a piece has been fired and is considered finished, any rough surfaces on functional wares, particularly bases, should be polished smooth (unless it is your intention to keep them rough) so they do not scratch other surfaces such as worktops or tables. Glaze is not the only conclusion to a ceramic surface, and in the following pages we discuss a wide range of techniques, both conventional and experimental, including flocking, gold leaf, mixed media, assembling, and gluing.

Lee Renninger (US)
Lace (detail), 2005
H: 30in (76cm), W: 48in (122cm),
D: 5in (12.5cm)
Porcelain, fiberglass, fiber

With this piece, Lee was interested in creating a lace-like pattern using materials that don't lend themselves to this application.

Grinding and polishing methods

After firing, ceramic surfaces can feel rough to the touch. A smooth, marble-like finish can be achieved by grinding and polishing. This can be done in two ways: by hand or with a power tool.

By hand

There are two methods you can use to grind and polish by hand: using wet and dry sandpaper, or using diamond-polishing pads.

Wet and dry sandpaper

Using wet and dry sandpaper is most effective at the bisque stage, when the ceramic surface is still quite soft. Unsightly marks or fettling lines can be lightly sanded away with a fine-grade paper. Sponge the piece with water and wet the sandpaper. Rub the paper in a circular motion against the surface. Reapply water and use a fresh piece of sandpaper when necessary.

Pieces should be thoroughly washed and left to dry prior to glazing. The silicone carbide grit on the sandpaper can cause technical problems, especially for slip-cast pieces, if not properly washed off. It is advisable to re-bisque slip-cast pieces to ensure that all the silicone carbide residue has been removed.

Diamond-polishing pads

The industrial diamond coating on a polishing pad is more abrasive than the grit on wet and dry sandpaper. It is excellent for finishing the bases of glazed pieces or for smoothing a surface. The diamond grades are distinguished by the color of the pad: black = coarse; pink = medium; yellow = fine. Diamond-polishing tools can also be purchased as toothbrush-like objects for small, intricate areas or as a thin sheet for sanding curved objects.

Water must be used in conjunction with the pad. Start with the black pad and apply a circular motion. Swap to the pink pad and repeat the action before finishing with the yellow pad.

Using a wet grinder

A wet grinder is a type of angle grinder that has been adapted for use with water. It is typically used to grind and polish unglazed ceramic surfaces. Using the tool with water lowers the surface temperature and minimizes dust. Grinding disks of varying grades are worked through until the piece is ready to be polished with a buffing attachment.

The piece to be polished should be set up in a large outdoor space, where there is access to a hose and an electrical point (the tool must also be plugged into a power trip switch). Suitable clothing and safety gear must be worn. Follow the instructions on the manufacturer's leaflet for further guidance.

A wet grinder

A selection of diamond-coated grinding and polishing disks

Post-firing techniques

Once a piece has been fired in the kiln, it does not necessarily have to end there. The following post-firing techniques have the potential to free the artist from material constraints and are ideal for experimenting with sculptural and non-functional work.

Assembling and gluing

There are challenges with any material, and in ceramics there are particular forms that are too awkward to fire as a whole piece. Making the form in separate sections and assembling it after the final firing allows more freedom with the composition and scale of a piece. This technique is very versatile and can be used to create large sculptures and mixed-media collages. Some artists exploit this further by using a wet saw to slice a ceramic piece into sections, after which they assemble and glue the pieces together to produce the final construction.

There are many adhesives available on the market; which one you choose depends on the specific requirements of the task. To join ceramics, epoxy glue (which is mixed together in two parts, one being the resin, the other being the hardener) should be sufficient for general use. For industrial strength, ultraviolet-sensitive glue will produce the most secure bond. This glue is applied to the sections to be bonded and clamped together. It is then cured with ultraviolet light from a lamp. Rough surfaces are easier to bond because the texture helps the glue to grip. With any solvent-based adhesive, make sure there is good ventilation and always refer to the product instructions and safety advice before use.

ABOVE
UK-based ceramicist Katharine Morling assembles her pieces using glue

LEFT
A series of maquettes for *Sketch of My Chair*, by Katharine Morling

Lacquer

Traditionally, lacquer was made from organic materials such as tree sap or tar and used to seal wood. Now the term *lacquer* lends itself to other media including spray paints, acrylic, oil-based paints, and varnishes. It can be used as an alternative to a glazed surface and is particularly useful for coating prototype models and experimental samples. Lacquer and paint are not as rich as a glaze and can be tonally flat, but it can offer a slick surface, and there is a broad range of colors and finishes to choose from. These finishes should be applied to a sealed and primed surface, building up the layers between each coat.

Polish and inks

A gentle, tonal color can be achieved by saturating a porous ceramic surface with inks. Preparation of the surface is the key; the piece will require vigorous sanding until it is smooth to the touch. The ink is generously applied and absorbed into the bisque. A few coats of ink may be required to reach the desired depth of color. The surface can then be given a subtle sheen by rubbing clear polish or beeswax over the surface and buffing with a brush and polishing cloth. Inks can also be used to accentuate the crazing feature of raku.

Brushing purple ink into the bisque surface

Spraying the ceramic object with black oil-based spray paint

Buffing the inked surface with beeswax to seal the color

Gilding

Gilding is the application of fine gold, copper, silver, or bronze leaf to a surface. The weight of gold leaf is measured in carats, ranging from 6 carats to 24 carats. Gold leaf is usually sold as transfer leaf or loose leaf in booklets of 25 leaves.

Transfer leaf is supplied on a backing sheet that is pressed face down onto the surface and rubbed to release the gold. It is convenient to use and ideal for large areas. Loose leaf is used to gild carved or intricate details. It cannot be handled because it is very delicate and tears easily. A soft wide brush called a gilder's tip is used to transfer the leaf from the booklet directly to the surface. Before starting, the surface to be gilded will need to be sealed and prepared with an adhesive size.

Once the size is tacky, the leaf is applied. It is then sealed with a clear varnish to prevent the metal from oxidizing.

Cutting the gold leaf with scissors

ABOVE
Adhesive size is applied to the surface with a brush

The gold leaf is transferred to the piece and the backing paper peeled away

DECORATIVE AND FINISHING TECHNIQUES // POST-FIRING TECHNIQUES

Flocking

A flocked surface has the appearance and feel of velvet. Flocking is not a decorative technique usually associated with ceramics; however, it can create an interesting tactile finish. It can be stenciled as a pattern or used to coat an entire piece. The process of flocking involves covering the surface of the piece in adhesive. The flock fibers are then electrostatically charged and become attracted to the surface, resulting in a uniform coverage. Handheld flocking guns are available and are best used for small areas. For overall coverage or complicated designs, it may be worth using a professional company to flock the piece for you.

Natasha Lewer (UK)
Primaries 2, 2008
H: 18in (46cm), W: 47¼in (120cm), D: 47¼in (120cm)
Assembled from handbuilt, extruded, and wheel-thrown elements; glazed and flocked

"I make groups of large-scale sculptures that are semi-abstract and often playful in appearance. Texture, tactility, and color are vital elements, and synthetic materials, such as flock, contrast with the clay from which they are made. The sculptures are made to be touched; how they feel is as important as how they look. My sources range from microbiology to children's toys, which I draw on to create a personal interpretation of the essential building blocks of life."

Fixing and display

How a piece will be displayed is an important consideration of the design and making process. Making provisions for fixings and mountings at an early stage will minimize problems later on and lead to a suitable installation.

Wall fixtures

When creating pieces intended to be hung on the wall, a mechanical fixing is always stronger than a chemical bond. Prepare in advance a secure fixing compatible with the wall or vertical surface in question. On the back of the ceramic piece there should ideally be a hole or groove to locate a screw head. This can easily be carved by hand when the clay is unfired; allow enough room for adjustment to achieve a level mounting. When a piece cannot directly accommodate a mechanical fixing, a wooden or metal plate with a hole or groove can be bonded to the back of the piece with suitable adhesive and used to secure it to the wall. If the object is asymmetric and heavier on one side, you will need to have at least two holes in the back to prevent it from tilting.

Jeff Schmuki (US)
Nursury, 2008
H: 68in (172cm), W: 87in (220cm), D: 17in (43cm)
Earthenware, sponge cloth, cress

The intention of this piece was to involve the community and encourage them to water and tend to the nursery. The piece is interactive and non-static.

Ceiling installations

To suspend a piece from the ceiling, it is vital that the fixing is suitable for the load being supported and the construction or type of ceiling. Light objects can be hung with nylon fishing line with a breaking strain that exceeds the weight of the piece. Consider how the line will be tied to the piece, and use a suitable knot or clasp fastening to anchor the line. Heavy objects should be hung with steel tension wire, which requires specialist fastenings to secure in place. Always seek advice if unsure how to hang an object correctly; never compromise on safety.

Tips
- A sculpture vulnerable to tipping over can be filled with sand to weigh it down.
- Heavy objects may require an internal metal structure for extra support.
- Museum putty is nonpermanent and good for securing objects to the surface without damaging them.
- Special round adhesive pads to hang plates are a useful alternative to conventional metal-sprung frames.

Margaret O'Rorke (UK)
Woven Light and Porcelain, 2009
H: 118in (300cm), W: 31½in (80cm), D: 6¼in (16cm)
Steel fiber, light fiber, and thrown porcelain

This piece was the result of a collaboration between Margaret O'Rorke and Finnish art weaver Sirkka Paikkar.

Gallery: finishing

Tyler Lotz (US)
Cultured Clearing, 2008
H: 18½in (47cm), W: 26in (66cm),
D: 19in (48cm)
Slip-cast ceramic, acrylic, concrete board, hardware

"My sculpture is a speculative response to the many ways in which we remake nature to suit our own purposes. It questions the assumption that 'the artificial' could be an acceptable stand-in for 'the real' in regard to human interaction with our natural world."

Firth McMillan (US)
Trestle, 2009
H: 10in (25.5cm), L: 24in (61cm),
D: ½in (1.3cm)
Paper clay, terra sigilatta, epoxy, paint, magnets

Trestle emerged from time spent photographing and drawing structures and fortifications of New York City; it acted as a means toward comprehension and acclimatization to an unfamiliar environment.

DECORATIVE AND FINISHING TECHNIQUES // GALLERY: FINISHING

Steve Irvine (Canada)
Pattern Jar, 2009
H: 12½in (32cm), Dia: 9½in (24cm)
Stoneware, reduction-fired at 2372°F (1300°C/cone 10); black glaze; post-firing application of 24-carat gold leaf

Craig Mitchell (UK)
Technophobe, 2010
H: 17¾in (45cm), L: 12in (30cm)
Earthenware, commercial glazes, luster, and transfer

This piece was handbuilt from clay slabs using dressmaker-style templates. Component parts are fired separately and assembled using steel pins and epoxy resin. *Technophobe* is about being both attracted to and repelled by new technology while celebrating the aesthetics of old formats but not the function.

Hitomi Hosono (Japan/UK)
Round Flowers Box, 2010
H: 4¾in (12cm), Dia: 4¾in (12cm)
Porcelain-molded spriggs, gold-leaf interior

250 // 251

Artist profile: Neil Brownsword

British artist Neil Brownsword was born in Stoke-on-Trent, England, in 1970. He studied 3D Design, Ceramics at the University of Wales Institute Cardiff, before going on to complete his Master of Arts at London's Royal College of Art, in 1995. Since graduating from the RCA, Neil has gained both national and international acclaim for his work, and he is positioned at the forefront of experimental ceramic practice in the United Kingdom.

"My continual fascination for clay as a sole medium for expression remains deeply embedded within my personal and social histories. Being born in Stoke-on-Trent—a world center for ceramic production, I grew up surrounded by a landscape scarred by hundreds of years of industrial activity. The omnipresence of this, alongside family employment in the ceramic industry, was formative in paving the way for my own career, which began with an apprenticeship at the Josiah Wedgwood Factory in 1987. These intimate connections and experiences have instilled a great appreciation for the area's past and ceramic traditions, which the work continues to reverberate.

"For over a decade, my work has commented upon the decline of this industry. The steady closure of factories and the disappearance of indigenous skills are mediated via a visual language inspired by the past and present remnants of manufacture. Assuming the role of artist/archaeologist, I unearth and salvage by-products from factories still in operation, and regenerate these vestiges of labor into poetic abstract amalgams. Through its metaphoric exploration of absence, fragmentation, and the discarded, the work signifies the inevitable effects of global capitalism, which continue to disrupt a heritage economy rooted in North Staffordshire for nearly three centuries."

Block Band, 2008
L: 13¾in (35cm)
Ceramic, industrial archaeology; found assemblage

Spare, 2008
L: 12in (30cm)
Ceramic, industrial archaeology; found assemblage

Trowe, 2008
L: 17¾in (45cm)
Ceramic, industrial archaeology;
found assemblage

Raft, 2008
L: 8in (20cm)
Ceramic, industrial archaeology;
found assemblage

SECTION 5

Resources

Training courses	256
Residencies	258
Marketing	260
Trade shows	261
Art gallery and museum collections	262
Representation	264
Guilds, organizations, and associations	266
Workshops and studios	268
Suppliers	270
Useful charts	274
Contributors	276
Bibliography	278
Glossary	280
Index	282
Acknowledgments	288

Marc Leuthold (US)
Eclipse (detail), 2008
Dia: 8½in (22cm)
Porcelain, carved and unglazed

Training courses

Australia

Australian National University, Canberra, School of Art
BA (Hons) Ceramics
Tel: (02) 6125 5824
www.anu.edu.au/ITA/CSA

College of Fine Arts, University of NSW
BFA, BDes, BArtEd, MDes, MFA, MDes-Hons, PhD Design Ceramics
Tel: (02) 9331 5602
www.cofa.unsw.edu.au

Jam Factory Contemporary Craft & Design
A practical two-year, studio-based training program
Tel: (08) 8410 0727
www.jamfactory.com.au

National Art School
Ceramics short course
Tel: (02) 9339 8631
www.nas.edu.au

RMIT University
BA (Hons) Ceramics
Tel: (03) 9925 3865; 0417 377 758
www.rmit.edu.au/art

Sydney College of the Arts
BA (Hons) Ceramics
Tel: (02) 9351 1046
www.usyd.edu.au/sca

Canada

Concordia University
BFA Ceramics
Tel: 514 848 2424
www.concordia.ca

Europe

Buckinghamshire New University, UK
BA (Hons) 3-D Contemporary Crafts and Products: Jewellery, Metal, Glass, Ceramics
Tel: 0800 0565 660
www.bucks.ac.uk

Central Saint Martins College of Art and Design, UK
BA (Hons) Ceramics Design
MA Design: Ceramics, Furniture, or Jewellery
Tel: 020 7514 7022
www.csm.arts.ac.uk

University of Wales Institute, Cardiff (UWIC), UK
BA (Hons)/MA Ceramics
Tel: 029 2041 6154
csad@uwic.ac.uk

University of Brighton, UK
BA (Hons)/MDes/MFA Design and Craft
Tel: 01273 600900
www.arts.brighton.ac.uk

University of the Creative Arts, UK
BA (Hons) Three Dimensional Design
MA Contemporary Crafts (Ceramics, Glass, and Jewellery)
Tel: 01252 722441
www.ucreative.ac.uk

Staffordshire University, UK
BA (Hons) 3-D Design: Crafts
MA Ceramic Design
Tel: 01782 294000
www.staffs.ac.uk

University of Wolverhampton, UK
BA (Hons) Applied Arts (Ceramics)
Tel: 0800 953 3222
www.wlv.ac.uk

University of Ulster, UK
BA (Hons) Fine and Applied Arts
Tel: 028 70123456
www.ulster.ac.uk

Royal College of Art, UK
MA Ceramics and Glass
Tel: 020 7590 4252
www.rca.ac.uk

University of Arts and Industrial Design Linz Austria
MA Sculptural Conceptions/Ceramics
Tel: 0732 7898 343
www.ufg.ac.at

Konstfack, University College of Arts, Crafts, and Design, Sweden
MA Ceramics and Glass
Tel: 08 450 41 00
www.konstfack.se

United States

Cranbrook Academy of Art
MA Ceramics
Tel: 248 645 3300
www.cranbrookart.edu

Alfred University
MFA Ceramic Art
Tel: 607 871 2441
www.art.alfred.edu

California College of the Arts
BA/MA Ceramics
Tel: 510 594 3600
www.cca.edu

Illinois State University
BFA/MFA Ceramics
Tel: 309 438 8321
www.cfa.ilstu.edu

Kansas City Art Institute
BA Ceramics
Tel: 816 472 4852
www.kcai.edu

State University of New York at New Paltz
BA Ceramics
Tel: 845 257 3125
www.newpaltz.edu

Residencies

Residency programs provide an opportunity for artists to travel, research, experiment, and develop their practice for a set period. Studio and accommodation facilities are usually provided for, with teams of specialized professionals on hand to assist. There are many excellent institutions to choose from around the world. Some offer quite broad programs whereas others are more specialized, offering subjects such as wood/salt firing, mold making, surface design, etc. Residency programs vary in cost, and some provide scholarship and funding as listed on their individual websites.

Asia

The Pottery Workshop, China
139 East Xinchang Lu
Jingdezhen 333001
Tel: (86798) 8440582
www.potteryworkshop.org/jingdezhen

The Foundation of Shigaraki Ceramic Cultural Park, Japan
2188-7 Shigarakicho-Chokushi
Koka City
Shiga Prefecture
529-1804
Tel: 748 83 0909
souken@sccp.jp
sccp.main.jp

Canada

Banff Centre for Arts
The Banff Centre
Box 1020
Banff, Alberta
T1L 1H5
Tel: 403 762 6100
www.banffcentre.ca

Europe

A.I.R. Vallauris, France
Place Lisnard, 1 Boulevard des Deux Vallons
06220 Vallauris
Tel: 0493 64 65 50
www.air-vallauris.org

Guldagergaard, Denmark
International Ceramic Research Centre
Heilmannsvej 31A
DK-4230 Skælskør
Tel: 58190016
ceramic@ceramic.dk

The European Ceramic Work Studio (EKWC), the Netherlands
Zuid Willemsvaart 215
5211 SG 's-Hertogenbosch
Tel: 073 6124500
sundaymorning.ekwc.nl

RESOURCES // RESIDENCIES

The International Ceramics Studio (ICS), Hungary
H-6000 Kecskemét
Kápolna u.11
Tel: 76 486 867
www.icshu.org

Rufford Craft Centre, UK
Nottinghamshire County Council
Council Offices
Thoroton Road
West Bridgford
Nottingham
NG2 5FT
Tel: 0115 977 4589
artsadmin@nottscc.gov.uk
www.nottinghamshire.gov.uk

United States

Clay Space
28 W 210 Warrenville Road
Warrenville
Illinois 60555
Tel: 630 393 2529
info@clayspace.net
www.clayspace.net

The Clay Art Center
40 Beech Street
Port Chester
New York 10573
Tel: 914 937 2047
mail@clayartcenter.org
www.clayartcenter.org

The Archie Bray Foundation
2915 Country Club Avenue
Helena
Montana 59602
Tel: 406 443 3502
www.archiebray.org

The Appalachian Center for Crafts
Tennessee Tech University
1 William L Jones Drive
Cookeville
Tennessee 38505
Tel: 931 372 3888
www.tntech.edu

The Anderson Ranch Arts Center
USPS PO Box 5598
Snowmass Village
Colorado 81615
Tel: 970 923 3181
info@andersonranch.org
www.andersonranch.org

Watershed Ceramic Arts Studios
19 Brick Hill Road
Newcastle
Maine 04553
Tel: 207 882 6075
info@watershedceramics.org
www.watershedceramics.org

Two Stone Arts
501 Hurricane Road
PO Box 376
Keene
New York 12942
Tel: 518 576 9121
studios@twostonearts.org
twostonearts.org

John Michael Kohler Arts Center
608 New York Avenue
Sheboygan
Wisconsin 53081
Tel: 920 458 6144
www.jmkac.org

Red Lodge Clay Center
PO Box 1527
Red Lodge
Montana 59068
Tel: 406 446 399
www.redlodgeclaycenter.com

Marketing

The purpose of marketing is to raise your profile and promote your business to wider audiences. Here are four pointers to get you started.

CV (curriculum vitae) and artist statement

These are the two most commonly requested documents from galleries, press, or other agencies. A CV is a list of your academic achievements, exhibitions, publications/press, and work experience. It is good to have two versions: one quite brief (around one page), to give a general overview of your career to date, and the other more thorough (two pages or more), which you would use for applying for a job or residency position.

An artist statement is a short text about your work, ideas, influences, and technical expertise. It should be succinct and informative. Aim to keep the text to two or three paragraphs—certainly no more than 300 words. The artist profiles in this book are great examples of how to write a statement.

Photography

A portfolio of good-quality images of your work is essential when applying to exhibitions, fairs, galleries, competitions, etc. Photographs taken by a professional photographer may seem an expensive option but are well worth the investment. Ask for recommendations or research other artists' photography and check the photographer's credit. If you have a good camera, you could take the images yourself. Make the image press friendly by allowing space in the shot for text and avoiding fussy backgrounds or distracting props.

Postcards/Business cards

Postcards and/or business cards are a direct form of advertising and fundamental to promoting your work. A good option is to have a strong image of your work on one side to prompt the memory of the person who collected the card. The other side should list your contact details clearly, including your studio address, telephone/fax number, email address, and website address. Always carry some cards with you to give out should the opportunity arise.

Web presence

A website is a powerful marketing tool. Often the first thing someone interested in your work (a potential client or press contact) will do is enter your name into a search engine. A strong web presence will help you get noticed and potentially lead to sales, gallery interest, or media exposure. You may decide to make your own website or pay for a professional designer to create one for you. Social networking sites and blogs are an excellent way to promote your work too. Most importantly, keep your website updated regularly with new images and the latest information about forthcoming events/exhibitions.

Trade shows

Exhibiting at a trade show, fair, or event is one of the best ways to promote your work and raise your profile. It provides an excellent opportunity to establish networks and gain valuable contacts. However, it is important to research or visit the event prior to applying to make sure it is suitable for you. Note the quality of the work, the presentation of the stands, and the attendance of the event. Trade fairs can be very expensive, but the exposure and potential for sales far outweigh the negatives.

Tips for exhibiting

- Dress professionally.
- Invest in your stand: use good-quality plinths/shelving/wall vinyl. The aim is to encourage people to come and take a closer look at your work.
- Consider the display of your work. Avoid fussy layouts and clutter. Keep it clean looking and simple.
- Have suitable marketing material, including postcards and business cards. A press pack containing images of your work, a CV, and an artist statement are useful tools for optimizing media interest. You may also want to give out the packs to potential galleries and clients.
- Keep a book that you can staple business cards to and jot down any notes that are relevant.
- Follow up with contacts after the event with an email or phone call.

Annual events

Europe
100% Design
www.100percentdesign.co.uk

Art in Clay
www.hatfield.artinclay.co.uk

Art in Action
www.artinaction.org.uk

Ceramic Art London
www.ceramics.org.uk

Collect
www.craftscouncil.org.uk/collect

Earth and Fire
www.nottinghamshire.gov.uk

European Ceramic Context
www.europeanceramiccontext.com

Origin
www.originuk.org

United States
SOFA
www.sofaexpo.com

New York Gift Fair
www.nyigf.com

Art gallery and museum collections

The following is a list of selected art galleries and museums with collections of ceramics.

Australia

Shepparton Art Gallery
Locked Bag 1000
Shepparton
Victoria 3632
www.sheppartonartgallery.com.au

Powerhouse Museum
500 Harris Street
Ultimo
Sydney
New South Wales 1238
www.powerhousemuseum.com

Belgium

Museum of Ceramics, Andenne
Lapierre Charles Street, 29
5300, Andenne
Namur
www.ceramandenne.be

Canada

George R. Gardiner Museum of Ceramic Art
111 Queen's Park
Toronto
Ontario M5S 2C7
www.gardinermuseum.on.ca

Denmark

Museum of International Ceramic Art
Kongebrovej 42
5500 Middelfart
www.gimmerhus.dk

France

Galerie Du Don
Le Don du Fel
12140 Le Fel
www.ledondufel.com

National Museum of Ceramics, Sèvres
Place de la Manufacturer
92310 Sèvres
Paris
www.musee-ceramique-sevres.fr

Germany

Grossherzoglich-Hessische, Porcelain Collection
Prinz-George-Palais
Schlossgardenstr 10
64289 Darmstadt
www.porzellanmuseum-darmstadt.de

International Ceramic Museum
Waldsassener Kasten
Luitpoldstrasse 25
92637 Weiden
www.die-neue-sammlung.de/z/weiden/blick/deindex.htm

Ceramic Museum Berlin (KMB)
Schustehrusstrasse 13
10585 Berlin-Charlottenburg
www.keramik-museum-berlin.de

Italy

International Museum of Ceramics, Faenza
Via Campidori 2
36055 Nove (VI)
www.micfaenza.org

Japan

Museum of Modern Ceramic Art, Gifu
4-2-5, Higashi-machi
Tijimi-city
Gifu 507 0801
www.cpm-gifu.jp/museum/english/index.html

Raku Museum
Aburanokoji Nakadachiuri Agaru
Kyoto 602 0923
www.raku-yaki.or.jp

Spain

Museum of Ceramics
Carretera Nacional
43860 L'Ametlla de Mar
Catalonia
www.museuceramica-ametlla.com

United Kingdom

The British Museum
Great Russell Street
London WC1B 3DG
www.britishmuseum.org

Leach Pottery, Studio and Museum
Higher Stennack
St Ives
Cornwall TR26 2HE
www.leachpottery.com

The Potteries Museum & Art Gallery
Bethesda Street
Hanley
Stoke-on-Trent
Staffordshire ST1 3DW
www.stoke.gov.uk

The Wedgwood Museum
Wedgwood Drive
Barlaston
Stoke-on-Trent
Staffordshire ST12 9ER
www.wedgwoodmuseum.org.uk

Middlesbrough Institute of Modern Art (MIMA)
Centre Square
Middlesbrough TS1 2AZ
www.visitmima.com

York Art Gallery
Exhibition Square
York YO1 7EW
www.yorkartgallery.org

Aberystwyth University
The Ceramic Collection & Archive
School of Art
Buarth
Aberystwyth SY23 1NG
www.aber.ac.uk/ceramics/index.htm

Victoria & Albert Museum
Cromwell Road
London SW7 2RL
www.vam.ac.uk

United States

American Museum of Ceramic Art (AMOCA)
340 S. Garey Avenue
Pomona
California 91766
www.ceramicmuseum.org

The Metropolitan Museum of Art
1000 Fifth Avenue
New York
New York 10028-0198
www.metmuseum.org

The Museum of Ceramics
400 East Fifth Street
East Liverpool
Ohio 43920
www.themuseumofceramics.org

The Museum of Modern Art (MoMA)
11 West 53 Street
New York
New York 10019-5497
www.moma.org

The Schein-Joseph International Museum of Ceramic Art
Alfred University Campus
Binns-Merrill Hall
Pine Street
New York
New York 14802
ceramicsmuseum.alfred.edu

Representation

Many of the artists featured in this book are represented by the following galleries/agents.

Australia

Cudgegong Gallery
102 Herbert Street
PO Box 420
Gulgong
New South Wales 2852
Tel: (02) 6374 1630
www.cudgegonggallery.com.au

Raglan Gallery
28/117 Old Pittwater Road
Brookvale
New South Wales 2100
Tel: (02) 9939 3727
www.raglangallery.com.au

Sabbia Gallery
120 Glenmore Road
Paddington
Sydney
New South Wales 2021
Tel: (02) 9361 6448
www.sabbiagallery.com

Belgium

Puls Contemporary Ceramics
4 Place du Châtelain
b-1050 Brussels
Tel: 02 640 26 55
www.pulsceramics.com

Canada

Jonathon Bancroft-Snell Gallery
258 Dundas Street
London
Ontario N6A 1H3
Tel: 519 434 5443
www.jonathons.ca

Germany

Kasino
Casino Strasse 7
56203 Höhr-Grenzhausen
Tel: 02624 9416990
www.kultur-kasino.de

The Netherlands

Galerie Carla Koch
Veemkade 500 (6e etage)
gebouw Detroit
1019 HE
Amsterdam
Tel: 0642397440
www.carlakoch.nl

United Kingdom

Adrian Sassoon
14 Rutland Gate
London SW7 1BB
Tel: 020 7581 9888
www.adriansassoon.com

Contemporary Ceramics Centre
63 Great Russell Street
Bloomsbury
London WC1B 3BF
Tel: 020 7242 9644
www.cpaceramics.com

Contemporary Applied Arts
2 Percy Street
London W1T 1DD
Tel: 020 7436 2344
www.caa.org.uk

Marsden Woo Gallery
17–18 Great Sutton Street
London EC1V 0DN
Tel: 020 7336 6396
www.marsdenwoo.com

Ruthin Craft Centre
Park Road
Ruthin
Denbighshire LL15 1BB
Tel: 01824 704774
www.ruthincraftcentre.org.uk

The Scottish Gallery
16 Dundas Street
Edinburgh EH3 6HZ
Tel: 0131 558 1200
www.scottish-gallery.co.uk

Galerie Besson
15 Royal Arcade
28 Old Bond Street
London W1S 4SP
Tel: 020 7491 1706
www.galeriebesson.co.uk

Joanna Bird Pottery
19 Grove Park Terrace
Chiswick
London W4 3QE
Tel: 020 8995 9960
www.joannabirdpottery.com

United States

AKAR Gallery
257 East Iowa Avenue
Iowa City
Iowa 52240
Tel: 319 351 1227
www.akardesign.com

Ferrin Gallery
437 North Street
Pittsfield
Massachussetts 01201
Tel: 412 442 1622
www.ferringallery.com

Frank Lloyd Gallery
2525 Michigan Avenue
B5B Santa Monica
California 90404
Tel: 310 264 3866
www.franklloyd.com

Sherrie Gallerie
694 North High Street
Columbus
Ohio 43215
Tel: 614 221 8580
www.sherriegallerie.com

Schaller Gallery
The Iron Gate Building
353 West Main Street
Benton Harbor
Michigan 49022
Tel: 406 425 3114
www.schallergallery.com

Clark & Delvecchio
223 N. Guadalupe #274
Santa Fe
New Mexico 87501
Tel: 917 318 0768
www.garthclark.com

Guilds, organizations, and associations

Australia

Canberra Potters' Society
www.canberrapotters.com.au

Ceramic Art Association of NSW
www.caansw.asn.au

Ceramic Arts Association of Western Australia
www.ceramicartswa.asn.au

Canada

Canadian Crafts Federation
canadiancraftsfederation.typepad.com

London Potters Guild
londonpottersguild.org

Ottawa Guild of Potters
www.ottawaguildofpotters.ca

Europe

Dutch Ceramists Association (NVK), the Netherlands
www.nvk-keramiek.nl/english.html

European Ceramics Society
ecers.org

International Academy of Ceramics, Switzerland
www.aic-iac.org

Arterres Virtual Foundation, France
www.arterres.com

Association Dargiles, France
www.dargiles.org

Instituto de Promoción Cerámica, Spain
www.ipc.org.es

Japan

The Ceramic Society of Japan
www.ceramic.or.jp

New Zealand

New Zealand Society of Potters
www.nzpotters.com

United Kingdom

Arts Council England
www.artscouncil.org.uk

Arts Council of Northern Ireland
www.artscouncil-ni.org

Arts Council of Wales
www.artswales.org.uk

Scottish Arts Council
www.scottisharts.org.uk

Crafts Council
www.craftscouncil.org.uk

Craft Potters Association
www.cpaceramics.co.uk

Anglian Potters Association
www.anglianpotters.org.uk

Buckinghamshire Pottery and Sculpture
www.buckspotters.com

The Dacorum and Chiltern Potters Guild
www.thedcpg.org.uk

The Gloucestershire Guild of Craftsmen
www.guildcrafts.com

Kent Potters Association
www.kentpotters.co.uk

London Potters
www.londonpotters.com

Midlands Potters' Association
www.midlandpotters.pwp.blueyonder.co.uk

Northern Potters
www.northern-potters.co.uk

North Wales Potters
www.northwalespotters.co.uk

RESOURCES // GUILDS, ORGANIZATIONS, AND ASSOCIATIONS

Northamptonshire Guild of Designer Craftsmen
www.northantscraftsguild.co.uk

Scottish Potters Association
scottishpotters.org.dnpwebhosting.net

Southern Ceramics Group
www.southernceramicgroup.co.uk

South Wales Potters
www.southwalespotters.org.uk

Studio Pottery UK
www.studiopottery.co.uk

The Sussex Guild
www.thesussexguild.co.uk

West Country Potters Association
www.westcountrypotters.co.uk

Wey Ceramics
www.weyceramics.co.uk

Ceramics Ireland
www.ceramicsireland.org

United States

American Ceramic Society
ceramics.org

American Craft Council
www.craftcouncil.org

Association of Clay and Glass Artists of California
www.acga.net

Clay Artists of San Diego, Inc.
clayartistsofsandiego.org

Michigan Ceramic Art Association
www.michiganceramicartassociation.org

National Council on Education for Ceramic Arts
nceca.net

New Mexico Potters and Clay Artists Association
www.nelsonmoore.com/nmpca

Potters' Guild of New Jersey
www.pottersguildnj.org

Prince George Potters' Guild
www.pgpotters.ca

Washington Clay Arts Association
washingtonpotters.org

Workshops and studios

United Kingdom

401½ Studios
401 Wandsworth Road
London SW8 2JP
Tel: 020 7627 0405
www.401studios.org

Atom Studios
1st Floor, Anderson House
114 Thornton Road
Bradford BD1 2DX
Tel: 01274 746 677
www.atomstudios.co.uk

Chapter Arts Centre
Market Road
Canton
Cardiff CF5 1QE
Wales
Tel: 02920 311 064
www.chapter.org

Coburg House Art Studios
15 Coburg Street
Edinburgh EH6 6ET
Tel: 0131 553 2266
www.coburghouseartstudios.co.uk

Cockpit Arts
Cockpit Yard
Northington Street
London WC1N 2NP
Tel: 020 7419 1959
www.cockpitarts.com

Craft Central
Pennybank Chambers
33–35 St John's Square
London EC1M 4DS
Tel: 020 7251 0276
www.craftcentral.org.uk

Oxo Tower Wharf
Bargehouse Street
South Bank
London SE1 9PH
Tel: 020 7021 1650
www.coinstreet.org/spacehire/retail-units.html

Persistence Works/Yorkshire Art Space
Persistence Works
21 Brown Street
Sheffield
Yorkshire S1 2BS
Tel: 0114 276 1769
www.artspace.org.uk

Phoenix Art Studios
10–14 Waterloo Place
Brighton
East Sussex BN2 9NB
Tel: 01273 603 700
www.phoenixarts.org

The Chocolate Factory
Farleigh Place
Stoke Newington
London N16 7SX
Tel: 020 7503 7896 or 020 7209 5862
www.chocolatefactoryN16.com

Wasps Artists Studios
77 Hanson Street
Glasgow G31 2HF
Tel: 0141 554 8299
www.waspsstudios.org.uk

United States

Clay Art Studio
Clay Art Center
40 Beech Street
Port Chester
New York 10573
Tel: 914 937 2047
www.clayartcenter.org

Fired Up Studios
1701 E Hennepin Avenue
Minneapolis
Minnesota 55414
Tel: 612 852 2787
www.firedupstudios.com

The Clay Studio
61 Bluxome Street
San Francisco
California 94107
Tel: 415 777 9080
www.theclaystudio.com

Mud Fire
175 Laredo Drive
Decatur
Georgia 30030
Tel: 404 377 8033
www.mudfire.com

Useful websites

Artspace
www.artspace.org

Axis
www.axisweb.org

Ceramics Today
www.ceramicstoday.com/links/tuition2.html

The National Federation of Artist's Studio Providers (NFASP)
www.nfasp.org.uk

British Arts
www.britisharts.co.uk/studiospace.htm

Suppliers

United Kingdom

GENERAL SUPPLIES

Bath Potters' Supplies
Unit 18, Forth Avenue
Westfield Trading Estate
Radstock
Bath BA3 4XE
Tel: 01761 411077
sales@bathpotters.co.uk
www.bathpotters.co.uk

Clay Man
Morells Barn
Park Lane
Lower Bognor Road
Lagness
Chichester
West Sussex PO20 1LR
Tel: 01243 265845
www.claymansupplies.co.uk

CTM Supplies
9 Spruce Close
Exeter EXU 9JU
Tel: 01395 233077
admin@ctmsupplies.co.uk
www.ctmpotterssupplies.co.uk

Pot Clays Ltd
Brick Kiln Lane
Etruria
Stoke-on-Trent ST4 7BP
Tel: 01782 286506
sales@potclays.co.uk
www.potclays.co.uk

Potterycrafts Ltd
Campbell Road
Stoke-on-Trent ST4 4ET
Tel: 01782 745000
sales@potterycrafts.co.uk
www.potterycrafts.co.uk

The Potters Connection
Chadwick Street
Longton
Stoke-on-Trent ST3 1PJ
Tel: 01782 598729
www.pottersconnection.com

Scarva Pottery Supplies
Unit 20, Scarva Road Industrial Estate
Banbridge
Co. Down BT32 3QD
Northern Ireland
Tel: 028 406 69699
www.scarvapottery.com

Top Pot Supplies
Celadon House
8 Plough Lane
Newport
Shropshire TF10 8BS
Tel: 01952 813203
www.toppotsupplies.co.uk

Valentine Clays Ltd
The Sliphouse
18–20 Chell Street
Hanley
Stoke-on-Trent ST1 6BA
Tel: 01782 271200
www.valentineclays.com

W. G. Ball Ltd
Anchor Road
Longton
Stoke-on-Trent ST3 1JW
Tel: 01782 312286
www.wgball.com

Kilns and equipment

Briar Wheels & Suppliers Ltd
Whitsbury Road
Fordingbridge
Hampshire SP6 1NQ
Tel: 01425 652991
www.briarwheels.co.uk

Kilns and Furnaces
Cinderhill Industrial Estate
Weston Coyney Road
Longton
Stoke-on-Trent ST3 5JU
Tel: 01782 344270
sales@kilns.co.uk
www.kilns.co.uk/contact

Longton Light Alloys (including Gladstone Engineering Co Ltd)
Foxley Lane
Milton
Stoke-on-Trent ST2 7EH
Tel: 01782 536615
info@pugmills.com
www.gladstone-engineering.com

Laser Kilns Ltd
Unit C9, Angel Road Works
Advent Way
London N18 3AH
Tel: 020 8803 1016
sales@laser-kilns.co.uk
www.laser-kilns.co.uk

Northern Kilns
Pilling Pottery
School Lane
Pilling, Nr. Garstang
Lancashire PR3 6HB
Tel: 01253 790307
www.northernkilns.com

ROHDE-CTM
(UK distributor of Rohde kilns and equipment)
Tel: 01392 464384
enquiries@kilnsandequipment.co.uk
www.kilnsandequipment.co.uk

Stafford Instruments Ltd
Unit 22, Wolseley Court
Staffordshire Technology Park
Stafford ST18 0GA
Tel: 01785 255588
sales@stafford-inst.co.uk
www.stafford-inst.co.uk

SERVICES

Diamond pads, wet-stone grinders, etc.

DK Holdings
Station Approach
Staplehurst
Kent TN12 0QN
Tel: 01580 891662
info@dk-holdings.co.uk
www-dk-holdings.co.uk

Display equipment

Preservation Equipment Ltd
Vinces Road
Diss
Norfolk IP22 4HQ
Tel: 01379 647400
info@preservationequipment.com
www.preservationequipment.com

Flocking services

Thomas & Vines Ltd
Units 5 & 6, Sutherland Court
Moor Park Industrial Centre
Tolpits Lane
Watford WD18 9SP
Tel: 01923 775111
orders@flocking.co.uk
www.flocking.co.uk

Rapid prototyping/ Laser cutting services

Metropolitan Works
Digital Manufacturing Centre
41 Commercial Road
London E1 1LA
Tel: 020 7320 1878
www.metropolitanworks.org

Transfers/Decals

Heraldic Pottery
Unit 2, Adderly Works
Sutherland Road
Longton
Stoke-on-Trent ST3 1HZ
Tel: 01782 330073
www.heraldicpottery.co.uk

Digital Ceramics
The Old School House
Outclough Road
Brindley Ford
Stoke-on-Trent ST8 7QD
Tel: 01782 512843
info@digitalceramics.com
www.digitalceramics.com

Canada

Tucker's Pottery Supplies, Inc.
15 West Pearce Street
Richmond Hill
Ontario L4B1 H6
Tel: 800 304 6185
www.tuckerspottery.com

United States

GENERAL SUPPLIES

Amaco
6060 Guion Road
Indianapolis
Indiana 46254 1222
Tel: 800 374 1600
www.amaco.com

Axner
490 Kane Court
Oviedo
Florida 32765
Tel: 407 365 2600
www.axner.com

BigCeramicStore.com
543 Vista Boulevard
Sparks
Nevada 89434
Tel: 775 351 2888
support@bigceramicstore.com
www.bigceramicstore.com

Clay People
1430 Potrero Ave.
Richmond
California 94804
Tel: 510 236 1492
www.claypeople.net

Clay Planet
1775 Russell Ave
Santa Clara
California 95054
Tel: 800 443 2529
www.claymaker.com

Columbus Clay
1080 Chambers Road
Columbus
Ohio 43212
Tel: 866 410 2529
www.columbusclay.com

Highwater Clays
600 Riverside Drive
Asheville
North Carolina 28801
Tel: 828 252 6033
www.highwaterclays.com

Kemper Tools
13595 12th Street
Chino
California 91710
Tel: 909 627 6191
www.kempertools.com

Laguna Clay
14400 Lomitas Avenue
City of Industry
California 91746
Tel: 626 452 48862
info@lagunaclay.com
www.lagunaclay.com

Mile Hi Ceramics, Inc.
77 Lipan
Denver
Colorado 80223
Tel: 303 825 4570
www.milehiceramics.com

Minnesota Clay Co.
8001 Grand Avenue South
Bloomington
Minnesota 55420
Tel: 612 884 9101
www.minnesotaclayusa.com

The Potters Shop
31 Thorpe Road
Needham Heights
Massachusetts 02194
Tel: 781 449 7687
www.thepottersshop.blogspot.com

Kilns and equipment

Aim Kilns
369 Main Street
Ramona
California 92065
www.aimkilns.com

Bailey Ceramic Supply
PO 1577
Kingston
New York 12401
www.baileypottery.com

Paragon Industries
PO Box 85808
Mesquite
Texas 75185-0808
www.paragonweb.com

Skutt Ceramic Products, Inc.
6441 SE Johnson Creek Boulevard
Portland
Oregon 97206
Tel: 503 774 6000
www.skutt.com

SERVICES

Flocking

Flocktex, Inc.
200 Founders Drive
Woonsocket
Rhode Island 02895
Tel: 401 765 2340
www.flocktex.com

Laser cutting

Laser Cutting, Inc.
1549 South 38th Street
Milwaukee
Wisconsin 53215 1717
Tel: 414 383 2000
www.lasercuttinginc.us

Useful charts

Weights and measures

Metric and Imperial

1 gram = 0.035 ounce
1 kilogram = 2.2 pounds

1 ounce = 28.35 grams
1 pound = 453.6 grams

1 milliliter = 0.034 fluid ounces
1 liter = 2.1 US pints
30 milliliters = 1 fluid ounce
470 milliliters = 1 US pint

1 millimeter = 1/32 inch
1 centimeter = 3/8 inch
1 meter = 39 3/8 inch

inch = 2.54 centimeters
1 foot = 30.48 centimeters

Orton Cone Chart

Large Cones

Cone no.	Approx. bending temp. Heating rate 108°F/hr (60°C) °C	°F	Approx. bending temp. Heating rate 270°F/hr (150°C) °C	°F
018	1314	712	1350	732
017	1357	736	1402	761
016	1416	769	1461	794
015	1450	788	1501	816
014	1485	807	1537	836
013	1539	837	1578	859
012	1579	858	1616	880
011	1603	873	1638	892
010	1648	898	1675	913
09	1683	917	1702	928
08	1728	942	1749	954
07	1783	973	1805	985
06	1823	995	1852	1011
05	1886	1030	1915	1046
04	1940	1060	1958	1070
03	1987	1086	2014	1101
02	2014	1101	2048	1120
01	2043	1117	2079	1137
1	2077	1136	2109	1154
2	2088	1142	2124	1162
3	2106	1152	2134	1168
4	2120	1160	2158	1170
5	2163	1184	2201	1205
6	2288	1220	2266	1241
7	2259	1237	2291	1255
8	2277	1247	2316	1269
9	2295	1257	2332	1278
10	2340	1282	2377	1303
11	2359	1293	2394	1312

Temperature conversion

$°C = (°F − 32) ÷ 1.8$
$°F = (°C × 1.8) + 32$

°F	°C
33.8	1
35.6	2
37.4	3
39.2	4
41.0	5
42.8	6
44.6	7
46.4	8
48.2	9
50	10
68	20
86	30
104	40
122	50
140	60
158	70
176	80
194	90
212	100
392	200
572	300
752	400
932	500
1112	600
1292	700
1472	800
1652	900
1832	1000
2012	1100
2192	1200
2372	1300
2552	1400
2732	1500

Materials

US Material	UK Equivalent
Ferro 3110, Frit 386, Pemco P-991	alkaline leadless frit
Ferro 3124	high alkaline frit
Kentucky Ball Clay, Tennessee Ball Clay	ball clay (Hyplas 71, AT ball clay)
Ferro 3134, Frit 550, Pemco P-926, Hommel 14	standard borax frit
Colmanite, Gerstley Borate	calcium borate frit
EPK, Georgia China Clay	china clay (kaolin)
Cornish stone, Carolina Stone, Kona A-3, Pyrophyllite	Cornish stone (China stone)
Bell, Buckingham G-200, Kingman K-200, Custer, Clinchfield # 202	feldspar (potash)
Spruce Pine 4, Kona F-4	feldspar (soda)
Albany slip	Fremington red clay
Ferro 3498, O Hommel 14, Frit 28, Pemco Pb-700	lead bisilicate
Ferro 210701	lead sesquisilicate
Zirconium silicate, Zircon, Disperson	Opax, Zircopax

Contributors

Thomas Aitken
www.thomasaitken.com
Photo: Donna Griffith

Felicity Aylieff
Photo: Derek Au

Maggie Barnes
www.maggiebarnes.co.uk
Photo: David Chalmers

Helen Beard
www.helenbeard.com
Photo: Michael Harvey

Susan Beiner
www.susanbeinerceramics.com
Photo: Darien Johnson

Kochevet Bendavid
www.kochevetceramics.com
Photo: Antony Dawton

David Binns
www.davidbinnsceramics.co.uk
Photo: by artist

Matthew Blakely
www.matthewblakely.co.uk
Photo: by artist

Ruth Borgenicht
www.ruthborgenicht.com
Photo: Joseph Painter

Dylan Bowen
www.dylanbowen.co.uk
Photo: Ben Ramos

Christie Brown
www.christiebrown.co.uk
Photo: Sussie Ahlburg

Sandy Brown
www.sandybrownarts.com
Photo: Sandy Brown

Neil Brownsword
Portrait image: Steve Speller
Photo: Guy Evans

Rebecca Catterall
www.rebeccacatterall.com
Photo: Prodoto

Matthew Chambers
www.matthewchambers.co.uk
Photo: Steve Thearle

Jacqui Chanarin
Photo: Full Stop Photography

Carina Ciscato
www.carinaciscato.com
Photo: Michael Harvey

Kirsten Coelho
www.kirstencoelho.srivilasa.com
Photo: Grant Hancock

Susan Collett
www.susancollett.ca
Photo: Nicholas Stirling

Nic Collins
www.nic-collins.co.uk
Photo: by artist
Image of anagama kiln on p. 158:
courtesy of artist

Robert Cooper
www.robertcooper.net
Photo: by artist

Claire Curneen
www.clairecurneen.com
Photo: Dewi Tannant Lloyd

Natasha Daintry
www.natashadaintry.com
Photo: Matthew Donaldson

Lowri Davies
www.lowridavies.com
Photo: Dewi Tannat Lloyd

Pippin Drysdale
www.pippindrysdale.com
Photo: Robert Firth, Acorn Photo Agency

Ken Eastman
www.keneastman.co.uk
Photo: by artist

Mike Eden
www.michael-eden.co.uk
Photo: Courtesy of Adrian Sasson

Sanam Emami
www.sanamemami.com
Photo: Joe Mendoza

Heather Mae Erickson
www.heathermaeerickson.com
Photo: John Carlano
Portrait image: Peter Pincus

Kathy Erteman
www.kathyerteman.com
Photo: by artist

Simcha Even-Chen
www.simcha-evenchen.com
Photo: Ilan Amihai

Sarah Flynn
www.saraflynnceramic.com
Photo: Roland Paschhoff

Debra Fritts
www.debrafritts.net
Photo: David Gulisano

Carolyn Genders
www.carolyngenders.co.uk
Photo: Steve Hawksley

Tanya Gomez
www.tgceramics.co.uk
Photo: Dominic Tschudin

Dimitra Grivellis
Photo: Jonnie Rutter

Mieke de Groot
www.miekedegroot.nl
Photo: Ron Zÿlstra

Susan Halls
www.susanhalls.com
Photo: John Polak

Jane Hamlyn
www.saltglaze.fsnet.co.uk
Photo: Ted Hamlyn

Ashraf Hanna
www.studiopottery.co.uk/profile/Ashraf/Hanna
Photo: by artist
Raku images on pp. 194/195:
courtesy of the artist

Marie Hermann
www.mariehermann.dk
Photo: Tim Thayer

Akiko Hirai
www.akikohiraiceramics.com
Photo: Toshiko Hirai

Hitomi Hosono
www.hitomi.hosono.com
Photo: by artist

Steve Irvine
www.steveirvine.com
Photo: by artist

Ikuko Iwamoto
www.ikukoi.co.uk
Photo: by artist

Stine Jespersen
www.stinejespersen.com
Photo: Tas Kyprianou

Walter Keeler
Photo: by artist

Chris Keenan
www.studiopottery.co.uk/profile/Chris/Keenan
Photo: Michael Harvey

Matt Kelleher
www.mattkelleher.com
Photo: by artist

Sun Ae Kim
www.sunaekim.com
Photo: by artist

Eva Kwong
www.personal.kent.edu/~ekwong
Photo on p. 75: Jasper Mangus
Photo on p. 201: Guoliang Xu

Pamela Leung
www.pamleung.com
Photo: Thomas Neille

Marc Leuthold
www.marcleuthold.com
Photo: Eva Heyd

RESOURCES // CONTRIBUTORS

Natasha Lewer
www.natashalewerceramics.co.uk
Photo: Jonathan Tickner

Maria Lintott
www.marialintott.net
Photo: by artist
Portrait photo: Joanne Underhill
Sandblaster image on p. 237:
courtesy of the artist
Photo on p. 239, bottom right:
Sylvain Deleu

Robbie Lobell
www.robbielobell.com
Photo: Mike Stadler

Uwe Löllmann
www.uweloellmann.de
Photo: by artist

Tyler Lotz
www.tylerlotz.com
Photo: by artist

Anja Lubach
www.anjalubach.com
Photo: Matthew Booth

Kuldeep Malhi
www.kuldeepmalhi.com
Photo: by artist

Janet Mansfield
www.janetmansfield.srivilasa.com
Photo: Greg Piper
Images on pp. 50 and 159: courtesy of the artist

Alice Mara
www.alicemara.com
Photo: by artist

Nao Matsunaga
www.naomatsunaga.com
Photo: Phil Sayer
Photo of Wall With a Doorway
on p. 76: Mirai Tomono

Firth McMillan
www.firthmacmillan.com
Photo: Jack Ramsdale

Craig Mitchell
www.craigmitchellceramics.com
Photo: Shannon Tofts

Sara Moorhouse
www.saramoorhouse.com
Photo: Malcom Bennett

Katharine Morling
www.katharinemorling.co.uk
Photo: Stephen Brayne

Margaret O'Rorke
www.castlight.co.uk
Photo: Tuukka Paikkarri

Heidi Parsons
www.heidiparsons.net
Photo: RCA Photographer

Rafael Perez
www.rafaperez.es
Photo: Carlos E. Hermosilla

Merete Rasmussen
www.mereterasmussen.com
Photo: Michael Harvey

Lee Renninger
www.leerenninger.com
Photo: by artist

James Rigler
www.jamesrigler.co.uk
Photo: by artist

Anders Ruhwald
www.ruhwald.net
Photo: Travis Roozee

Elke Sada
www.elkesada.de
Photo: Michael Wurzbach

Steve Sauer
www.sauerpottery.com
Photo: by artist

Micki Schloessingk
www.mickisaltglaze.co.uk
Photo: by artist

Jeff Schmuki
www.jeffschmuki.com
Photo: by artist

Kate Schuricht
www.kateschuricht.com
Photo: Greenhalf Photography

Zeita Scott
www.zeitascott.co.uk
Photo: by artist

Bonnie Seeman
www.bonnieseeman.com
Photo: by artist

Koji Shiraya
www.kojishiraya.com
Photo: by artist

Kaori Tatebayashi
www.kaoriceramics.com
Photo: by artist

Caroline Tattersall
www.carolinetattersall.com
Photo: Daan wan Vel

Louisa Taylor
www.louisataylorceramics.com
Photo: Matthew Booth

Sam Taylor
www.dogbarpottery.com
Photo: Howard Korn
Images on pp. 188/189: courtesy of the artist

Yo Thom
www.yothom.com
Photo: Will Thom

Jim Thomson
www.jimthomson.ca
Photo: by artist

Prue Venables
Photo: Terence Bogue
Portrait image: David Smith

Tina Vlassopulos
www.tinavlassopulos.com
Photo: Mike Abrahams

Jonathan Wade
www.jwadeceramics.co.uk
Photo: fotofit

Wendy Walgate
www.walgate.com
Photo: by artist

Jason Walker
www.jasonwalkerceramics.com
Photo: by artist

Owen Wall
www.owenwall.co.uk
Photo: James Champion

Sasha Wardell
www.sashawardell.com
Photo: Sebastian Mylius

James and Tilla Waters
www.jamesandtillawaters.co.uk
Photo: by artist

John Wheeldon
www.johnwheeldonceramics.co.uk
Photo: by artist

Andrew Wicks
www.andrewwicks.co.uk
Photo: by artist

Glen Wild
www.glenwild.co.uk
Photo: Ester Segarra

Conor Wilson
www.conwilson.com
Photo: by artist

Derek Wilson
www.derekwilsonceramics.com
Photo: Felicity Straker Graham

Robert Winokur
www.robertwinokur.com
Photo: John Carlano

Maria Wojdat
www.mariawojdat.co.uk
Photo: by artist

Rohde-CTM
Images on pp. 25, 51, 105, 156, and 161

Gladstone Engineering
Images on pp. 60, 102, 104, and 105

DK Holdings
Image on p. 243

Bibliography

Books

Andrews, Tim (2005) *Raku (second edition)*. A & C Black Publishers Ltd

Billington, Dora, and Colbeck, John (1974) *The Technique of Pottery*. BT Batsford Ltd

Birks, Tony (1979) *Pottery: A Complete Guide to Pottery-Making Techniques*. Pan Books Ltd

Bryers, Ian (1990) *The Complete Potter: Raku*. BT Batsford Ltd

Cooper, Emmanuel (2009) *Contemporary Ceramics*. Thames & Hudson

— (2004) *The Potter's Book of Glaze Recipes*. A & C Black Publishers Ltd

— (2010) *Ten Thousand Years of Pottery (fourth edition)*. The British Museum Press

Daly, Greg (1995) *Glazes and Glazing Techniques*. A & C Black Publishers Ltd

Eden, Michael and Victoria (1999) *Slipware – Contemporary Approaches*. A & C Black Publishers Ltd

Fraser, Harry (1994) *The Electric Kiln*. A & C Black Publishers Ltd

Hamer, Frank and Janet (1997) *The Potter's Dictionary of Materials and Techniques*. A & C Black Publishers Ltd

Hanoar, Ziggy (2007) *Breaking the Mould: New Approaches to Ceramics*. Black Dog Publishing

Hluch, Kevin, A (2001) *The Art of Contemporary American Pottery*. Krause Publications

Lark editors (2008) *Masters: Porcelain: Major Works by Leading Ceramicists*. Lark Books

Lefteri, Chris (2003) *Ceramics: Materials for Inspirational Design*. RotoVision

Mathieson, John (2010) *Techniques Using Slip*. A & C Black Publishers Ltd

Quinn, Anthony (2007) *The Ceramics Design Course*. Thames & Hudson

Reijnders, Anton (2005) *The Ceramic Process: A Manual and Source of Inspiration for Ceramic Art and Design*. A & C Black Publishers Ltd

Rhodes, Daniel (1989) *Clay and Glazes for the Potter*. Chilton Book Company

Rogers, Phil (2002) *Salt Glazing*. A & C Black Publishers Ltd

Tudball, Ruthanne (1995) *Soda Glazing*. A & C Black Publishers Ltd

Wardell, Sasha (1997) *Slipcasting*. A & C Black Publishers Ltd

Whiting, David (2009) *Modern British Potters and Their Studios*. A & C Black Publishers Ltd

Wood, Karen, A. (1999) *Tableware in Clay*. The Crowood Press Ltd

Magazines/Periodicals

Australia
Ceramics: Art and Perception and *Ceramics Technical*
www.ceramicart.com.au

Pottery in Australia
www.potteryinaustralia.com

France
La Revue de la Ceramique et du Verre
www.revue-ceramique-verre.com

Germany
Keramik Magazin Europa
www.keramikmagazine.de

Neue Keramik
www.neue-keramik.de

The Netherlands
Keramiek
www.nvk-keramiek.nl

Spain
Revista Ceramica
www.revistaceramica.com

Sweden
Form
www.svenskform.se

United Kingdom
Artist Newsletter
www.a-n.co.uk

Ceramic Review
www.ceramicreview.com

Crafts Magazine
www.craftscouncil.org.uk

Interpreting Ceramics
www.uwic.ac.uk/ICRC

United States
American Ceramics
www.amceram.org

Ceramics Monthly
www.ceramicartsdaily.org

Clay Times
www.claytimes.com

Studio Potter
www.studiopotter.org

Glossary

anagama kiln a single chamber, wood-fired climbing kiln

bisque ware (biscuit) unglazed ware that has been fired once, ready to receive a glaze

bleb blister underneath a clay skin

blunger machine to prepare and churn casting slip

bow harp c-shaped metal frame with a cutting wire attached between the opening. This tool is used to slice slabs quickly

CAD computer aided design

casting forming clay objects by pouring slip into a porous mold

casting slip clay and water in suspension, used for the process of slip casting

celadon a light green-gray-blue stoneware and porcelain glaze

chattering judder-type mark that sometimes appears when turning. This can be caused by blunt tools or because the clay is too soft or hard

chuck a thrown form, attached to and centered on the wheelhead, used to support a piece for turning

cottle/cuff mold sheet of flexible plastic that is wrapped around a model to form walls for a mold

enamels soft melting glass used for decorative purposes. Also referred to as low-fired on-glaze decoration

engobe slip containing glaze materials. It is usually more vitreous than the body it covers

extruder a tool used to compress clay through a die to produce a uniform section

fat oil a medium used to blend with enamel pigment so it can be applied to a surface

fettle/fettling cleaning up seam lines on greenware with a knife or sponge prior to firing

flux an ingredient in a glaze or clay body that lowers the melting point of silica to form a glass or glaze

frit ceramic materials melted together with silica in an industrial process and ground into a powder. The purpose of this is to render any soluble or toxic materials insoluble and therefore safe to use

galley a rim created on the inside or outside of a vessel to locate a lid securely

glaze layer of glass fused onto the ceramic surface

greenware raw, unfired clay ware

grog fired and ground ceramic added to clay bodies to give strength and texture

jigger/jolley the process of forming shapes with a profiled tool set over a rotating mold. To "jigger" is to profile the exterior of the mold; to "jolley" is to profile the interior of the mold

kaolin china clay, EPK

kidney (also referred to as a rib) a curved edge tool made from plastic or metal, used for modeling and shaping clay

kiln wash a mixture of 2 parts alumina, 1 part china clay and water used to protect kiln furniture. It can also be painted onto rims, bases, or galleries of pots to prevent them fusing together

leather-hard the stage between plastic clay and greenware. The clay is firm enough to be joined without distorting and can still be easily worked

maiolica decorated tin-glazed earthenware originating from the Mediterranean around the fifteenth century

maquette a basic three-dimensional scale model of an object

mold a former made from plaster, wood, or other materials used to shape/form clay

neriage the ancient Japanese technique of layering, cutting, and reforming different colors of clay to create intricately patterned sheets

noborigama kiln a multichambered wood-fired climbing kiln

oxide a chemical combination of oxygen with another element

plaster bat block or sheet of plaster used to aid mold making or reclaiming clay
porcelain a translucent white clay body
pug mill a machine for mixing and processing plastic clay
pyrometer a device connected to a thermocouple, used to measure temperature and heat work
pyrometric cones tall pyramid-shaped devices placed inside a kiln to measure and gauge heat work

raku traditional Japanese low-fire technique. The process involves the wares being fired quickly to around 1832°F (1000°C), taken out of the kiln red hot, then buried in sawdust and left to reduce
rapid prototyping three-dimensional modeling process using CAD software and sophisticated machinery to print physical objects (prototypes)
rib a wooden or metal tool used to shape and support the clay during throwing

saggar a box made from coarse refractory clay used to protect wares from flames and gases during a firing. A saggar can also be used as a chamber to smoke-fire individual pieces in a kiln
sang-de-boeuf a deep red reduction glaze produced by the addition of copper oxide. *Sang-de-boeuf* means "oxblood"
set term used to refer to the state of plaster when it has set enough to retain its shape but remains soft enough to work

sgraffito decorative technique, from the Italian word "graffiare" meaning to scratch. The term refers to the cutting or scratching of a clay surface, in particular when used in conjunction with slip, engobe, or glaze, to expose a different colored body underneath
shino Japanese high temperature glaze, typically deep orange to dark brown or black in color
slab roller a mechanical press used to roll flat sheets of clay of even thickness for slab building
sledging a technique that involves drawing a profile through wet plaster to create a shape
slip a suspension of clay in water. This can be used for joining and decoration, or made into a casting slip with the addition of a deflocculant
soft soap a resist applied to plaster to render it nonporous, essential for mold making
spare (slip-casting mold) the section of the model that creates a space at the top of the mold for a pouring hole. It also provides a reservoir to top up slip levels if they drop during the casting process
sprigg a fine, intricate mold used for detailing and relief work. The term *sprigging* means to apply a sprigg to a clay surface
surform tool a tool with a serrated blade, used to carve and shape clay or plaster

tenmoku a stoneware glaze heavily colored by iron oxide. Typical colors of a tenmoku range from black, through rust, to toffee browns
terra sigilatta a very fine slip
thermocouple a probe inserted into a kiln chamber to measure temperature

undercut an area (or design fault) on a model that prevents its release from the mold

vitrification the fusion of material or body during the firing process (around 2192°F/1200°C) rendering it nonporous and impervious to water.

wet and dry paper an abrasive paper used in conjunction with water to refine the surface
whirler a type of flatbed lathe used for making plaster models and drop out molds

Index

accessories 48–49
acrylic paints 245
adhesives 244
Adobe 226, 234
advertising 260
agate 213
agents 264–65
aggregates 18
air bubbles 25, 27, 80, 102
air-dry clay 19
Aitken, Thomas 171
Alfred University 100, 257
alkaline shiny glaze 138
alumina 134–35, 180–81
anagama kilns 158–59, 192
angle grinders 243
annual events 261
applying enamels 223
applying glaze 148–51
applying stains 42
applying transfers 227
apprenticeships 176, 252
arthritis 56
artist profiles 76–77, 100–101, 130–31, 172–73, 176–77, 186–87, 192–93, 198–99, 218–19, 230–31, 238–39, 252–53, 260
artist statements 260–61
assembling 241, 244
associations 266–67
atmospheric burners 175
automated kilns 158
Aylieff, Felicity 228

Bain, Alan 198
ball clay 36, 135, 138, 140, 181, 204, 214, 275
ball mills 42, 53
banding wheels 51, 63, 151
barium 36, 56, 138, 140

Barnes, Maggie 21
batch production 105, 117, 127, 226
Bath Spa University 218
bead-making 18
Beard, Helen 10
beeswax 195, 245
Beiner, Susan 137
Bendavid, Kochevet 135
bentonite 36, 138, 140, 194, 204
bi-axel blend 143
Binns, David 18
bisque 14, 38, 42, 78, 122, 134, 147–48, 152, 161–62, 165, 167–68, 180, 204, 212, 215, 232, 234, 241–42, 245
bits 234
black 41
Blakely, Matthew 176
blebs 152
blistering 152
bloating 152, 168
blogs 260
blowouts 115, 165–66, 214
blue 41
blue-green 41
blungers 96
bonding 244, 248
bone china 23, 96, 130, 165
bone-ash 36
books 278
Borgenicht, Ruth 99
bottle throwing 112–13
bow harps 71
Bowen, Dylan 168, 216
bowl lids 118
bowl throwing 110–11
breaking strain 249
brick clay 18, 186
bronze glaze 140

bronze leaf 246
brown 41
Brown, Christie 98
Brown, Sandy 216
Brownsword, Neil 252–53
bubbling 152
buffing 243, 245
burner systems 175
burnishing 65, 161, 208
business cards 260–61

callipers 117, 127
Cambridge University 172
capitalism 252
Capriccio 218
carats 246
car kilns 157, 192
carpal tunnel syndrome 56
castellated props 48
casting slip 81, 97
catenary arch kilns 160
Catterall, Rebecca 11
CDs 226
ceiling installations 249
celadon glaze 140, 174, 176
centering 106–7, 119–20
centerlines 92, 94
Central Saint Martins College of Art and Design 198, 238, 256
centrifugal force 103, 112–13, 120
ceramic pencils/crayons 214
ceramic wares 10–11
Ceramics: Art and Perception 192, 279
Ceramics Technical 192, 279
chamber size 154
Chambers, Matthew 129
Chanarin, Jacqui 17

chattering marks 121
China clay *see* kaolin
chrome 38, 41, 56
chucks 122–23
Ciscato, Carina 103
clay 8, 10, 14–25, 36, 44, 54, 88, 126–27, 166, 198, 202, 240, 248
closed-form throwing 114–15
CMYK format 226
cobalt oxide 38, 41, 135
Coelho, Kirsten 40
coiling 60–65, 124
cold spots 174
collage 244
collaring in 112–15, 118, 126
collectability 240
collections 262–63
Collett, Susan 75
Collins, Nic 182, 190
color 18–19, 36, 38, 41–42, 57, 135–36, 138, 140, 146, 150, 158, 168, 172, 175, 181–82, 188, 195, 202, 207–13, 215, 218, 220, 222–23, 235, 245
combing 208
combining stains/oxides 42
combustible materials 73, 214
commercial glaze 136, 150
composites 18
compressors 25, 53, 151
computer programs 226, 234
computer-aided design (CAD) 91
computerised reduction firing 175
coning process 106–7

consistency of glaze 147
contact details 260
controllers 169
cooling 167
Cooper, Robert 240
copper 38, 41, 57, 135, 137, 174–75, 246
Cornish stone 36, 138, 140, 275
cottles 86–89
courses 188, 256–57
Covercoat 221
crackle 138, 152, 195
cracks 34, 63, 70, 83, 97, 110, 115, 127, 152, 155, 162, 165, 205, 214
Craft Potters Association 176
Crafts Council 176, 230, 266
Cranbrook Academy of Art 100
craters 152
crawling 152
crayons 214
crazing 152, 245
cream 41
Cummings, Phoebe 11
cup lids 118
Curneen, Claire 228
curriculum vitae (CV) 260–61
cylinder throwing 108–9

Daintry, Natasha 172–73
dampers 169, 175, 182, 189
Davies, Lowri 81, 221
De Groot, Mieke 61
De Waal, Edmund 176
decals 221, 271
decanting 45
decorative techniques 81, 85, 121, 138, 152, 220, 247
decorative ware 10, 14
deflocculants 36, 81
denatured alcohol 222, 224, 227
dentistry 10
diamond-polishing pads 242–43, 271
dies 68
digital printing 221
digital transfers 226
diluting lusters 225
dipping method 148–50, 194
display 248–49, 271
distortion 192
dolomite 36, 134–35, 140
domestic ware 17
dots per inch (dpi) 226, 234
double-inset lids 118
downdraft kilns 175
drag test 151
drop-out molds 87, 92
dry glaze 140
drying 32–35
Drysdale, Pippin 171
dunting 152
dust management 54

Eagle Gallery 230
earthenware 14, 18, 22, 35, 38, 42, 48, 81, 96, 130, 134, 138–39, 146–47, 165–66, 202, 204, 213
East London Design Show 230
Eastman, Ken 75
effects 161, 203, 221, 232
eggshell matte glaze 138
Egyptian paste 18, 20
electric kilns 154–57, 161, 168–69, 175
electric wheels 103–5
Ella Doran Prize 230
email 226, 260–61
Emami, Sanam 128
embellishment 232
embossing 97, 215
enamels 42, 220–23, 228–29, 235
energy consumption 154
engobes 203–4
engraving 232–35
engraving tools 235
epoxy glue 244
EPS files 226
equipment 50–53, 57, 71, 102, 144, 151, 169, 270–71, 273
ergonomics 105
Erickson, Heather Mae 100–101
Erteman, Kathy 217
etching 232
Even-Chen, Simcha 197
events 261
extraction units 144, 151
extruding 60–61, 68–69, 90, 124
eye protection 162

factories 252
fastenings 249
fat oil 223
feathering 202, 208
feldspar 36, 54, 134–35, 137–38, 140, 181, 204, 275
felt-tip pens 236
fettling 32, 54, 73, 83, 97, 240, 242
figurative ware 11
file format 226
finishing 119, 232, 240–43, 245, 250–51
firing cycle 158, 166–71
firing temperatures 14, 17–18, 22, 38, 42, 48–49, 138, 140, 143, 152, 154, 161–62, 164–65, 175–76, 180, 182, 189, 192, 195, 214, 220–21
firing times 158–59
fixing 248–49
flint 36, 54, 134, 137–38, 140, 204
flocking 241, 247, 271, 273
flux 36, 134–35
Flynn, Sarah 174
food use 38, 57, 138
foot rings 121
forced-air burners 175
found objects 86
freehand designs 235
Freehand Gallery 100
fritting 36, 44, 57, 134, 194, 275
Fritts, Debra 11
front-loading kilns 156–57
fueled kilns 169
Fulbright scholarships 100
furniture 48–49

galleries 74–75, 98–99, 116–18, 128–29, 170–71, 176–77, 184–85, 190–91, 196–97, 228–29, 250–51
gas kilns 155, 158, 161, 168–69, 174–76, 182, 189
gauges 117, 127
Genders, Carolyn 203
Gifu City 130
gilding 232, 246

glaze 14, 18–19, 36, 38, 41–42, 48, 56–57, 134–53, 158, 161–62, 165–68, 172, 174–76, 180–81, 192, 194, 203, 220, 236
glazing equipment 52–53
glossary 280–81
gluing 241, 244
gold leaf 241, 246
Gomez, Tanya 176
good practice 144, 240
graphs 175
green 41
green ware 32, 38, 54, 97, 204, 232
Greenwich House Pottery 100
grinding 18, 223, 242–43, 271
Grivellis, Dimitra 233
grog 18, 20, 61
guidelines 147, 167
guilds 266–67
Guldagergaard 100, 258
gypsum 78

hacksaw blades 65
Halls, Susan 197
Hamlyn, Jane 184
hand finishing 242
hand pressing 83
hand-carving 88
handbuilding 18, 35, 46, 60–61, 74–76, 102, 172, 198, 240
handheld flocking guns 247
handles 121, 124–25
Hanna, Ashraf 198–99
hardwoods 188
Harrow School of Art 130
health hazards 45
heritage economy 252

Hermann, Marie 129
high bisque 165
Hirai, Akiko 177
Hosono, Hitomi 87, 251
hump molds 82, 84
hybrid glaze 143

illmenite 176
Illustrator 226, 234
imagery 220–21, 226, 230, 260
imperial weights and measures 274
inks 232, 245
inlay 212
inset lids 118
inside galleries 116, 118
installations 11, 248–49
International Academy of Ceramics 186, 266
inversions 152, 166
iridescent effects 221
iron 14, 18
iron oxide 38, 41–42, 135, 176
Irvine, Steve 251
Iwamoto, Ikuko 22

Jespersen, Stine 69
jewelry 10, 18
joining handles 125
journals 192, 279
JPEG files 226

kaolin 17, 34, 36, 135, 137–38, 140, 181, 194, 204, 275
Keeler, Walter 129, 184
Keenan, Chris 39, 176–77
Kelleher, Matt 185
kick wheels 104–5

kilns 8, 19, 32, 38, 48–49, 55, 57, 115, 134, 152, 154–65, 192, 214, 270–71, 273
Konstfack 76, 257
Kwong, Eva 75

labels 44, 143, 146
lacquer 245
large pieces 165
laser cutting 68, 234, 236, 271, 273
latex 211, 222, 236
lathes 88–89
lead release 57
leadless shiny transparent glaze 138
leather-hard stage 32, 64–65, 72–73, 97, 110–11, 115, 118–19, 205, 208, 212
left-handed potters 103
Leung, Pamela 134
Leuthold, Marc 216
Lewer, Natasha 247
libraries 143
lidded-vessel throwing 116–17
lids 117–18, 121
lifting 55
lighting 10
line blend 143
Lintott, Maria 99, 238–39
loading kilns 162–63, 175, 182, 195
Lobell, Robbie 185
Löllmann, Uwe 10
Lotz, Tyler 250
low bisque 165
low-fired clay 14
Lubach, Anja 16
lusters 161, 195, 220–21, 224–25, 228–29, 235

machinery 57, 88–89, 104–5, 234, 236
McMillan, Firth 250
magazines 51, 279
magnesium carbonate 36, 134
maintenance of kilns 154–55
Maiolica 138
Malhi, Kuldeep 79
manganese dioxide 38, 41, 135, 181
Mansfield, Janet 192–93
manual kilns 169
manual reduction firing 175, 182
manuals 175
maquettes 19
Mara, Alice 230–31
Mara, Tim 230
marbling 202, 209
marker pens 222, 235
marketing 260–61
Marsden Woo Gallery 76, 264
masking tape 236
material safety data sheets (MSDS) 44
materials 18–19, 36–37, 44–45, 56, 73, 136, 144, 146–47, 214, 275
Matsunaga, Nao 76–77
matte glaze 138, 140, 148
mattness 135
maturity 166–67
melting points 134–35
metallics 41, 220, 224
metric weights and measures 274
milk 223
El Minia College of Fine Art 198
Mitchell, Craig 251

mixed media 241, 244
mixing enamels 223
mixing glaze 146
models 19, 88–91, 102
mold-making 47, 78–81, 96–100, 258
monoprinting 210
Moorhouse, Sara 139
Morling, Katharine 169
mounting 248
multichamber kilns 159
multipart molds 85, 92
museum putty 249

Neolithic period 76
networks 260–61
New York State College of Ceramics 100, 186
newspaper 210, 213
nibs 207
nickel 38, 41, 140
noborigama kilns 159
non-traditional methods 8
notebooks 143, 261

oil kilns 169, 174, 182
oil-based paints 245
one-off production 226
one-piece drop-out molds 87
opacity 41, 135
optional kit 51, 53
organizations 266–67
Oribe Design Center 130
O'Rorke, Margaret 249
Orton cones 49
outdoor kilns 164, 188–89
outside galleries 117–18
over-firing 152
overlapping glaze 148
oxblood 38
oxidation 246

oxides 19, 38, 41–42, 44, 57, 135–36, 138, 140, 143–44, 174, 176, 181–82, 194, 202, 204, 215, 235
oxidized firing 168–71

painting 150, 152, 206
paints 245
paper clay 17, 20, 61
Parsons, Heidi 202
parts ratio 143
patterning 85, 182, 198, 208, 210–12, 232, 236, 247
pencils 214
Perez, Rafael 22
periodicals 279
personalization 235, 240
pestle-and-mortar grinding 223
petalite 36
Philadelphia International Airport 100
Philadelphia University of the Arts 100
photography 260
Photoshop 226
pinching 60–61, 66–67
pinholing 152, 165
pink 41
pit firing 14, 161, 198
planning 163
plaster 78–80, 82, 88–90, 93–95, 97, 100
plaster bats 93–94
plastic 32, 88
plasticine 88
plate hanging 249
poisons 45, 51
polishing 18, 241–43, 245
porcelain 17, 20, 22, 33, 35, 53, 61, 96, 130, 165, 172, 176, 218, 220

portfolios 260
post firing 241, 244–47
postcards 260–61
posts 48, 125, 162–63, 167, 181
pottery wheels see wheels
pouring glaze 148
pouring lips 113
powder storage 44
power feeds 154
power-breakers 57, 243
power-engraving tools 234
preparation techniques 24–25
preparing glaze 144–45
presentation 261
press molding 18, 78, 82–86, 92, 102, 124
professionalism 240, 261
programs 164–65
promotion 260–61
prototyping see rapid prototyping
pug mills 25
pulling handles 124
purple 41
pyramid technique 80
pyrometric bars 169
pyrometric cones 49, 57, 152, 164, 169, 182, 189, 195

quantities of glaze 137
quartz 36, 54, 134, 138, 166
Queensbury Hunt Prize 230

raku firing 22, 152, 161, 194–98, 245
ramps 164–65
ram's head wedging 28–29
rapid prototyping 91, 100, 245, 271

Rasmussen, Merete 171
raw materials 136, 144, 146–47
ready-made molds 86
ready-made transfers 226
recipes 18, 20–22, 34, 81, 136–41, 144, 146, 181, 194, 204–5
reclamation 25, 126
record keeping 143, 164, 175
recycling 20, 25
red glaze 140, 174–75
reduction techniques 165, 168–69, 174–77, 182, 189, 194–95
reference libraries 143
refiring 152, 167, 235
relief 85, 87, 215
Renninger, Lee 177, 241
reoxidation 195
repairs 235
repeat patterning 211
repetitive strain 56
representation 264–65
residency programs 258–60
resist techniques 180–81, 211, 232, 234, 236
resolution 226
respirators 236
Rhodes, Daniel 20
Richard Denis Gallery 230
Rigler, James 98
rims 64
rolling out slabs 70
Royal College of Art 76, 172, 198, 218, 230, 238, 252, 256
Ruhwald, Anders 74
rustic red matte glaze 140
rutile 38

Sada, Elke 15, 218–19
saddles 48
safety procedures 38, 44, 54–57, 138, 144, 162, 195, 234, 236, 243–44, 249
saggar 208
salt firing 22, 154, 160, 180–86, 192, 203–4, 258
sample tiles 146
sandblasting 232, 234, 236–37
sandpaper 242–43
Sauer, Steve 191
saving imagery 226
sawdust 194–95, 214
scaling up 222
Schloessingk, Micki 184
Schmuki, Jeff 248
Schuricht, Kate 153, 196
Scott, Zelta 217
screenprinting 221, 226
sculpture 11, 14, 17, 78, 88, 198, 244, 249
search engines 260
second-hand equipment 50–51
secondary throats 118
Seeman, Bonnie 169
self-glazing 203
semi-matte glaze 140
servicing kilns 154–55
sgraffito 121, 207, 232, 235
sheens 220, 224
shell wedging 30
shellac 232
shelves 48, 51, 55, 151, 163, 175, 181, 189, 195, 261
shift work 189
shino glaze 140, 174
shiny glaze 138, 140, 148
Shiraya, Koji 37

shocks 236
shrinkage 33, 117
sieves 146
signatures 240
signing work 235
silica 36, 54, 134–35, 152, 166, 180, 203
silicone carbide 242
silicosis 54
silver leaf 246
silver spoons 208
slab building 60, 70–73
slab rollers 51, 71
sledging 90
slip decoration 73, 202–17, 235
slip molds 78–79, 85
slip-casting 32, 35, 41–42, 47, 86–87, 92, 96–100, 127, 142, 148, 230, 242
slipware 65, 181, 202, 218
smoke firing 14, 198, 208
snagging 127
soaking 167
social networking 260
soda ash 36, 81
soda firing 154, 180–85, 203–4
sodium 180
software 226, 234
softwoods 188
solvents 244
space shuttles 10
spares 93
special needs wheels 105
spiral wedging 30–31
sponging 207, 212, 215
spouts 113
spray paints 245
spraying 151
spriggs 87, 215
spurs 48

stains 42–44, 97, 135, 140, 144, 204, 214–15, 235
stamps 240
static shocks 236
steel tension wire 249
stenciling 207, 211, 234, 236
sticky-backed plastic 222
stilts 48, 167
stoneware 17, 20, 22, 134, 137, 140–41, 146–47, 165–66, 204
storage 44–45, 152
striations 213
strontium carbonate 36
studio equipment 50–51, 268
styrofoam 88
Sun Ae Kim 229
sunvic dials 169
suppliers 270–73
surface techniques 47, 161, 202–17, 222, 232, 245, 258
surform tool 65–66, 73, 86, 88–89
Surrey Institute of Art and Design 172
Sydney National Art School 192

tableware 10, 23, 130
talc 36, 134–35, 140
Tatebayashi, Kaori 78
Tattersall, Caroline 12
Taylor, Louisa 40, 129, 170
Taylor, Sam 191
temperature conversion 275
temperature of kilns see firing temperatures
temperature points 166
templates 90

tenmoku glaze 140, 174–76
Teroforma 23
terra sigillata 202, 204
terra-cotta 14, 22
test blasts 236
test glaze 142–43
test rings 182
test tiles 142–43
testing centers 57
thermocouple probes 189, 195
thick pieces 165
thinners 225
Thom, Yo 15, 190
Thomson, Jim 61
throwing 35, 47, 102–3, 108–17, 126–30, 172, 176, 240
TIFF files 226
tin 41–42, 135, 138, 194
titanium oxide 38, 41
tone 17, 135, 245
tongs 149, 161, 195
tool snatch 57
tools 46–47, 51, 57, 65–66, 73, 76, 102, 119, 121, 151, 207–8, 234–35, 243
top-hat kilns 161
top-loading kilns 157
trade shows 261
traditional methods 8
trailing 202, 207–9
train kilns 192
training courses 57, 256–57
transfer leaf 246
transfers 220–21, 226–30, 271
transparent glaze 138, 140
treadle wheels 105
trimming 47, 111, 119–23
trip switches 243
troubleshooting 126–27, 152–53

tubular props 48
tumbling 192
tunnel kilns 158
turpentine 222–25, 227
two-piece molds 92–95
Tyler School of Art 186

ultraviolet-sensitive glue 244
underfiring 152
unfired stage 240, 248
unglazed ware 161, 220
University of Brighton 76
University of Hull 176
University of Wales 252, 256
updates 260
updraft kilns 175
utilitarian wares 14

vanadium oxide 38, 41, 56, 135
varnish 19, 232, 245–46
vector files 234
Venables, Prue 125, 130–31
vessels 10
vinegar 34
vitreous slip 203–4
vitrification 166–67, 220
Vlassopulos, Tina 67

wadding 181
Wade, Jonathan 128
Walgate, Wendy 170
Walker, Jason 229
wall fixtures 248
Wall, Owen 91
Wardell, Sasha 99
waste molds 86–89
water eroding 232
water smoking 166
Waters, James 141
Waters, Tilla 141

wax 211, 214, 236
wax-resist technique 150
websites 51, 256–67, 270–71, 276–77, 279
wedging 24–31, 61, 66, 102
Wedgwood 23, 252, 263
weighing out glaze 144
weights and measures 274
wet and dry sandpaper 242–43
wet grinders 243
wheel heads 119, 121–22
wheelchairs 105
Wheeldon, John 196
wheels 102, 104–17, 126–27, 172
whirlers 88
white 41
whiting 36, 134–35, 137–38, 140
Wicks, Andrew 233
wide pieces 165
Wild, Glen 19
Wilson, Conor 14, 203
Wilson, Derek 10
Winokur, Robert 186–87
wobbly pots 126
Wojdat, Maria 43
wollastonite 36, 140
wood 88, 198
wood ash 36
wood firing 22, 154, 160, 169, 174, 182, 188–92, 203–4, 258
working practice 144
workshops 188, 268

yellow-green 41

zinc oxide 41, 44, 135
zirconium 41, 135, 275

Acknowledgments

First of all, I would like to sincerely thank all the artists and contributors who so generously gave their time and permission to be featured in this book.

I would also like to thank the following people for their invaluable help:

The University of Brighton; Cockpit Arts, London; and Leach Pottery, St Ives, all in the United Kingdom, for allowing us to use their premises for photography.

My colleagues at The University of Brighton: Alma Boyes, Leyla Folwell, and Ulrika Jarl for their advice, ideas, and suggestions. A special thank-you to Ulrika for her expert assistance and participation in the slip casting step-by-step photography.

Rohde CTM, Gladstone Engineering, and DK Holdings who kindly gave permission to use images of their products.

The RotoVision team, art director Tony Seddon, and photographer Simon Punter. In particular, I would like to thank my editor Nicola Hodgson for her encouragement and commitment to the book.

Finally, to my partner, Matt, and my family and friends who have been so supportive and kept cheering me on.